MODERN EUROPEAN ART

ALAN BOWNESS

MODERN
EUROPEAN ART

with 207 illustrations

T & H

THAMES AND HUDSON

© 1972 Thames and Hudson Limited, London
Filmset by Keyspools Ltd, Golborne, Lancashire
Printed by N. V. Grafische Industrie Haarlem, Holland
Bound by Hollmann K. G., Darmstadt, Germany

0 500 62006 7 CLOTHBOUND
0 500 63006 2 PAPERBOUND

CONTENTS

Acknowledgments

The publishers are indebted to the museums and
collectors who provided photographs of works in
their possession, and also to the following individuals
and institutions who supplied photographs or allowed
them to be reproduced.
Copyright A.C.L. Brussels 187, 191; Stedelijk
Museum, Amsterdam 61, 62, 63, 67, 68; Arts
Council of Great Britain 110, 169; Oliver Baker 163;
Blauel 10; Archives Henry van de Velde, Biblio-
thèque Royale, Brussels (contemporary photograph
by Charles Lefebure) 188; Brecht-Einzig 207;
Bulloz 5, 34, 36, 49, 76, 79, 82; The Courtauld
Institute of Art, University of London 26, 87, 90;
Verlag DuMont Schauberg 148, 198; French
Government Tourist Office 202, 203, 205; Keith
Gibson 190; Giraudon 2, 15, 19, 20, 29, 31, 37, 39,
40, 52, 60, 97, 112, 162; Grubenbecher 100;
Rijksdienst voor de Monumentenzorg, The Hague
197; Hedrich-Blessing 194; The Museum of Finnish
Architecture, Helsinki 206; Tate Gallery 182;
Murray K. Keyes 55; Galerie Louise Leiris 111;
National Monuments Record, London 186; Mas
189; Maeght 104, 105; Museum of Modern Art,
New York 144; Archives Photographiques, Paris 1, 8,
9, 30; Roger Viollet 23; Dr Franz Stoedtner 192, 193,
196, 199, 200, 201; Eileen Tweedy 65, 78, 128, 129;
Charles Uht 107; United States Information Centre
204; O. Voering 80; Weill 178; Liselotte Witzel 16;
Julian Wonter 185.

In the pages that follow, I have tried to explain the evolution and development of modern art in straightforward narrative terms, so that the reader will, I hope, experience that feeling of a natural organic growth which in my view characterizes art and artistic change.

Art is the creation of individuals, but it is also the expression of a place and a time. Thus the story of modern art is told in terms of a handful of men of genius, whose work pursues a dialogue about the meaning of painting, and whose lives are lived against the social, economic and cultural background of the last hundred years. In this period, the idea of a 'Modern art' has been propounded, developed, and constantly attacked in an atmosphere of revolutionary confusion; yet by returning to the beginnings of the modern movement and following the argument stage by stage, a compelling logic does emerge, even in its most extreme manifestations.

For the sake of clarity and readability, I have concentrated on major artists and issues, and in general I have discussed only works of art that could be illustrated; accordingly, the book is far from being a comprehensive survey of the art of the last hundred years. And although it is called *Modern European Art*, references to American artists are introduced where the narrative demands. This becomes increasingly necessary in the later stages, but I have not attempted to bring the story up to date, and the treatment of new art after 1940 is a cursory one. This is not because I believe that art has come to an end, but the particular development that I am concerned to trace does seem to me to reach a certain conclusion, and the whole way in which this book is written demands a measure of historical perspective.

The central theme is the evolution of modern painting. Sculpture and architecture are discussed in similar terms, but in separate chapters: it would have been too con-

fusing to write about all three arts in a simultaneous chronological sequence. In the architecture chapter I have stressed connections with the painting because these are not always made manifest, and in any case I am not an architectural historian. I am extremely aware of the omissions in this chapter and elsewhere, but in any book of this kind a great deal has to be left out.

There are no references in the text, but the bibliography at the end provides sources and a guide to further reading. My own debts are considerable, and will be recognized by specialist scholars, who will appreciate better than anyone that a book like *Modern European Art* can be written only with the help of others. In this respect I should like to make a particular acknowledgment to my teachers, colleagues and students at the Courtauld Institute, to all of whom I am in different ways extremely grateful.

ALAN BOWNESS
London, 1971

Manet at the *Salon des Refusés*: The Birth of Modern Art

In Paris in the spring of 1863 a young painter, Edouard Manet (1832–83), submitted a picture to the jury of the Salon, which, along with hundreds of other works, was refused. The disgruntled artists appealed to the Emperor of France, Napoleon III, who agreed that there might have been a measure of injustice in the jury's decisions. He gave permission for an exhibition of the rejected paintings and sculptures: this was the *Salon des Refusés*, which marked a turning point in the history of art, and the most convenient date from which to begin any history of modern painting.

The entries in the *Salon des Refusés* would not seem very impressive today. With the exception of Manet's painting and two or three others, the work on view was indistinguishable from that in the official Salon – worthy but uninspired landscapes, portraits and figure subjects, painted for the most part in rather dark, dull colours. Then as now – or at any time since the early 19th century when art production began to rise rapidly – the great bulk of contemporary art was designed for ready appeal to popular tastes, and had no lasting qualities.

Yet the *Salon des Refusés* was important for several different but related reasons. Firstly, it undermined the prestige of the Salon, in the eyes both of the public and of the artists. It is hard now to appreciate the dominant role played in the mid-19th century by the Paris Salon, or the Royal Academy in England, or similar bodies elsewhere.

Their large mixed annual exhibitions provided the normal channel for the public exposure of artists' works. There were no alternatives, and for an artist to say that he was not going to exhibit at the Salon was rather like an artist today saying he does not believe in selling his work, or would have nothing to do with museums.

But after the *Salon des Refusés* the situation was never the same. Artists began to arrange their own exhibitions,

as the Impressionists, for example, did in 1874; and, more significantly, the activities of the art dealers increased rapidly in importance. Very quickly there emerged the pattern familiar in advanced capitalist countries today, where the dealer acts as the artist's agent, administering his business affairs, and organizing the public exhibition of his work. There was a marked shift of attitude from one generation to the next: whereas Manet could never quite break with the Salon and until the end of his life still sought Salon success, Monet, eight years his junior, with the support of dealers like Paul Durand-Ruel, could afford to be completely independent.

And this is the second reason for the importance of the *Salon des Refusés* – as a sign of the growing independence of artists. Painters and sculptors had once worked for patrons – kings, princes of the church, aristocrats, wealthy merchants. It would not have occurred to them to demand the kind of freedom a modern artist takes for granted. But the more independent spirits – a Michelangelo or a Caravaggio, for example – rebelled against the restraints of patronage, and slowly conditions changed. At first artists were still prepared to accept the judgment

1 ÉDOUARD MANET (1832–83)
*Le Déjeuner sur l'herbe, 1863. Oil on canvas, 6′11″ × 8′10″ (211 × 270).
Louvre, Paris*

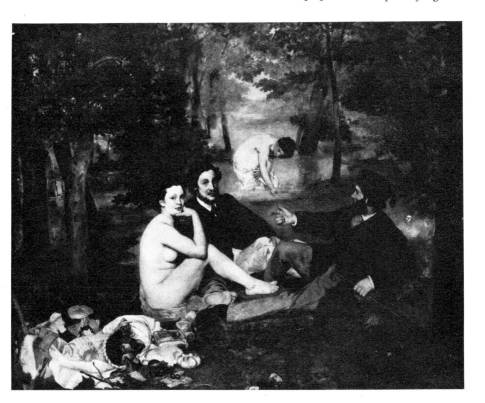

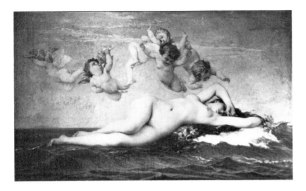

of their fellow-practitioners, and the 18th century was the great age of Academies, when the authority of men like Joshua Reynolds was recognized by artist and public alike.

But submitting one's work even to one's peers became intolerable, which partly accounted for the outburst in Paris in 1863. Painters have increasingly demanded complete freedom to do what they want, with no obligation to please anybody. This freedom is sometimes more theoretical than real, and entails demands that perhaps no artist but a Michelangelo could in fact meet. It is, however, a characteristic of modern art, and a major factor in its development over the last hundred years.

This brings us to the third and perhaps most fundamental reason for the particular importance of the *Salon des Refusés*. It marked the début of Edouard Manet as the leading young artist in Paris, taking over the position that had been Gustave Courbet's (1819–77) for almost fifteen years. Manet, more than any of his contemporaries, was thinking in a new way about art – a way, moreover, which is recognizably modern. Such a judgment can best be clarified and justified by a consideration of the picture which was the sensation at the *Salon des Refusés*, and of the reasons for its having seemed so disconcerting a work.

Le Déjeuner sur l'herbe (*Ill. 1*) shows two fashionably dressed young men with two undressed girls taking lunch in a woodland setting. Nudes were common enough at the Salons – perhaps the most admired picture at the official Salon in 1863 was the *Birth of Venus* (*Ill. 2*) by Alexandre Cabanel (1823–89) – but to juxtapose nudes with elegantly attired men smacked of

3 ÉDOUARD MANET (1832–83) *Fishing at Saint-Ouen, near Paris,* 1860–61. *Oil on canvas,* 2′6″× 4′1″ (77 × 123). *The Metropolitan Museum of Art, New York (Mr and Mrs Richard Bernhard Fund,* 1957)

impropriety. In addition, one of the girls stares provocatively out of the picture, not so much in invitation, as to remind the spectator that it is only a painting he is looking at.

Manet was probably unaware of his picture's potential. He was not a communicative artist, and the only real evidence we have of his ideas is in the paintings themselves. He seems to have been genuinely surprised at the public reaction to his work. He was after all following a traditional composition and subject – did not the *Concert Champêtre*, one of the most popular pictures in the Louvre, show a similar scene? And had not Manet also borrowed from a well-known engraving after Raphael in working out the design?

Manet was in fact a traditionalist, but of a special kind. He was attracted neither by the conventional art of the Salon, nor by the naturalism that appealed to his more adventurous contemporaries. There were qualities in the art of the past – and especially that of Velasquez, of Rembrandt, of Rubens and of Titian – that he admired, and wanted to re-introduce into modern painting. An early landscape like *Fishing (Ill. 3)* might appear to be nothing more than a pastiche of Rubens, just as the *Spanish Artist's Studio (Ill. 4)* frankly crosses Velasquez with the recently rediscovered Vermeer. These pictures show the young Manet learning by imitating the Old Masters, yet unmistakably reveal his personal touch.

For there is a quality of self-awareness about even these early pictures: the young couple in the corner of *Fishing* seem to be the artist and his wife, in fancy dress, inviting us to consider the contrivances of the picture. And again

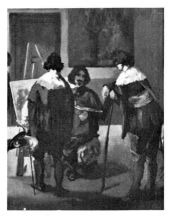

4 ÉDOUARD MANET (1832–83) *Spanish Artist's Studio,* 1860. *Oil on canvas,* 18″×15″ (46 × 38). *Collection Galerie Lorenceau, Paris*

in the *Artist's Studio* the barrier between the spectator's world and the world inside the painting is broken down by the artist's stare. It is as if Manet wanted to point out the essential artificiality of picture-making, to disabuse us of the idea that the world of the painting is a real world with an independent existence.

Manet's interest in paintings of artists in their studios is significant for this reason. He would certainly have regarded Velasquez' *Las Meninas* as one of the greatest pictures ever painted, and here the theme of the artist's awareness of his own art is for the first time tentatively stated. This idea becomes the explicit subject of Courbet's enormous picture, *L'Atelier du Peintre* (*Ill. 5*), which Manet saw in 1855 when he was still a student in the studio of Thomas Couture (1815–79). The *Atelier* was too difficult and subtle a picture for the audiences of 1855, who, like many of their successors, could see little in it but an assertion of self-love on the artist's part. But while we may admit Courbet's egotism, we must acknowledge that he was as concerned with the freedom of others as with his own.

Courbet's *Atelier* was clearly important for Manet, but not in easily definable ways. Courbet's fame rested on his realism, and he claimed the term realist when he thought it could be of use to him. But the *Atelier* is not a realist picture; it does not show what Courbet's studio was actually like while he was at work, or imply that there was ever such an incongruous assembly of people in the

5 GUSTAVE COURBET (1819–77) *L'Atelier du Peintre*, 1855. Oil on canvas, 11′11″ × 19′7″ (359 × 596). *Louvre, Paris*

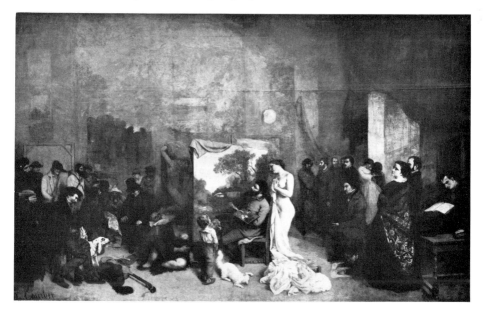

studio at any one time. In other words, this is not a picture like the *Funeral at Ornans* or the *Stonebreakers*, with which Courbet made his name. In such works he had painted exactly what he saw, without regard for pictorial conventions or social implications.

The *Atelier's* subtitle, *Real Allegory, summing up seven years of my artistic life*, helps to clarify Courbet's intentions. The painting was to be an artistic testimony, on several levels of meaning, open to interpretation by the spectator. But essentially it demonstrates that the artist can draw only from his own experiences, that all his acquaintances –the models who pose for him, his friends and supporters– are subservient to his own creative drive. In the centre of the picture, in the centre of the studio, is a landscape to which the artist puts the finishing touch: this seems to represent an order of reality more permanent, more truly real, than anything going on in the studio itself.

That Manet thought much about Courbet's picture seems evident. One has only to consider the way in which two of Manet's most ambitious early works, *The Old Musician* and *La Musique aux Tuileries*, relate respectively to the left and right halves of Courbet's *Atelier*. *The Old Musician* (*Ill. 6*) is a random assembly of Manet's models – there is no other explanation for the grouping of figures with no apparent psychological justification – the gypsy girl, the absinthe drinker, the Velasquez Philosopher, the Watteau-type child. They are raw material for Manet's early painting: that is the only reason for their existence, just as it is for the motley assortment of models

6 ÉDOUARD MANET (1832–83) *The Old Musician*, 1862. *Oil on canvas, 6' 2" × 8' 2" (187 × 248). The National Gallery of Art, Washington D.C. (Chester Dale Collection, 1962)*

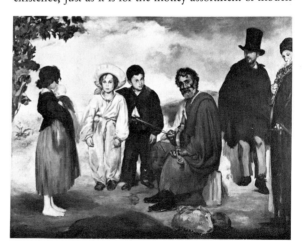

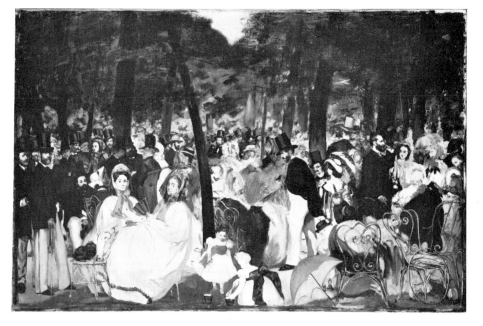

on the left of the *Atelier*, whom Courbet dismissed as 'the others – those whose lives are of no consequence'.

La Musique aux Tuileries (Ill. 7), on the other hand, shows Manet, on the extreme left, among his friends in the fashionable Paris of the early 1860s. It seems at first sight a more or less faithful rendering of an actual scene, until we realize just how artificial the whole composition is. The haunted figure of Baudelaire appears in both paintings, though neither Manet nor Courbet shared that sense of personal damnation which was so fundamental to their poet friend.

Manet in particular was much impressed by Charles Baudelaire (1821–67) whom he met in 1858. For a short while the two became intimates and Manet's whole attitude to art was permanently coloured by Baudelaire's ideas. Baudelaire was greatly concerned with the 'painting of modern life'; at its most obvious, this meant taking one's subject-matter from contemporary Paris, accepting modern dress (which was thought inappropriate to great painting or sculpture), and making ambitious figure compositions out of things seen at the theatre or in the café. At its deeper level, it meant a search for that quality of modernity in art which was to be Manet's particular achievement.

7 ÉDOUARD MANET (1832–83) *La Musique aux Tuileries*, 1862. *Oil on canvas, 30" × 46½" (76 × 118). By courtesy of the Trustees of the National Gallery, London)*

15

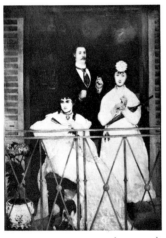

This modernity can be explained in yet another way, one that relates directly to Baudelaire. Baudelaire made a cult of the dandy, and to a certain extent Manet followed his example, as a young man always dressing most elegantly, and in later life perhaps somewhat vicariously transposing his own dandyism into an interest in women's fashions, which he shared with the poet Mallarmé. Dandyism was admired not for its own sake, but because the dandy was playing a part, disguising his own feelings beneath his often extravagant costumes.

To hide one's personal feelings may seem at first a strange artistic ambition, but at certain times in the history of art this becomes essential. The 1860s was such a time, as was to be the decade of the 1960s a century later. The excesses of abstract expressionism brought a cool, impersonal reaction; in the same way Manet knew that to break with the Romanticism of Delacroix and Ingres he needed to create an art which would permit him to establish a distance between himself and his audience. Hence the distancing stare of his model Victorine Meurent as she poses for *Le Déjeuner* or for *Olympia* (Ill. 8), the thoroughly Baudelairean picture with which Manet confirmed his position as leader of the Parisian avant-garde at the Salon of 1865.

One gets a clearer idea of the emotional coolness of Manet's art when one considers his major paintings of the later 1860s. In *The Balcony* (Ill. 9) the two couples are held enmeshed in the very complexity of the composition – a pattern of elongated rectangles with crossing diagonals, announced in the railings of the balcony itself, and repeated in the shutters and in the fans held in gloved hands. The two women are the Oriental-looking

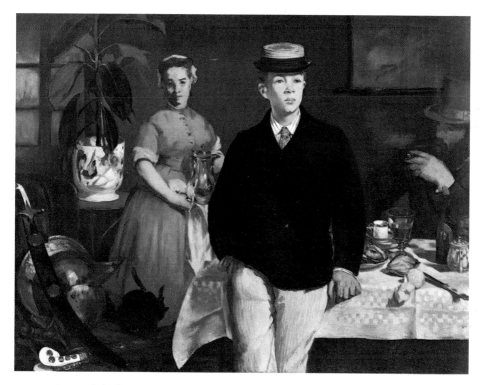

Jenny Claas and the beautiful Berthe Morisot, for whom Manet had a more than passing affection: their with-drawn expressions suggest depths of hidden feelings. And *Le Déjeuner dans l'Atelier (Ill. 10)* of the same year, 1869, confronts us like an insoluble equation: what do these figures signify – the grey-clad serving woman, the elderly man smoking a pipe, and the boy who gazes at us, resting against the improbably laid luncheon table? The whole composition is a compound of the calculated, the artificial, the unreal; all the elements of painting – colour, tone, texture, shape, space – are here demonstrated with the mastery of a supreme painter.

Another major work, the *Execution of the Emperor Maximilian (Ill. 11)*, painted only weeks after the event in Mexico in the summer of 1867, is altogether too emotionally detached for us to believe that Manet intended it as the political manifesto that some critics have suggested. But just as *The Balcony* echoes Goya's *Majas on the Balcony*, so does the *Execution* echo Goya's *Third of May, 1808*, which Manet had seen on his brief visit to Spain in 1865. Maximilian's death gave Manet

10 ÉDOUARD MANET (1832–83) Le Déjeuner dans l'Atelier, 1869. Oil on canvas, 3' 11" × 5' (118 × 154). Bayerische Staatsgemäldesamm-lungen, Munich

17

the excuse for painting Goya's subject again, but in the modern manner.

With a succession of such extraordinarily original masterpieces, Manet established a new kind of painting in the 1860s. He justified the greater measure of freedom given to the artist by asserting a more complete control over the work of art itself. Great art of the past had been made for the glory of God, or in accordance with an idea of the perfectibility of man, or in the service of Nature. Manet's art seems to turn inwards, to be made for art's sake alone. His painting was generated by the art of the past in a manner that went beyond the normal practice of learning from one's predecessors. The issues it concerned itself with were central to the nature of painting itself, and set in motion the chain of thinking that led directly to the radical experiments in artistic language made in the 20th century.

In his own time, however, the implications of Manet's paintings went largely unremarked. He seems indeed to have lost confidence a little in the 1870s, when his work clearly shows the influence of younger painters like Monet. His last major painting, *Un Bar aux Folies-Bergère* (*Ill. 13*), has the gravity and finality of a statement made only after a long period of indecision.

A few people did see the point of Manet's paintings of the '60s. One was Paul Cézanne, who was to build on Manet's foundations in his struggle to find a viable way of painting nature. Another was the poet Mallarmé who

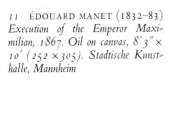

11 ÉDOUARD MANET (1832–83) *Execution of the Emperor Maximilian, 1867. Oil on canvas, 8'3" × 10' (252 ×305). Stadtische Kunsthalle, Mannheim*

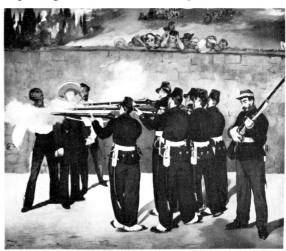

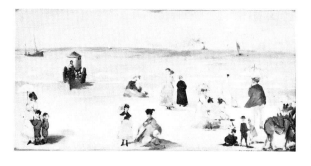

12 ÉDOUARD MANET (1832–83)
*On the Beach at Boulogne, 1869. Oil
on canvas, 12¾″ × 25¾″ (33 × 65).
Collection Mr and Mrs Paul Mellon*

was to initiate a comparable post-Baudelairean revolu-
tion in poetry. Stéphane Mallarmé (1842–98) got to
know Manet intimately in the late 1870s, and made it
his daily habit to call at the painter's studio after he had
finished his day's teaching.

Mallarmé greatly admired Manet's painting, which
confirmed the direction in which his own poetry was
moving. Both artists were looking inwards, but in an
objective rather than a subjective way. Creating a poem
was for Mallarmé the only durable, meaningful act in an
otherwise godless, irrational existence. It became a
distillation of experience so precious as to be almost
impossible to achieve, and for most of the period of
intimacy with Manet, Mallarmé was unable to write
poetry. When he started again his work was markedly
more abstract, concerned above all with formal values,
exactly as in Manet's painting. Poetry is made with
words, not ideas, Mallarmé told Degas, who fancied
himself as a writer of sonnets; and in his rare essays on art
Mallarmé was at pains to stress that a picture is made of
oils and colours, and is not a substitute for or representa-
tion of anything.

Another side of Manet's art fascinated the poet: his
introduction into the making of a painting of the element
of chance. There can be no explanation for the appear-
ance of certain early works of Manet's – *The Old Musician*,
for example – unless we accept that he was interested in
random composition. Figures touch without over-
lapping, thus flattening the space but in an altogether
arbitrary manner. Sometimes the images may approxi-
mate to our visual experience, as for example *On the Beach
at Boulogne* (*Ill. 12*), which is, however, far from being a
naturalistic rendering of the scene. There is something
quite erratic, illogical, absurd, about the construction of

19

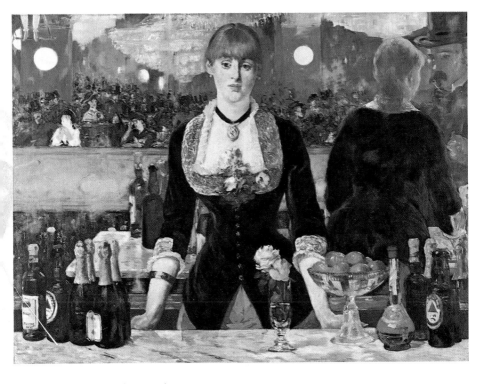

this picture, as if an element of chance had been permitted to challenge the artist's control.

Mallarmé was obsessed with the idea of chance, and it forms the subject of his last published work, *Un coup de dés n'abolira le hasard* (A dice throw never will abolish chance). Quite apart from the increasing abstraction of late Mallarmé (which reaches an extraordinary apogee in the posthumously published *L'Œuvre*), and the visual aspect of the poem's presentation (its typographical experiment is the main source for 'concrete poetry'), *Un coup de dés* is concerned with the role of chance in the creative act. A man is drowning (= the artist), a dice is thrown (= chance), a constellation of stars emerges (= the poem). The image of the drowning man may well have been suggested by Manet, who, according to Mallarmé himself, likened starting work on a new picture to a plunge into water by a man who cannot swim.

The significance of all this may not be immediately apparent, but some things will become clear in the succeeding pages, for many of the innovations of 20th century painting may be traced to Manet, as the com-

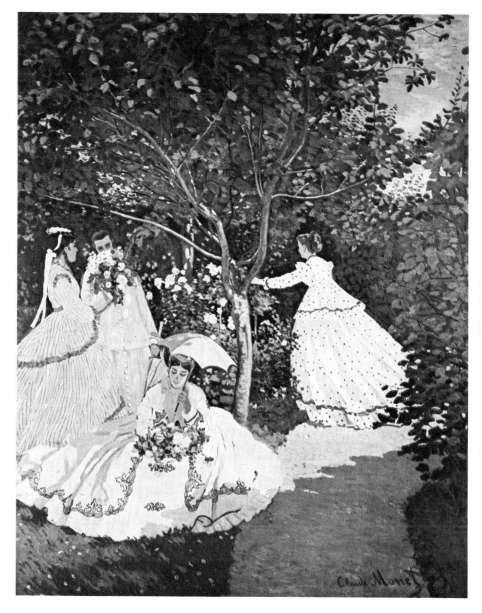

parable growth and development of modern poetry may be to Mallarmé. Both men were themselves deeply influenced by Baudelaire, but they belong to our own time, whereas Baudelaire was still enmeshed in a guilt-ridden, romantic past.

14 CLAUDE MONET (1840–1926) *Women in the Garden, 1866–67. Oil on canvas, 8′ 4″ × 6′ 9″ (235 × 205). Louvre, Paris*

CHAPTER TWO

Impressionism

Right up to his death in 1883 Manet remained in the public eye as the leader of the advanced painters, but he had in fact some fifteen years earlier surrendered this position (in so far as it existed) to a younger man. This was Claude Monet (1840–1926), and the similarity of their names led to confusion at the time, and gave rise in the popular imagination to a kind of composite figure of the iconoclastic avant-garde artist. Innovating artists up to and including Manet had placed their new work before the general public; but Monet and his friends gave up the Salons and worked for a much smaller, more appreciative and more sympathetic audience.

It is of course true that Monet and his friends began to hold public exhibitions in Paris from 1874 onwards, and the eight impressionist exhibitions up to 1886 now figure prominently in any history of the art of the period. Their impact, however, was confined to a very restricted circle, compared with those who were affronted by the *Salon des Refusés* of 1863. Vincent van Gogh, as a young art dealer in Paris in 1875–76, had never heard of the impressionists: for him the modern artists were Millet and Corot and their followers. It was not until some of the paintings in Gustave Caillebotte's bequest were grudgingly accepted by the Louvre in 1897 that the impressionists began to be popularly accepted.

By this time the men who had banded together to show their work in 1874 – Monet, Renoir, Degas, Cézanne, Pissarro – were elderly, tolerably successful, and on the whole accepted painters. As inevitably happens, they had apparently been eclipsed by younger and more intransigent talents, and with the appearance of fauvism and cubism in the early 20th century, they seemed to be pushed still further into the background. Admittedly Cézanne was quite properly regarded at the time as the father-figure of these 20th century art move-

ments, but Monet's position has only recently been clearly assessed. He now appears as Cézanne's equal: between them the two men established the language of modern art, building on foundations laid by Manet.

The late reassessment of Monet arose in part from the fact that his most original work was done at the end of an extremely long career and was in fact contemporary with the invention of cubism, abstraction and even surrealism. Much the same sort of thing happened thirty years later with Matisse, and is perhaps happening today with Henry Moore.

Another reason lies simply in the length of Monet's activity as a painter – more than sixty years – and the difficulty of fully comprehending any man's career until it is completed. This was a particularly acute problem in Monet's case, because he was an extremely consistent artist who pursued a course that was scarcely affected by anything extraneous to his own painting. More than with most artists, each picture generated the next, and Monet worried at a particular artistic problem, searching for a solution, only to find himself more deeply involved in an exploration of the problem itself.

Monet's problem was, to put it crudely, to find the pictorial equivalent for his sensations before nature. He begins, in the 1860s, as a naturalist for whom the final answer seems just round the corner: he ends, in the 1920s, as an almost abstract painter, for whom the act of painting itself has become a mysterious, ineffable gesture. And the way in which this happens has a logic that is irresistible and deeply impressive.

One can start by considering Monet's probable reactions to Manet's *Déjeuner sur l'herbe*, which he must certainly have admired in the *Salon des Refusés*. It is a fair guess that he would not have appreciated Manet's attempt to revivify traditional pictorial values. Monet was not a young painter who haunted the museums: he had very little use for them. He had grown up in Le Havre, where a struggling young landscape painter, Eugène Boudin (1824–98), had encouraged him to paint from nature, and this seemed artistic ambition enough. Manet's `Déjeuner` was impressive, but by Monet's standards there was something wrong with it – it just did not look like a group of young people sitting out of doors. It was only too obvious that Manet, like Courbet before him, had painted figures and landscape separately. Manet

15 CLAUDE MONET (1840–1926) *Déjeuner, fragment, 1865–66. Oil on canvas, 13′9″ × 4′11″ (418 × 150). Louvre, Paris*

16 PIERRE AUGUSTE RENOIR (1841–1919) *Lise with the Parasol, 1867. Oil on canvas, 41¾″ × 31½″ (106 × 80). Folkwang Museum, Essen*

in any case was manipulating the lighting in his pictures to produce a flattening effect – half tones were deliberately eliminated, and shadowed areas round a face were so reduced as to look like heavy contours.

The 25-year old Monet lacked Manet's feeling for the essential artifice of painting. He accepted the prevailing naturalist aesthetic, which was to put down only what was actually visible. So he set to work to paint a true picture of figures in natural daylight. He abandoned his first composition of a group of Parisians picnicking in Fontainebleau Forest as too ambitious. The fragments that remain (*Ill. 15*) testify to the nature of Monet's talent – tough, intractable, determined. The work is built out of great dabs of paint, each one bearing the clear mark of his brush.

The second attempt was more successful: this was the *Women in the Garden* (*Ill. 14*), in which one model, his mistress Camille, posed for all the figures. Monet worked entirely out of doors, and only when the sun was shining. As a consequence this was the most faithful pictorial record to date of the fall of light on a figure: a little in advance of the *Lise with the Parasol* (*Ill. 16*), painted by Monet's great friend and companion, Auguste Renoir (1841–1919).

Renoir's picture was shown at the 1868 Salon, but Monet's *Women in the Garden* had been rejected by the Jury the year before. The practical difficulties of executing large figure compositions out of doors were discouragement enough – Monet had had to dig a trench in the garden while he was at work and lower his canvas into it – and Monet therefore turned to landscape painting, which henceforth became almost his total preoccupation.

He was still obsessed with the effects of light, and especially with certain problems of pictorial representation which no one seemed to have tackled before. Who had painted landscapes in bright sunlight? Only the English Pre-Raphaelites, of whose work Monet was probably totally unaware. In the summer of 1869, Monet worked with Renoir at La Grenouillère, a boating and bathing place on the Seine in the outer suburbs of Paris. In the pictures they painted together (*Ills. 17, 18*) of the fall of sunshine on water, Monet used big dabs of pure colour, Renoir a softer, more feathery touch. Both men showed their awareness of the way Courbet painted landscapes – with a feeling for the materiality of things

17 CLAUDE MONET (1840–1926) *La Grenouillère, 1869. Oil on canvas, 29½″ × 39¼″* (75 × 99). *The Metropolitan Museum of Art, New York (Bequest of Mrs H. O. Have-meyer, 1929)*

18 PIERRE AUGUSTE RENOIR (1841–1919) *La Grenouillère, 1869. Oil on canvas, 26″ × 32″ (66 × 81). Nationalmuseum, Stockholm*

19 CLAUDE MONET (1840–1926)
*Poppy Field, 1873. Oil on canvas,
19¾" × 25½" (50.5 × 63.5). Louvre,
Paris*

(rocks, trees, grass, water) that he translated into the texture of the paint itself, and with an insistence on local colour. Courbet knew that grass was green, and that was an end to it. But Monet and Renoir saw that grass could look grey, or yellow, or blue, depending on the light, and this observation revolutionized their painting.

One can test the intensity of their perception of nature in a close examination of a shadowed area in one of their paintings. The touch is broken so that a wide variety of pure colours can be juxtaposed. Monet, like Delacroix before him, had been to North Africa where the fall of light and shadow is more extreme than in France, and had realized that shadows are coloured, and not various tones of brown, as in conventional representations. He was also aware of certain optical effects, concerning both tone and colour, and in particular of the way the pure colours attract their complementaries. Monet tried to record his observations as directly as possible. A few years later, a younger artist, Georges Seurat, was to codify them into a system.

In the 1870s Monet painted a long series of landscapes in which he put these new ideas into practice. Despite personal and financial worries, he worked with extra-ordinary confidence and optimism, like a man who has found the secret of painting. His subject-matter is invariably serene and delightful – grassy meadows rich with flowers, boats on the river, scenes full of light and air, all painted in bright colours; ochre and black pig-

ments were banished from his palette. In the *Poppy Field* (*Ill. 19*) there is a casual spattering of red on green, a simplicity of design, a feeling of movement that cannot fail to captivate. And yet this was among the paintings dismissed as ephemeral and trivial with the label 'impressionist' when shown in the first independent exhibition of 1874.

By the end of the 1880s Monet was a successful artist, though always aloof from the old and now rapidly decaying Salon establishment. He had created one of the most influential styles in the history of art – impressionism, the culmination of naturalistic painting, but a dead-end as far as the vital development of painting was concerned. The seeds sown by Manet were soon to bear fruit.

Monet remained totally devoted to the recording of appearances, but as he went on grappling with it the problem only became more complex. To put down what one sees sounds easy, but a record of perceptual sensations inevitably involves the artist's own sensibility. Monet was sometimes elated, frequently depressed, in the 1880s, and he discovered that his emotional state affected what and how he saw. In the great seascapes of this period (*Ill. 20*) he seems to recognize the inherent subjectivity of impressionism, and tries to find instead a way of expressing the forces stirring behind appearances. As with Cézanne, there is an awareness of cosmic movement, embodied in the brushwork of the paintings – that calligraphic touch, which becomes the new architecture of painting.

20 CLAUDE MONET (1840–1926) *Rough Sea at Belle-Ile, 1886. Oil on canvas, 25¼" × 29½" (64 × 80). Louvre, Paris*

22 CLAUDE MONET (1840–1926) *Nymphéas, detail. Musée de l'Orangerie, Paris*

23 CLAUDE MONET (1840–1926) *Nymphéas, general view, c. 1916–23. Oil on canvas, each 6′ 6″ × 13′ 11″ (197 × 425). Musée de l'Orangerie, Paris*

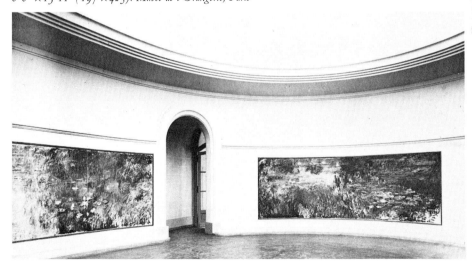

◀ 21 CLAUDE MONET (1840–1926) *Rouen Cathedral : Sunset, 1894. Oil on canvas, 39″ × 25″ (99 × 63.5). National Museum of Wales, Cardiff*

The paint itself is always real; it never disappears into the scene it represents, but forms a coloured web or tissue that hangs on the flat surface of the canvas.

Monet now began to choose intractable subjects, like a morning mist on the river, and he also painted others – a haystack, a line of poplars, the façade of Rouen Cathedral (*Ill. 21*) – over and over again in different light conditions. But people began to suspect that Monet's passion for recording light and atmosphere had led to an indifference to his actual subject. His own reactions now preoccupied him: 'I am driven more and more frantic by the need to render what I experience,' he wrote in 1890. The west front of Rouen Cathedral provided him with an unchanging objective constant: the inconstant, and the more difficult to represent, was his own perceptual experience. In the twenty pictures that resulted, we have, in George Heard Hamilton's words, 'a new kind of painting which reveals the nature of perception, rather than the nature of the thing perceived.'

The truth of this remark is nowhere more apparent than in the water-garden pictures which dominate the last thirty years of Monet's long life. Indeed, apart from the two 'architectural' series of London and Venice pictures, he painted nothing else. The subject itself was, quite literally, planted by Monet – he made the water-garden itself, just as Cézanne set up his still-life groups. The *Nymphéas* – lily pads and flowers floating on the surface of the water, the overhanging willows and their reflections, mingled with the reflections of clouds passing overhead – Monet paints these like a man who is meditating on the nature of reality, and ultimately he seems to break through to a level of reality that is beyond physical vision. Thus Monet's naturalism becomes transformed into a kind of cosmic symbolism that comes very close to abstract art. And in fact the debts owed to Monet by the two great pioneers of abstraction, Mondrian and Kandinsky, are important and quite specific ones.

In the course of his meditation on the *Nymphéas* Monet was led to other pictorial innovations. There exists an equivalence between the surface of the water and the surface of Monet's canvases. Because the subject demands it, the paint texture itself becomes much less tangible and opaque than it had been in the wall-like surfaces of the Cathedral pictures. The space both behind and in front of the picture-surface is increasingly apparent, just

as the depths of the water and the vault of the sky are drawn together on the surface of the pond itself.

All earlier paintings had been like windows through which the spectator looked: the space lies behind the picture-surface, and the frame is a device necessary to isolate the painting from the real world. Monet dispensed with the frame altogether. He extended the dimensions of his canvases laterally until they completely filled the field of vision, curving the pictures round, and finally, in the two rooms at the Orangerie in Paris (*Ills. 22, 23*) entirely surrounding the spectator, who finds himself immersed in Monet's world. Forms seem to float forward and to recede from the picture-surface, and the barrier between the world of the picture and our own disappears.

It is perhaps not just a coincidence that something of the same sort happens in the last pictures of Cézanne and in the cubist paintings of Picasso and Braque, all executed in the first two decades of this century. The dimension of painting itself seems to change. Monet's particular contribution lay in the new scale of his paintings, for many of the *Nymphéas* panels were more than twenty feet wide and sometimes ten feet high. Paintings this size were not emulated until the middle of the 20th century, when the New York painters began to use canvases of these dimensions with startling results.

Monet's career is paralleled, more closely than was at first realized, by that of Paul Cézanne (1839–1906). They were almost exact contemporaries, though Monet outlived Cézanne by twenty years. They knew each other, but not well. Each seems to have recognized the other as his only rival. They shared certain basic preoccupations – a concern with perception, for instance – but their solutions, like their temperaments, were very different.

For Cézanne, Monet was only 'an eye'. He neglected the problem of picture construction that worried Cézanne, the essential problem of reinterpreting the three-dimensional world in terms of a flat, rectangular picture. Cézanne shared Manet's interest in the art of the past: to the end of his life he always found something to learn from a visit to the Louvre. Monet was almost totally uninterested in other painters' work. In 1869, when Monet was exploring effects of sunlight on water,

24 PAUL CÉZANNE (1839–1906)
*The Blue Vase, c. 1888–89. Oil on
canvas, 24″ × 19½″ (61″ × 50).
Louvre, Paris*

25 PAUL CÉZANNE (1839–1906)
*Mont Sainte Victoire, c. 1904–06.
Oil on canvas, 22″ × 36″ (53 ×
91.5). Philadelphia Museum of Art
(G. W. Elkins Collection)*

Cézanne, following Manet's lead, was trying to invent a new kind of pictorial composition.

Everyone, without exception, dismissed Cézanne's early attempts as childish: he seemed such a hopelessly untalented artist that even a close and sympathetic friend like Émile Zola (1840–1902) never had any real faith in him. Yet an early picture like *Pastorale* (*Ill. 26*) embodies a Baudelairean naïvety, the prerequisite attitude to any radical reshaping of an art. *Pastorale* seems to be an erotic fantasy, centred both psychologically and formally upon the reclining figure of the artist himself. Here are the same disproportionate figures and unexplained space that occur in Manet's *On the Beach at Boulogne* (*Ill. 12*); Cézanne appears even more wilful until we begin to appreciate the logic behind the pictorial argument.

Cézanne wanted to start with the experience of visual perception itself, which he knew was a much more confused and complex matter than painters had hitherto been prepared to admit. We have two eyes that are always on the move, exploring proximity and depth, darting here and there. Our vision has a central focus, with a vague periphery; things seen out of the corner of our eyes seem blurred.

This was the sort of information that Cézanne applied to such paintings as *Pastorale*. The corners are empty; we focus on the artist on the river bank; the other figures fit into the broad curves around him. Indeed, for Cézanne, space was curved. There are no straight lines in nature. Straight lines are imposed by the artist – they are composition lines which relate to the picture plane and the picture rectangle. They keep the composition in balance, on the surface. Cézanne's head is where the lines of bank and horizon meet, fixed in a locking pose.

Cézanne also attempts in *Pastorale* something that is to become his common practice – the utilization of discontinuities and alignments. The rules are simple: if a straight line appears to exist in nature (for example, the edge of a table), it must be made discontinuous in the picture. Conversely, objects that have no relationship outside the picture must be brought into alignment, especially if they are in different spatial planes. Thus in *Pastorale* the line of the bottle in the foreground leads directly into the dead tree on the island in the background, establishing a visual link that unifies the picture. Such examples can be multiplied endlessly in Cézanne's work.

It was hardly surprising that Cézanne disliked the Florentine system of linear perspective, which related all receding lines to a vanishing point and treated the picture space as a sort of funnel. To Cézanne this made a hole in the picture; he much preferred the alternative Venetian tonal system, which treated the picture as a shallow box, with layers of space behind the surface. Cézanne's first great landscape painting, *The Railway Cutting* (*Ill. 27*), is a perfect example of this approach. There is no vanish-ing point, only a succession of parallel layers of stratified space, differentiated by tone and colour. The shapes do not diminish in size, but are repeated throughout the picture. There is not even any aerial perspective; the mountain does not fade into the distance, its outline is sharp and clear and contrasts with the ambiguities of the abstracted foreground. It is never certain which plane is receding grass, or rising wall, or receding top of wall.

The Railway Cutting certainly contains space, but as a painting its colours are dull, and it lacks a feeling for light. We may presume this to be Cézanne's own judgment, for in 1872 he asked Pissarro to show him how the impressionists used colour to bring a new sensation of light and space into painting. Camille Pissarro (1830–1903) was a great and good man, but, by comparison with his contemporaries, he was not a very original painter. His ability to recognize their nascent greatness – and he gave decisive early encourage-ment to Gauguin, Seurat and van Gogh, as well as to

Cézanne – was perhaps a measure of his own lack of certainty. For one short period in the late 1860s, with such pictures as *La Côte du Jallais, Pontoise* (Ill. 28), Pissarro combined elements of Corot and of Courbet into a monumental landscape style, but a year or two later he was so impressed by Monet's more forceful talent that he changed his palette and his compositional methods to follow the younger man's example. Because Pissarro so passionately believed in the village existence that he painted as an exemplar for the ideal life, his work has a generosity and a conviction that are wholly admirable, but he was no visual innovator, and played no part in the reshaping of visual language that his friends were engaged upon. Alfred Sisley (1839–99), was another delightful painter who added nothing to Monet's impressionism except an almost Constable-like sensitivity to cloud effects.

Cézanne certainly learnt from Pissarro during the two years he spent at Pontoise, though it might be argued that he taught Pissarro more. A comparison of the work each painter was doing at this time reveals the obvious contrast in artistic character. Pissarro's *Entry to the Village* (Ill. 29) shows him still reluctant to abandon earth colours or break away from conventional compositional formulae. Cézanne's *House of the Hanged Man* (Ill. 30), on the other hand, though a clumsy, overworked picture, is an attempt to move forward and has a toughness the Pissarro altogether lacks. Look, for example, at each artist's treatment of the foreground. Pissarro draws the road as he does because that was where he happened to be sitting, and because the scheme could be fitted into a linear perspective construction. Cézanne rejects this sort of casualness, and turns the foreground zone into an abstract shape that provides the foundation on which the picture rests.

Eventually Cézanne decided that he was not an impressionist. He was too slow a worker to be able to catch fleeting effects, as Monet did, and the importance given to light now seemed to him exaggerated. Though still obsessed with his 'little sensations before nature', Cézanne wanted to penetrate appearances to a more fundamental reality. His paintings of the 1880s and 1890s are ordered reconstructions in pictorial terms of confused sensations received over a period of time, laboriously made images of temporal as well as spatial experience.

28 CAMILLE PISSARRO (1830–1903) *La Côte du Jallais, Pontoise,* 1867. *Oil on canvas,* 34¼" × 45¼" (87 × 120). *The Metropolitan Museum of Art, New York (Bequest of William Church Osborn, 1951)*

29 CAMILLE PISSARRO (1830–1903) *Entry to the Village of Voisins,* 1872. *Oil on canvas,* 18¾" × 22" (45 × 55). *Louvre, Paris*

30 PAUL CÉZANNE (1839–1906) *House of the Hanged Man,* 1873. *Oil on canvas,* 22¼" × 26¾" (56.5 × 68). *Louvre, Paris*

35

The process is most plain in the still-lifes. Here Cézanne was able to dominate his subject-matter in a manner impossible with landscape or portraiture. Objects could be placed where he wanted them. Shapes could be introduced or dismissed in accordance with formal necessity only. Analysis of a painting like *The Blue Vase* (*Il. 24*) demonstrates the complexity of the situation in which Cézanne found himself by 1890. Ambiguities and uncertainties are everywhere: how can we explain the background of the picture? Cézanne's practice of combining several viewpoints is very evident here: the two parts of the plate on each side of the blue vase, for instance, are treated quite separately. They do not fit together: and this is intended to remind us that the plate cannot be seen as a whole – only part by part, at different moments in time and from different angles.

The Blue Vase also shows us how Cézanne divorced line from colour. Contours – outlines – gave him a feeling of imprisonment, of restriction. Moreover, they did not exist in nature – there is no line around an apple, and only a pictorial convention dictates the drawing of an outline and colouring it in afterwards. Cézanne wanted to abandon this method, and, using thin bluish-violet paint, for reasons shortly to be explained, gave his lines a tentative, indefinite quality. They help to place things, but do not constrict them.

Cézanne also disliked the practice of modelling – the way in which Courbet had painted apples, working from dark to light, and even moulding the form in a very low relief of paint. Instead, Cézanne used what he called colour modulation – touches of thin liquid paint, placed directly on the canvas side by side, which, because of their differences of colour and tone, give the sensation of three-dimensionality. His practice was affected by his interest in the watercolour medium in which transparent washes of colour all relate to the white background of the paper. Cézanne used his white canvas in a similar way, leaving bare patches that a painter of an earlier generation would have found quite unacceptable.

We can also see from *The Blue Vase* how Cézanne was using colour. He had noticed the verifiable optical phenomenon of colour induction – the attraction of the complementary colour. A red apple seen against a neutral grey wall will seem to have a green halo; a yellow

apple has an apparent bluish-violet contour around it. Cézanne frequently uses these bluish-violet haloes for objects seen in bright light, because that colour is the complementary of yellow sunlight. His procedure is always empirical, not dogmatic – Cézanne is not following a set of rules, but trying, with every new picture, to record his sensations before nature.

At the same time he is so constructing his pictures that they assume a magisterial, monumental quality. Consider *The Woman with the Coffee Pot* (*Ill. 31*): the subject-matter is utterly simple, with no psychological overtones, yet it provides Cézanne with the materials for a pictorial composition of the utmost subtlety. The woman's head, body and skirt provide a succession of harmonious geometrical forms, arranged on the central axis of the picture, which is, characteristically, tipped a little to avoid over-rigidity and to set in play compensating balances which run right through the picture. One can observe Cézanne's use of alignments and discontinuities, his echoing forms and colours. Recession into space is so strictly controlled that extremes of distortion occur – as in the coffee cup on the table top – and yet these are acceptable within the overall concept of the picture itself. The artist is imposing himself on the natural world in a heroic struggle to create the picture.

As Cézanne grew older, he achieved an increasing integration of the means of picture-making. In a late landscape of *Mont Sainte Victoire* (*Ill. 25*) it is impossible to separate modelling, drawing, colour, tone and composition. Painting has been reduced to the coloured brushmark: this is the all-important common denominator of everything that happens on the canvas. Colour dominates, destroying the more solid forms and linear constructions of Cézanne's earlier work, alone giving spatial definition to the picture. As Cézanne told a visitor at the end of his life, 'The main thing in a picture is to achieve distance: I try to render perspective solely by means of colour.'

In the last years before his death in 1906 Cézanne returned to his obsession of a great composition of nude figures in a landscape. The subject itself recurs constantly throughout the history of art – the vision of an ideal world where man exists in complete harmony with nature. The idea may derive from folk-memory – the Garden of Eden story has its parallel in every culture –

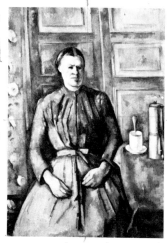

31 PAUL CÉZANNE (1839–1906) *The Woman with the Coffee Pot, c. 1890–92. Oil on canvas, 4′3″ × 3′2″ (130.5 × 96.5). Louvre, Paris*

or it may be a personal nostalgia for a lost world of childhood which mature experience has never quite matched. Cézanne indeed seems to have looked back to days spent as a boy with his friends in the woods around Mont Sainte Victoire as the summit of his experience of life.

The memories were overlaid with erotic fantasies and an obscure sense of guilt. In the long series of *Bathers* compositions Cézanne had first to give the erotic a monumental quality. This was partly achieved by incorporating poses derived from other works of art, and especially from the statuary that he had copied in the Louvre: in such a way he achieved the more objective approach demanded by Manet.

The *Bathers* idea culminated in three large paintings – much the largest Cézanne ever did – of which the version in the National Gallery in London (*Ill. 32*) is perhaps the most resolved. In all of them there is a colossal struggle between the artist's vision and the result; Cézanne's ever-present sense of failure was never more acute than with the *Bathers*. 'Shall I be like Moses and die before reaching the promised land?' he asked shortly before his death. As with Monet it was this constant pursuit of the unrealizable that sustained his career at an intense pitch from beginning to end.

The comparison with Monet is apt, because the late *Bathers* compositions, like the late *Nymphéas*, were first widely regarded as failures. Only now do we begin to understand Cézanne's striving after a representation of some kind of symbolic union between desire and reality, between actual and ideal life. Like some ancient seer, the old Cézanne seems to be on the edge of an understanding of mysteries normally veiled. And he has achieved this state through his chosen medium as a painter – colour. Cézanne wanted to penetrate beneath appearances, and his colour somehow comes to express the depths of nature, the roots of the world. The entire picture is alive and caught up in some universal rhythm: it seems to be aglow with an inner illumination.

Cézanne is quoted as saying, shortly before his death: 'I sometimes imagine colours as great noumenal entities, living ideas, beings of pure reason.' The philosophical terminology is strangely out of character, and perhaps, like many of Cézanne's quoted remarks, reflects the questioner rather than the artist himself. But one can

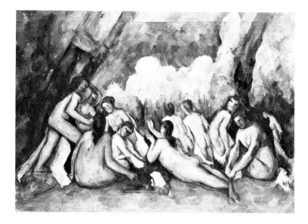

use it to say that Cézanne, like Monet, proceeds from the
phenomenon to the noumenon: after years of recording
the appearance of things, these artists grow close to the
thing itself, which is essentially unknown and unknow-
able. In the course of this development their attitude to
space changes. Cézanne and Monet both realized that,
as Bergson claimed, we can only know space in and
through time, and that the changing consciousness of
the observer would have to be taken into account. There
is a close parallel here between the painters and such
prominent literary figures as Mallarmé and Proust.
Whether one can also relate pictorial innovations to the
scientific discoveries of Einstein and Freud is more
disputable.

About the other two great impressionists, Renoir and
Degas, less need be said, not because their painting is
inferior, but because the implications of their work have
had so much less impact on others. Auguste Renoir
(1841–1919) was a natural painter. More than any of
the other impressionists, he could have had the easy
success of a Salon portrait painter; he must have often
felt tempted to abandon the intransigent position adopted
by his friends. He was never as deeply committed to
landscape painting in natural light as his friend Monet
was, and landscape is an important but subsidiary part
of his *œuvre*.

Renoir was essentially a painter of people, and more
specifically of attractive young women. The frank
sensuality of his art is evident in his colour, his touch,

his preferred forms, as in the subjects themselves. He was the heir to Watteau, to Boucher and to Fragonard, whose works he greatly admired, and the existence of this bond with the French 18th century is a reminder that at heart Renoir was a traditionalist, not a revolutionary. His tastes were conservative – learnt from other painters, not from nature – and while his friends talked of innovation Renoir quietly continued what others had done before him. Thus his painting relates directly to all his immediate predecessors – Ingres, Delacroix, Corot, Courbet, Manet – in a natural, unforced way.

Renoir had no private means, and had to earn a living from painting. After Salon refusals, he was one of the most active organizers of the first group-exhibition in 1874: it was very important for him that he should get a following of patrons and collectors. Yet the paintings that he showed in 1874 hardly merit the label impressionist: *La Loge* (*Ill. 33*), for example, is a highly sophisticated picture, appropriately for the subject. It shows what Renoir has learnt from the Old Masters, from Titian and Velasquez in particular, and from his older contemporaries, Manet and Degas. The palette is not the rainbow palette of the impressionists, but, as with early Manet, one dominated by black and white. In fact Renoir uses black as a definite colour, at the same time that Monet was urging its abolition.

Perhaps Renoir felt the force of this argument, because after *La Loge* he adopted a different palette, and began to use cool, chalky colours. In the *Moulin de la Galette* (*Ill. 34*) a flickering light falls over the young people as they sit round the table on the café terrace. The modern life subject-matter derives from Baudelaire, and has its immediate precedents in Manet's café conversation-pieces. But whereas Manet, like Degas, remains emotionally removed from the subject, Renoir is a participant. The *Moulin de la Galette* is a painting of Renoir's friends, and it is this peculiar intimacy that gives the picture and others like it a human warmth and radiance that is Renoir's most striking quality.

To a certain extent Renoir was putting impressionist principles into practice in the late 1870s. He was painting out of doors, observing the colours of shadows and reflections, and had a particular predilection for dappled, broken-light effects. His rapid, deft technique allowed him to break up colours, juxtaposing complementaries,

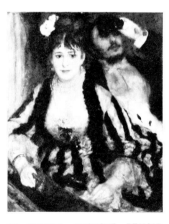

33 PIERRE AUGUSTE RENOIR (1841–1919) *La Loge, 1874. Oil on canvas, 31½" × 23½" (80 × 64). The Courtauld Institute Galleries, London*

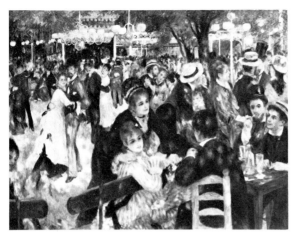

34 PIERRE AUGUSTE RENOIR
(1841–1919) *Moulin de la Galette,
1876*. Oil on canvas, 4′4″×5′9″
(131 ×175). Louvre, Paris

and concentrating sometimes on the hot end, sometimes
on the cool end, of the spectrum. But his progress was
never consistent; he admitted to Monet late in life that
he never quite knew what he was going to do next.

Renoir's uncertainties over his own painting reached
a high pitch in 1881. Dissatisfied with the lack of public
response to the early impressionist exhibitions, he had
started showing at the Salon again. As he told the dealer
Durand-Ruel who did what he could to help him,
'There are hardly fifteen art lovers in Paris capable of
liking a picture without Salon approval.' And Renoir's
paintings in the 1878 and 1879 Salons won him
immediate public support and some wealthy and power-
ful patrons whose personal friendship at once changed
his way of life.

Trying to find a way out of his personal dilemmas,
Renoir began to travel, visiting North Africa and Italy.
The latent traditionalism in his temperament now came
out, and he turned to Raphael, to Pompeian painting,
to Ingres as exemplars. Feeling increasingly out of
sympathy with the younger generation of artists in Paris,
and perhaps with Seurat and his followers in particular,
Renoir turned away from contemporary subject-matter.
The climactic work of this period is a large *Bathers*
composition (*Ill. 35*) – a deliberate rejection of the art
of his time in favour of a hard, dry technique and a
carefully composed articulation of near-sculptural forms.
And the whole idea of painting nymphs bathing around
a pool seemed a provocative reversion to a timeless,

41

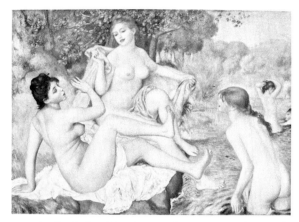

35 PIERRE AUGUSTE RENOIR (1841–1919) *Bathers, 1885–87. Oil on canvas, 3'10" × 5'7" (116 × 170). Philadelphia Museum of Art (Mr and Mrs Carroll S. Tyson Collection)*

unreal, classical subject just at the moment when such painting seemed to be finally dead.

It was scarcely surprising that, when *The Bathers* was publicly exhibited in 1887. Renoir's friends found it disconcerting. 'I do not understand what he is trying to do,' Camille Pissarro wrote to his son. Even Renoir admitted that 'everybody agreed that I was really sunk, and some said I was irresponsible.' One imagines that only Cézanne, who remained close to Renoir at this time, would have had some sympathy for Renoir's ambitions, even if the means used would certainly not have appealed to him.

Renoir rode out the storms of the 1880s, withdrew to Cagnes in the South of France among his growing family, and settled down to paint whatever he enjoyed painting. He softened the harsh forms in his compositions, and allowed his naturally delicate brushwork to dominate his canvases. For a time his preferred palette was of cool greens and blues, often with a pearly, iridescent quality, but as he grew older so the colours became warm and richer, until finally hot reds and a golden-orange predominated.

Most of the late paintings are of women, and many are of Gabrielle, the nursemaid of the Renoir children who became the painter's favourite model (*Ill. 36*). She served as nymph and goddess just as readily as she posed as herself. Renoir saw in her the epitome of woman. His art is a homage to feminine qualities – gentleness, sensitivity, protectiveness – and a testimony to love and affection, both maternal and sensual.

This is at once obvious if one compares Renoir with Degas, the fourth great impressionist and the one who shared with Renoir a preference for figure subjects. Edgar Degas (1834–1917) was also obsessed with women, but his treatment altogether lacks the warmth and humanity of Renoir's. Nor is the detachment with which he paints and draws his models the same as the more objective attitude demanded by Manet: it seems something extremely personal, the consequence of Degas' psychological make-up rather than of any considered artistic position.

The association of Degas with the term impressionism presents some difficulty of definition. He was an impressionist in so far as he belonged to the group of young men who stopped showing at the Salon and arranged their own group exhibitions between 1874 and 1886. He also, if a little belatedly, adopted subject-matter drawn from everyday existence, but he was not a painter of nature. Degas also lacked Monet's interest in light, and never developed the kind of broken brushwork and divided colour seen in the work of Monet, Renoir, Cézanne and for a time even Manet. If one has to justify using the term impressionist for Degas' paintings it must be on other grounds, and in particular because of his interest in movement, or, more explicitly, in seizing that phase of a movement which somehow reveals both what has passed and what is to come.

This was to become Degas' obsession, but it had already begun to appear in much earlier works. Consider the *Misfortunes of the City of Orléans* (Ill. 37), a curious bid for Salon success in 1865, which demonstrates very clearly how this kind of picture lost its *raison d'être* as its

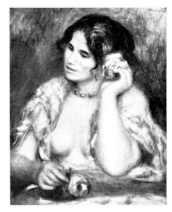

36 PIERRE AUGUSTE RENOIR (1841–1919) *Gabrielle à la rose, 1911. Oil on canvas, 22″ × 18½″ (55.5 × 47). Louvre, Paris*

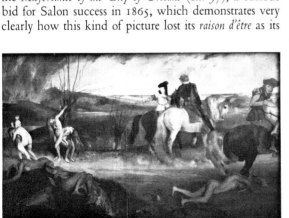

37 EDGAR DEGAS (1834–1917) *Misfortunes of the City of Orléans, 1865. Paper on canvas, 2′10″ × 4′10″ (85 × 147). Louvre, Paris*

conventions and assumptions were questioned by younger artists of Degas' intelligence and sensitivity. Degas certainly wanted to paint large figure compositions with classical or historical subjects: he wanted his work to have the harmonious composition and clarity of line of the Old Master paintings that he had studied in Italy. And yet somehow everything falls apart and is unconvincing; we may admire the *Misfortunes of Orléans* for its parts and forget what the whole is intended to represent. It is the details of the horsemen and especially of the fleeing girls with long flowing hair that prefigure exactly the Degas of the future.

Degas was painting these historical Salon pieces at a time when Manet, the disciple of Baudelaire, derided such subject-matter. But once Degas had accepted their obsolescence, he moved quickly into the painting of modern life. He made a special study of horse-racing scenes, the depiction of moving animals offering him the sort of challenge that he best responded to. Again and again he would draw a subject, trying to achieve a satisfactory pictorial representation. His own observations were supported by the evidence of photography, now for the first time available to the artist.

It is natural that Degas should have been interested in the camera, because his own early portraits represent that phase of naturalistic painting which comes closest to the photograph. In the portrait of the *Belleli Family* of 1859–62 (*Ill. 38*) every detail is set forth with precision, and the composition is constructed with extreme care. Degas' aim seems to be a sort of stasis, an immobility that represents a moment fixed in time. Only a painter later to be so concerned with movement could paint its absence with such fidelity. Degas went on to exploit the snapshot effects made possible by the camera, even before it was technically possible to use a short exposure. Figures hurrying across a square, dancers rehearsing, the hubbub in an office – such movements caught his eye and tempted his brush.

Degas' portraiture shows an interesting change of emphasis. He was a man of private means, and did not need to seek commissions as Renoir did: he could please himself about his subjects. Most of the portraits are in fact of his family and friends; they start as studies of physiognomy, in the manner of Ingres, but the sitter's environment becomes increasingly important for Degas,

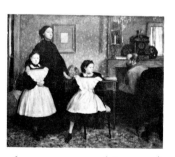

38 EDGAR DEGAS (1834–1917) *The Belleli Family*, 1859–62. Oil on canvas, 6'7" × 8'4" (200 × 253). Louvre, Paris

and he devotes more and more time to the setting for the figures. In a sense, both the *Belleli Family* and the *Cotton Market in New Orleans* (*Ill.* 39) are the same sort of picture – family conversation pieces; but in the later one we are made aware of the kind of life the young business-men lead – how they spend their time, what their working environment is like, who their acquaintances are. More than any other painter, Degas comes close to the naturalist novels of Zola and the Goncourts. *L'Absinthe* (*Ill.* 40) is like an illustration to a novel: we find ourselves asking questions about the personal histories of the man and woman involved, as though their existence was some-thing that extended beyond this scene in the café.

Degas' interest in the anecdotal, story-telling role of painting was comparatively shortlived, though it was shared by contemporaries like James Tissot and followers like the English painter W. R. Sickert. It was of course opposed to the general tendency in advanced painting in the 1870s, which, as we have seen, was towards the progressive elimination of anything non-pictorial. In itself this helps to explain Degas' isolated, even anoma-lous, position in the later 19th century: though indis-putably a very great painter, he played little part in the movements of his time.

Confirmation can be found in Degas' interest in perspective construction. Manet, Monet and Cézanne were all anxious to flatten their pictures, avoiding spatial recession: they considered a picture essentially a flat surface, covered with colours arranged in a certain order, to paraphrase a later definition. This approach un-questionably became a fundamental of modern art. Degas, however, was slow in accepting it. In the 1870s. as we see from the *Cotton Market* and *L'Absinthe*, he rejects any generally flattening device, and instead exploits the contrasts between shallow and receding space. In his pictures the eye is led back to land upon key features that are pushed to one side or into corners. We get used to jumpy compositions, with figures and vistas cut by the frame, and areas of empty space as formally telling as the figures or objects that inhabit them. The voids between the legs of the dancers may make more interesting shapes than the legs themselves. Degas often shows remarkable originality and audacity in his compositional procedures – as in the way the newspaper bridges the café tables in *L'Absinthe*, holding together a composition

39 EDGAR DEGAS (1834–1917) *Cotton Market in New Orleans,* *1873. Oil on canvas, 29″ × 36″ (71 × 92). Musée des Beaux Arts, Pau*

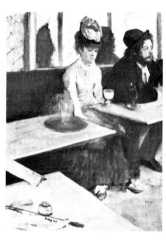

40 EDGAR DEGAS (1834–1917) *L'Absinthe, 1876. Oil on canvas, 36¼″ × 26¾″ (92 × 68). Louvre, Paris*

45

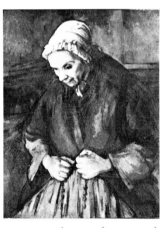

41 PAUL CÉZANNE (1839–1906) *Old Woman with the Rosary, c. 1898. Oil on canvas, 31¾″ × 25½″ (81 × 65.5). By courtesy of the Trustees of the National Gallery, London*

that otherwise would certainly collapse. Yet this is not the sort of thing that Degas' contemporaries were much concerned with.

Nevertheless, Degas' late work shows that same simplification and concentration that we find in Monet and Cézanne. After the 1870s he progressively limits his subject-matter until finally his exclusive concern is with his female model, whom he paints performing certain basic actions – washing and drying herself, stepping in and out of a tub (*Ill. 83*). Even the actual movement matters less and less, and though the presence of the figure is essential, Degas is now so emotionally detached that the woman's only function is to make the creation of a picture possible.

Figures tend to fill the paintings, excluding all other elements. One gets closer and closer to them, and this is perhaps a consequence of Degas' failing eyesight, as if he needed to reassure himself of their physical existence. Difficulties of vision also encouraged Degas' interest in sculpture; he had for long been in the habit of making three-dimensional studies to help in the preparation of pictures. But it would be a mistake with Degas, as with Monet, to attribute too many facets of his late work to a visual defect.

Degas was always interested in the craft of painting, and his ability as a draughtsman was outstanding. Increasing dissatisfaction with oil paint led him to constant experiment, and he diluted the paint until it flowed across the canvas as easily as watercolour. He revived the use of pastel, sometimes in conjunction with thin oil washes, and the light and bright colour range of pastel dominates his later work. His final preference was for charcoal, often supported by pastel, and the lines are repeated and the emphasis on the form shifts within the painting much as it does in late portraits of Cézanne – the *Old Woman with the Rosary (Ill. 41)* for example.

Degas' best work, like Cézanne's and Monet's, was done at the end of a long career, at a time when younger generations had already surpassed it in invention and daring. Yet all three men approached the ultimate mysteries of painting, leaving behind pictures that silence us by their depth and profundity. On the threshold of the 20th century, it is the old men of the 19th who provide us with the touchstone to which we must constantly revert.

Post-Impressionism

Inevitably the dissatisfaction with their own work that all the impressionist painters felt in the 1880s was reflected in the next generation. For Seurat, Van Gogh and Gauguin, the painting of Monet and his friends represented a final phase of naturalism which was inadequate to the demands of the time. They all became critical of a certain triviality in the matter and manner of the new painting of the 1870s, and were convinced that something more fundamental, more profound, should take its place.

It was not clear, however, what the alternative should be, and in the later 1880s the avant-garde divided into two sometimes very hostile factions. Seurat and Gauguin were the respective leaders: neo-impressionist (or division-ist, or pointillist) and synthetist (or symbolist, or cloisson-ist) were the labels attached to them and to their followers and associates. But the antagonism was essentially one of personal antipathy and rivalry, and in some respects the two men had common ground. The greatest artist of this generation, Vincent van Gogh, refused to commit him-self entirely to the practices or beliefs of either.

The short career of Georges Seurat (1859–91) has the same kind of logic and precision that his own painting possesses. In place of the disorder and untidiness of the art of his time, whether academic or avant-garde, Seurat offered a carefully worked out alternative. At first he shared the confidence in scientific method of many of his late 19th century contemporaries, and seems to have believed it possible to put the art of painting on a quasi-scientific footing. He, like Courbet, was convinced that the final solution to all pictorial problems was near at hand. His preparation for implementing his ambition, on both theoretical and practical levels, was thorough, comprehensive and rapidly achieved. Born in Paris, he began with a conventional academic training at the

Ecole des Beaux-Arts, where Ingres, though he had been dead for a decade, was still the dominant influence. Here Seurat drew male nudes and casts of Praxitelean and Hellenistic sculpture in an unmodelled, highly linear style: he copied paintings and drawings by Ingres, and by the Old Masters – Raphael, Poussin, Holbein – whom Ingres had so greatly admired. His own first paintings were unoriginal exercises in the tradition of Ingres and the then half-neglected, half-revered mural painter, Puvis de Chavannes (1824–98).

Once out of art school, and after a year's military service, Seurat very quickly extended his range of interest. He was undoubtedly deeply influenced by the great French peasant painter, Jean François Millet (1814–75), and adopted both his subjects and his manner of drawing. Seurat also learnt from Millet's contemporaries – Daumier, Courbet, Corot, Delacroix. By the time of the seventh impressionist exhibition in March 1882, Seurat was ready for impressionism, and the landscapes by Monet and Renoir and especially Pissarro encouraged him to paint a series of small oil studies of men at work, which are perhaps his first mature works (*Ill. 42*).

At the same time, Seurat had not been neglecting his theoretical training, for which, unlike most artists, he had developed a taste. As a student he had read Charles Blanc's *Grammaire des Arts du Dessin*, which had become a standard text since its first publication in 1867. In Blanc's book he found a discussion of Delacroix's views on colour, and a summary of an earlier treatise, Eugène Chevreul's *De la loi du contraste simultané des couleurs* (On the law of simultaneous contrast in colours), originally published in 1827. This was just a beginning: in 1880, many young artists felt that it was essential to bring the new scientific knowledge about colour and optics to the art of painting, and Seurat read everything he could find. Of particular importance to him were the articles by David Sutter on the phenomena of vision in the magazine *L'Art* of 1880, and the French translation in 1881 of an American book, Rood's *Modern Chromatics*.

Seurat organized his own artistic development like a military campaign, setting himself a succession of objectives to be achieved. At first he concentrated on drawing, experimenting with different methods of recording tonal values – long, diagonal, pencil hatching, with lines of varying densities; then the broader forms of

42 GEORGES SEURAT (1859–91) *Man with a Hoe, 1884. Oil on canvas, 18″×22″ (47 ×56). The Solomon R. Guggenheim Museum, New York*

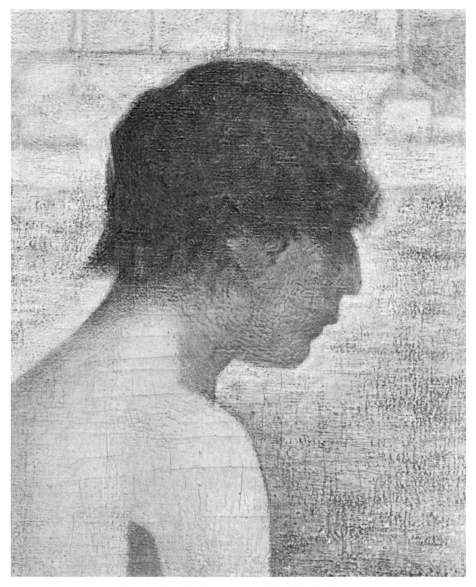

43 GEORGES SEURAT (1859–91) *Head of a Young Man (detail of Ill. 46)*

44 GEORGES SEURAT (1859–91) *The Artist's Mother, 1882–83. Conté crayon on paper, 13″ × 9½″ (32.5 × 24). The Metropolitan Museum of Art, New York (Joseph Pulitzer Bequest)*

45 PUVIS DE CHAVANNES (1824–98) *Le Doux Pays (The Happy Land), 1882 (small version). Oil on canvas, 10″ × 19″ (25.5 × 48). Yale University Art Gallery (Abbey Fund)*

chiaroscuro shading, obtained by the use of the soft conté crayon. In his early drawings Seurat displays subtle gradations of tone, and a mastery over the balance of dark and light masses, observing dark haloes around light areas, and the reverse phenomenon (*Ill. 44*).

Once he had achieved control of tone, Seurat was ready to examine, systematically and exhaustively, the role of colour in painting. The approach of Monet or Renoir was an empirical one: they added touches of colour until the desired effect was realized. Such a procedure was too imprecise for Seurat. He gradually eliminated earth colours from his palette, believing that any colour could be achieved by a combination, or better still, by a juxtaposition of primaries and their complementaries. Colours were divided and kept separate so far as possible – hence the term divisionism – and in certain cases Seurat seems to have expected them to merge optically and give the impression of another colour. He experimented with his brushstrokes, at first adopting the kind of handling found in impressionist paintings of the early 1880s, but later systematizing it. He first adopted a lightly brushed-in, criss-cross stroke, for which the French term 'balayé' has been adopted, and then, around 1883 he began to use tiny dabs of colour – the dots of the final 'pointillist' technique.

Seurat's first great masterpiece was *Une Baignade* (*Ill. 46*), which he began in the spring of 1883 and completed early in 1884. It is a much larger work than any impressionist picture, and he painted it to show at the official Salon; Seurat's model was *Le Doux Pays* (The Happy Land)

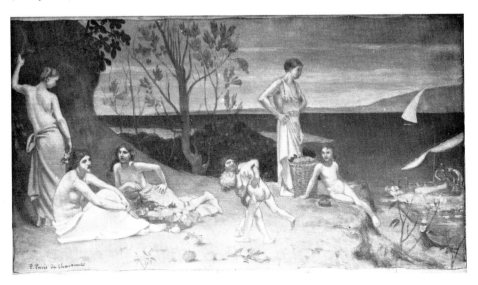

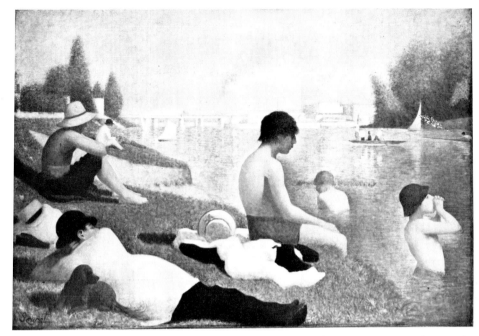

(*Ill. 45*) by Puvis de Chavannes, which he had seen there in 1882. Only when the Salon jury refused to show Seurat's enormous picture did he turn to the rival exhibiting societies, and characteristically became a most active organizer of one of them, the *Société des Artistes Indépendants*.

Une Baignade was most carefully planned. Seurat first decided on the landscape setting of his composition, then made a dozen or more small oil sketches on the spot, and a similar number of figure drawings in the studio. He was then ready for work on the big canvas. From the start of his career Seurat had adopted certain ancient compositional devices to give him general guidelines. The most notable of these is the golden section – said to be the most harmonious and aesthetically satisfying way of dividing a line (and by extension an area) into two parts; expressed in terms of proportion, the shorter section is related to the longer section as the longer section is to the whole. Reference to the golden section helps explain why the most prominent young man on the grass is sitting in precisely that spot in the picture, and why he seems to epitomize the air of calm and balanced monumentality that characterizes the whole picture. We feel at once the stillness of a hot summer day.

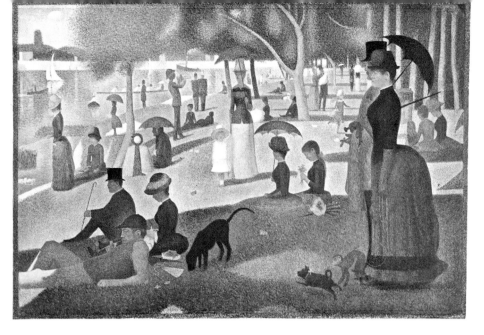

47 GEORGES SEURAT (1859–91)
Un Dimanche à la Grande Jatte,
1884–85. Oil on canvas, 6′11″×10′
(205.5×305). Courtesy the Art
Institute of Chicago (Helen Birch
Bartlett Memorial Collection)

In other respects, too, *Une Baignade* is the sum of this remarkable young artist's pictorial knowledge. We can easily observe the light tonal haloes around dark forms. Because Seurat retouched the picture in 1887 the development of his painting technique is observable – the grass is painted, appropriately enough, in the early criss-cross, 'balayé' manner, but other areas – around the head of the young man, for example (*Ill. 43*) – show the tiny dots of Seurat's mature style. The colour of the sunlit grass is a demonstration of Seurat's artistic principles. Green – the local colour of grass – is mixed with yellow and orange (sunlight); then blue, reflected from shady areas, is added; finally touches of complementaries heighten the effect. Seurat used the colour wheels he found in such books as Rood's *Modern Chromatics* as guides to the proper hues.

Seurat's seascapes are of exceptional serenity and beauty, but the development of his pictorial thinking can best be followed in the succession of half a dozen major figure compositions. After *Une Baignade* came the even larger, grander, *Un Dimanche à la Grande Jatte* (*Ill. 47*). The relaxed working-class boys of *Une Baignade* have here found a pendant in this picture of the Parisian

bourgeoisie dressed up in their Sunday best: Seurat intends, perhaps, a deliberate social comment on modern urban life, though we cannot be sure about this.

Because of the greater complexity of *La Grand Jatte*, Seurat made even more small oil sketches and detailed drawings, though he was probably at work on the big canvas from the very beginning. The earth colours that may still be seen in places in *Une Baignade* have now disappeared, and the basic colour contrasts of red‑green, yellow‑purple and blue‑orange are now dominant. Though the picture was essentially painted in the winter of 1884–85, Seurat reworked it in the following winter in a more strictly pointillist style, and this gave him the opportunity of emphasizing the colour programme.

The numerous figures of *La Grande Jatte* lack the solidity of the boys in *Une Baignade* – they are flatter, and exist in a more puzzling, irrational, spatial relationship to one another. Most of them do not overlap, or even touch, but instead of diminishing in size only as they recede into the distance, they also appear to diminish from right to left. There now clearly appears for the first time Seurat's wilful, perhaps comic, rather disconcerting touch – consider the use he makes of umbrellas, hats and animals' tails to set up a pattern of straight and curved lines, or the way he will shift his viewpoint in different parts of the picture – high in the foreground, at eye‑level in the back. It is the same kind of device that occurs in Manet or in Cézanne, but Seurat's use of it excites a suspicion that this clever young man is clowning about and teasing the viewer.

This may partly explain the extreme annoyance of Monet and of Renoir in particular, when *La Grande Jatte* dominated the eighth (and last) impressionist exhibition in May 1886. A young critic, Félix Fénéon, made matters worse by coining the term 'neo‑impressionist' in his review of the exhibition, with its obvious implica‑ tion that this new approach had eclipsed the old impres‑ sionist manner. Seurat, it must be said, preferred the epithet 'chromo‑luminarist' for his kind of painting, but for obvious reasons this term never caught on. Fénéon also argued that Seurat was simply providing a scientific systematization of impressionist technique: this was convincing enough to bring Seurat the converts he seems never to have wanted, like old Pissarro, or young Signac. Paul Signac (1863–1935) had been working in a Monet‑

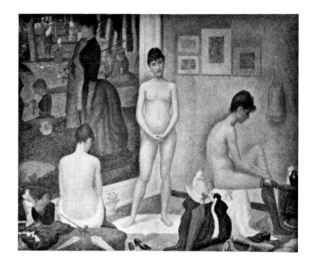

48 GEORGES SEURAT (1859–91)
*Les Poseuses, 1888. Oil on canvas,
6'6" × 8'3" (188 × 251). Copy-
right 1972, The Barnes Foundation,
Merion, Pa.*

49 JEAN-AUGUSTE-DOMINIQUE
INGRES (1780–1867) *La Source,
1856. Oil on canvas, 5'4" × 2'8"
(163 × 80). Louvre, Paris*

derived manner and went on, after Seurat's premature
death, to become the great champion and leader of the
neo-impressionist school.

As for Seurat himself, he was immediately off in
another direction. For *La Grande Jatte* also has a private,
obscure, dream-like quality; it captures a moment of
absolute stillness, and there was something about
Seurat's disengagement from the subject that appealed
to the symbolists. The discovery beneath the surface of
the bourgeois Sunday afternoon outing of some more
profound and mysterious significance was precisely in
tune with the ideas of the new young generation of poets
and critics who assumed prominence on the Parisian
literary scene after the appearance of Moréas's symbolist
manifesto in 1886.

Seurat in fact became in November 1886 the close
associate of one of the most remarkable figures of this
generation, the mathematician Charles Henry. In 1884
Henry had begun to give lectures at the Sorbonne to a
fascinated audience: he had already written a thesis
demonstrating biological function by the use of mathe-
matical curves, and in 1885 published *Une aesthétique
scientifique*. In his lectures, concerned with the emotional
values of colours and lines, Henry claimed that every
direction had symbolic significance – that lines rising to
the right, for example, suggest pleasure – and he associated
colours with each linear direction. Henry attempted to

reduce everything to mathematical formulae – not only physical movement, which he related to the magnetism of the earth, but also metaphysical propositions, like the existence of God.

Henry did not presume to tell painters what to do, but that his ideas are reflected in Seurat's work is evident in the next two major paintings, *Les Poseuses* (*Ill. 48*) and *La Parade*, both painted for exhibition in March 1888. The umbrellas of *Les Poseuses*, for example, point precisely in the direction that Henry associated with their colours; and the many horizontal and vertical divisions of *La Parade* probably conform to the kind of mathematical progression in which both Henry and Seurat were interested.

The subject of *Les Poseuses* – front, back and side views of the same nude model – pays an indirect homage to such Ingres paintings as *La Source* (*Ill. 49*); it seems to have been chosen by Seurat primarily to demonstrate that his new style was as appropriate to an interior as to an outdoor setting. But with *La Parade* Seurat also confesses his passion for popular entertainments, especially fairs, cabarets and circuses, and this was to inspire the last two great pictures, *Le Chahut* and *Le Cirque*. In them the flatness of *La Parade* becomes extreme: the design of *Le Cirque* (*Ill. 50*) is kept entirely on the surface, as in the posters of Chéret and Lautrec which Seurat admired. The eye-level moves up and down the picture, giving a curious multi-perspectival effect. The figures are cartoon-like grotesques, the colours strident and artificial, the complex composition overlaid with linear patterning.

Le Cirque was exhibited in March 1891, though it was not quite finished. Later that month, very suddenly, Seurat caught pneumonia and died. He was only 31. In August 1890 he had explained in a letter his system of painting: art is a harmony of contrasts, he declared, and to the contrasts of tone and colour that he had early established, he now added contrasts of line. Within each formal division, a distinct mood could be expressed – dark tones, cool colours, descending lines suggesting sadness and despair; light tones, warm colours, ascending lines suggesting gaiety and excitement. Seurat was aware of the naïvety of this conclusion, but he remained convinced that somehow a more expressive language of painting might be developed if only the abstract qualities of art were recognized as the most meaningful ones.

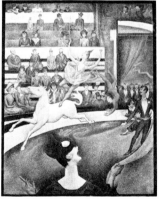

50 GEORGES SEURAT (1859–91) *Le Cirque*, 1890–91. Oil on canvas, 6′ 1″ × 4′ 11″ (185.5 × 150.5). *Louvre, Paris*

This was a conviction which Seurat shared with his erstwhile rival, Paul Gauguin (1848–1903). Long before he was able to make any practical use of his ideas, Gauguin too was thinking about the abstract significance of lines, numbers, colours and shapes. He wrote to his friend Émile Schuffenecker on 14 January 1885: 'All five senses, on which a multiplicity of things have impressed themselves in such a way as to be indelible, communicate directly with the brain. From this fact I conclude that there are lines which are noble, others which are misleading, etc., a straight line creates infinity, a curve limits creation, not to speak of the fatality of numbers. Have we talked enough about the numbers 3 and 7? Colours, though less diverse than lines, are nevertheless more explanatory by virtue of their power over the eye. There are tonalities which are noble and others which are vulgar, harmonies which are calm or consoling, and others which are exciting because of their boldness.'

As everybody knows, Gauguin was in his middle thirties when he became a full-time painter, having been both sailor and businessman in the early part of his career. But although his lack of formal training remained a considerable disadvantage to him, his preparation was in its way as thorough as Seurat's. He was a dedicated and accomplished Sunday painter, and as early as 1876 had had a landscape accepted at the Salon. He was also wealthy enough to pursue his studies of modern art by buying the paintings he wanted to study.

Gauguin was much more thoroughly immersed in impressionism than Seurat ever was, contributing to the exhibitions of 1880–82 landscapes that were not unjustly called a 'dilution of Pissarro'. Pissarro was a tremendous help and support to Gauguin, as to so many others, although Gauguin realized very quickly that Pissarro's friend Cézanne was the more original and important painter. When they met in 1881 Gauguin was fascinated; later in the year we find him writing to Pissarro: 'Has M. Cézanne found the exact formula for a work acceptable to everyone? If he discoveres the prescription for compressing the intense expression of all his sensations into a single and unique procedure, try to make him talk in his sleep by giving him one of those mysterious homeopathic drugs, and come immediately to Paris to share it with us'. It is perhaps hardly surprising that Cézanne remained mistrustful of Gauguin, whom he

suspected of wanting to steal his ideas. Gauguin's landscapes of 1884 (*Ill. 51*) unquestionably pay explicit homage to Cézanne.

This same accusation of stealing his ideas was brought against Gauguin a few years later by Emile Bernard (1868–1941). There is no doubt whatever that in the summer of 1888 this young painter had shown Gauguin certain pictures that had a revolutionary impact on the older artist's style. But the important point about any artistic controversy of this sort is not who had the ideas first, but who painted the best pictures. Here the answer is not in doubt, for compared with Gauguin, Bernard is a very minor artist indeed.

His place in the history of art is assured only by the picture, *Breton Women in a Meadow* (*Ill. 52*), which he painted in August 1888, and at once showed to Gauguin. Its unmodelled, heavily outlined, simplified figures, placed irregularly on a flat, abstract ground were exactly what Gauguin had been looking for. He acquired Bernard's picture by exchange of one of his own, and then, using a similar palette, immediately painted his own version of it – *The Vision after the Sermon* (*Ill. 56*), which is possibly the most important picture in his entire œuvre.

Gauguin's problem in the months immediately preceding August 1888 had been to find a manner of painting that would accord with his conception of art. This is a by no means uncommon situation, especially among painters of the more reflective, intellectual cast of mind; Mondrian and Kandinsky were to find themselves in a similar position some twenty years later. Gauguin knew that art must move away from the 'error of naturalism', and become more abstract. 'A word of advice,' he told his confidant Schuffenecker on 14 August 1888. 'Don't paint too much from nature. Art is an abstraction. Extract it from nature by meditating in front of it, and think more of the creation which will result.'

In *The Vision after the Sermon*, Gauguin tries to put these principles into practice. The subject is antinaturalistic, and Gauguin brings back into modern art the angels which had been firmly banished by Courbet, on the grounds that, although he had never seen an angel either, the intensity of a simple religious faith impressed him (even if, unlike Bernard, he did not share it). Accordingly he felt justified in painting the vision seen

51 PAUL GAUGUIN (1848–1903) *Blue Roofs, Rouen, 1884.* Oil on canvas, 29″ × 23½″ (74 × 60). Collection Oskar Reinhart am Römerholz, Wintherthur

52 ÉMILE BERNARD (1868–1941) *Breton Women in a Meadow, 1888.* Oil on canvas, 29″ × 36¼″ (74 × 92). Collection Denis, St Germain en Laye

57

53 PAUL GAUGUIN (1848–1903)
*Christ in Gethsemane, 1889. Oil on
canvas, 28½″ × 36″ (72.5 × 91.5).
Norton Gallery and School of Art,
West Palm Beach, Florida*

by the credulous Breton women, so moved by the story of Jacob and the Angel that on coming out of church they seemed to see the struggle taking place before their very eyes. In order to remove the wrestling figures from the everyday world, Gauguin copied them from a Japanese colour-print that he owned; and he painted the meadow red instead of green, to emphasize that the landscape, as he told Van Gogh, 'is not real and is out of proportion'.

Colour was in fact the first element in painting that could be treated abstractly. Gauguin was quite confident about this. When a few weeks later a young art student from Paris, Paul Sérusier (1864–1927), came to see him, Gauguin gave him a painting lesson: 'How do you see these trees? They are yellow. Well then, put down yellow. And that shadow is rather blue. So render it with pure ultramarine. Those red leaves? Use vermilion.' From such an arbitrary procedure, it is only a small step to the use of colour for its emotional connotations, rather than for any descriptive reason, and this was the path that both Gauguin and his friend Vincent van Gogh were taking.

The two men spent an uneasy two months together in Arles at the end of 1888, with consequences that are well known. Gauguin arrived on 20 October, bringing with him Bernard's painting as well as his own recent work, and feeling certain that he was now on the right track. Though his influence over Vincent was considerable, the visit was of little benefit to Gauguin himself. He didn't like Arles and, after spending the cold winter months in Paris, was glad to get back to Brittany.

Gauguin felt at home in Brittany, because of its wildness and primitiveness. 'When my wooden shoes ring on the granite, I hear the muffled, dull and powerful tone that I try to achieve in painting,' he told Schuffenecker early in 1888. He was sure that to break with naturalism and find a more abstract art, a primitive environment was necessary. It was this conviction that made him want to leave Europe, and drove him to Martinique for several months in 1887, and finally to Tahiti in 1891.

For the moment, however, Brittany provided what his art needed. He began to tire of painting mainly landscapes, as he had on earlier visits, and chose instead religious subjects. Gauguin's two *Crucifixions* and his *Christ in*

Gethsemane (Ill. 53), however, are religious paintings with a difference: the blasphemous identification of the artist with Christ. This can be partly explained by Gauguin's conviction that the artist was the sole creator of a meaningful universe, an idea that derives from Manet and Mallarmé, both of whom he particularly admired. But Gauguin also came to regard himself as a Messiah figure, the prophet of a new morality as well as of a new art. In this way the post-impressionist generation differed sharply from their impressionist elders: they regarded art and life as inseparable, so that artistic research was pursued not for its own sake alone, but as a means to universal ends. Gauguin took to making wood carvings

54 PAUL GAUGUIN (1848–1903) *The Loss of Virginity, 1891. Oil on canvas,* 2′11″ × 4′3″ (90 × 130). *Chrysler Museum at Norfolk, Virginia*

55 PAUL GAUGUIN (1848–1903) *Manao Tupapau, 1892. Oil on canvas,* 28¾″ × 36¼″ (73 × 92). *Albright-Knox Art Gallery, Buffalo*

express clearly his conviction that the message of his
pictures could be conveyed as much through line and
colour as through a more literary symbolism. The
musical analogy is a particularly important one, because
music provides the example of an art which, though

60

abstract, cannot be called meaningless. Profound human emotions can be expressed in music without recourse to any descriptive functions: why should this not be possible in painting? The question was to exercise many of Gauguin's contemporaries and successors, to whom it seemed that the answer must lie in the imaginative use of colour. In 1899 Gauguin wrote to a friend: 'Think of the musical role which colour will henceforth play in modern painting. Colour, which vibrates just like music, is able to attain what is most general and yet most elusive in nature – namely its inner force.'

And it was the search for the essence, the inner force, that sustained Gauguin. He had rejected the painting of the impressionists because 'they seek around the eye, and not at the mysterious centre of thought.' So he was driven back upon himself, and in a quite explicit sense, because there is little doubt that his flight to the South Seas was an attempt to recapture certain infantile experiences of his fatherless babyhood in Peru. For Gauguin regression became both a personal and an

56 PAUL GAUGUIN (1848–1903) *The Vision after the Sermon, 1888. Oil on canvas, 28¾″ × 36¼″ (73 × 92). The National Gallery of Scotland, Edinburgh*

61

57 PAUL GAUGUIN (1848–1903)
The Call, 1902. *Oil on canvas,*
4'3" × 3' (130 × 90.5). The Cleve-
land Museum of Art (Gift of Hanna
Fund and Leonard G. Hanna Jnr.,
1943)

artistic necessity. He turned to the primitive and the exotic as the only way of liberating art from the great classical-Renaissance-naturalist tradition which he thought had come to an end. And he accepted the privations and disappointments of life in Tahiti and the Marquesas Islands where he lived, apart from an unproductive short spell in France, from 1891 until his death in 1903.

Unfortunately, the South Seas did not provide him with the primitive environment he sought. Gauguin was a century too late: civilization had got there before him. The ancient myths and gods had all been forgotten; they had disappeared, as had the naked bodies beneath the missionaries' shifts. Gauguin's Tahiti is a dream world, an imaginative reconstruction of something that did not exist. In the last pictures he painted, *Contes Barbares* and *The Call (Ill. 57),* for instance, the pretence is abandoned: what we see is Gauguin's version of the Golden Age. This, one of the great myths of art, obsessed him, just as it did Ingres, or old Cézanne, or the young Matisse.

In Tahiti, sick with syphilis and often hungry, Gauguin attempted suicide. His survival (because he vomited the poison) must have seemed to him an ironic joke. But in 1898 he wrote: 'The martyr is often necessary for a revolution. My work has little importance com-pared to its consequences: the freeing of painting from all restrictions.'

The third member of this extraordinary post-impressionist triumvirate was the Dutchman, Vincent van Gogh (1853–90). The eldest son of a Protestant pastor, he always remained a preacher at heart, a man with a message of Christian love and charity eternally frustrated by an inability to communicate with others. In early manhood Vincent faced a succession of humiliating failures – as art dealer, as ordinand, as evangelist. At the age of 26 he was reduced to a state of misery and total helplessness, familiar enough among the depressed mining families of the Borinage to whom Vincent had unsuccessfully tried to preach. And in this moment of darkness he realized that his personal salvation lay through painting.

Vincent's career as a painter lasted eleven years, six and a half of which were spent in Holland. In the Dutch period, Vincent taught himself to draw and to paint,

learning as much from copying and instruction manuals as he did from any teacher. His early progress – in fact his whole life – is documented in a way unparalleled among great artists. Thanks largely to the devotion of his art-dealer brother, Theo (and to the total indifference of the general public in his lifetime), almost every work he executed survives, even the earliest drawings. And there are extant almost a thousand letters, the most moving and revealing ever written by an artist; these give us a detailed knowledge of Vincent's day-to-day existence, and a remarkable insight into the way he felt about his own work.

At first he was not even sure that he wanted to be a painter. He had been tremendously impressed by the English illustrators of *The Graphic* magazine, who had used their art to draw attention to the plight of the urban proletariat in mid-Victorian London. This seemed to Vincent a noble ambition for an artist. He gave his lithograph *Sorrow* (*Ill. 58*) an English title, and added a quotation in French which asks, 'How can it be that there is a lonely, desperate woman upon earth?' Vincent's model was a prostitute from the Hague whom he was trying to reform: unfortunately, like every other personal relationship, even the one with his saintly brother, Theo, this ended sadly. The tragedy was that life was impossible for Vincent; everything had to go into the paintings.

Vincent did a drawing of tree roots in dry ground to make a pair with *Sorrow*. 'I tried to put the same sentiment into the landscape as I put into the figure', he told his brother, 'the same passionate clinging to the earth, and yet being half torn up by the storm.' Such a comment helps to explain why Vincent proclaimed that 'all reality is at the same time symbolic', and why he so admired Millet, 'who painted Christ's teaching.' The symbolism of the *Sower* (*Ill. 59*) had haunted Van Gogh's imagination from the moment he began to draw and paint.

Jean François Millet (1814–75) was a very great artist who has yet to regain the esteem in which he was once held. His paintings are dull in colour in comparison with those of the impressionists, and some have in fact deteriorated considerably. He suffers too, from his historical position as a pre-modern artist, yet his powers as a visual image maker were remarkable. Abandoning Paris in 1848 at a moment when the rise of capitalism

58 VINCENT VAN GOGH (1853–90) *Sorrow, 1882. Lithograph, 15¼″ × 11½″ (38.5 × 29). Gemeentemuseum, The Hague*

59 JEAN-FRANÇOIS MILLET (1814–75) *Sower, 1850. Oil on canvas, 39¾″ × 32½″ (101 × 87.5). Courtesy, Museum of Fine Arts, Boston (Quincy Adams Shaw Collection)*

60 VINCENT VAN GOGH (1853–90)
*Portrait of an Artist Friend (Eugene Boch),
1888. Oil on canvas, 23¼″ × 17¾″
(60 × 45). Louvre, Paris*

61 VINCENT VAN GOGH (1853–90)
*Boats on the Beach, 1888. Oil on canvas,
25½″ × 32″ (64 × 81). Van Gogh Founda-
tion, Amsterdam*

and the industrial revolution were beginning to affect people's lives, Millet chose instead to paint a rural existence in which human values were paramount, and commercial ones non-existent. Millet's realities were birth, marriage, procreation and death: he was not a Christian, as is often believed, and he tempered his humanism not with optimism but with stoic resignation.

The relevance of Millet's art in the mid-19th century was obvious. Not only did he gather around him in the village of Barbizon a circle of devoted friends and followers, but his ideas were carried beyond France to every country in Europe. The argument that such pictorial innovations as those proposed by Manet and the impressionists are trivial in comparison with the issues raised by Millet is one that has continued to recur, *mutatis mutandis*, up to the present day. But without formal re-newal, new ideas cannot be expressed, and Millet's true followers were men like Pissarro and Seurat and Van Gogh and the young Picasso, rather than his more un-imaginative imitators.

Vincent's masterpiece of the years in Holland, *The Potato Eaters* (*Ill. 62*) is a picture entirely in the Millet tradition: he seems almost completely ignorant of the whole development of modern art up to that date. The idea for the picture may have come from a very similar subject, *The Frugal Meal*, painted in 1883 by Josef Israels (1824–1911), the founder and leader of the Hague School, the Dutch counterpart of Millet's Barbizon. But the hushed, sacramental atmosphere of *The Potato Eaters*, the clumsy strength of the figures, and the sure suggestion that we are not looking merely at a repre-sentation of Dutch peasants – these are qualities that only Vincent (and Millet) could have given such a picture.

In certain respects Vincent was none too happy about *The Potato Eaters*. He was over-sensitive to a friend's criticism that concentration on the heads and hands had led him to neglect the bodies of the peasants. And he was aware that the colour – that 'of a very dirty potato', as he said – was unadventurous: he was still working within the tradition of tonal painting, where subtle gradation of tone is all-important, and colour tends to be monochromatic. We know from the letters that Vincent wrote to his brother Theo in the summer and autumn of 1885 how keenly he was feeling the need to leave this Dutch backwater and see some modern painting.

62 VINCENT VAN GOGH (1853–
90) *The Potato Eaters, 1885. Oil on
canvas, 32¼″ × 45″ (82 × 114). Van
Gogh Foundation, Amsterdam*

Vincent arrived in Paris on 27 February 1886, and for almost exactly two years lived there with his brother. Vincent could have had no more perceptive guide than Theo to the complexities of modern painting. Theo also helped with introductions, and the gauche, intense and humourless Dutchman found himself in the company of such artists as Pissarro, Gauguin, Lautrec, Bernard and Signac, none of whom could have had much sympathy, let alone admiration, for his still somewhat immature painting. But these contacts taught Vincent a great deal, because, like many painters, he was often more impressed by the work of an artist he knew personally than by someone he had never met. He greedily absorbed all there was to see in Paris, taking what he could from one painter after another, working his way through the development of modern art. First, it was Delacroix and Monticelli; then the impressionism proper of Degas and particularly of Monet; finally the alternative avantgardes of neoimpressionism and synthetism, represented respectively by his friends Signac and Bernard.

By the time he painted the *Wheatfield with a Lark* (*Ill. 63*) in June or July of 1887, Van Gogh had arrived at that personal interpretation of impressionism which marks his mature style. His composition was simplicity itself, with a tendency towards symmetry. Light fills the picture; the colours are high in key and blend together, showing that Vincent has observed local colours and their complementaries, and has painted sunlight and shadow. The brushwork has an immediately evident

nervous intensity. And although Vincent has painted directly from nature, putting down exactly what he saw, he cannot avoid the symbolic associations evoked by such an image.

Vincent left Paris for Arles in February 1888, and in the Provençal sunshine his art blossomed with a new richness. No painter had yet used colour so uninhibitedly; no painter had ever left his brushmarks so plainly visible on the surface of his canvas. In rapid succession one memorable picture follows another – the orchards, the drawbridge, the harvest, the haystacks, the boats on the beach (*Ill. 61*); the portraits of the postman, the poet and the *mousmé*; the sunflowers, the yellow house, the café interior, the bedroom, and many more. In Paris, Vincent had stopped painting peasants and workers, humble objects and familiar landscapes, and had turned instead to the more impersonal and anonymous subject-matter of impressionism. Alone in the South, he was himself again, and cast his spell over the Arles landscape and the people who inhabited it.

He felt confident and free to improvise, so that the boats he saw on the beach at Saintes-Maries have the bold design and bright colours of the Japanese wood-block prints that he admired so much. He wrote to Émile Bernard: 'On the beach, quite flat and sandy, were a number of smallish green, red, and blue boats, so delightful both in shape and colour that they made me think of flowers.' In the summer of 1888 a single colour tends to dominate the individual paintings: blue in the seascapes and the nightpieces, yellow in the harvests and the sunflowers. Vincent associated particular emotions with each colour. 'I have become an arbitrary colourist', he tells his brother, explaining that in the *Portrait of an Artist Friend (Ill. 60)*, 'instead of painting the matter-of-fact wall in a trite room behind the head, I paint infinity, a simple background of the richest most intense blue that I can contrive'.

The blue background was intended to set off the orange-yellow colour of the poet's fair hair, exaggerated by Vincent because 'I want to paint men and women with that eternal something about them which the halo used to symbolize of old, and which we now try to express by the actual radiance, the vibrations of colour.' He was fascinated by the emotional impact created by the juxtaposition of complementary colours. He wrote

63 VINCENT VAN GOGH (1853–90) *Wheatfield with a Lark, 1887. Oil on canvas, 21¼″ × 25½″ (54 × 64). Van Gogh Foundation, Amsterdam*

64 VINCENT VAN GOGH (1853–
90) *The Night Café, 1888. Oil on
canvas, 27½″ × 35″ (69.5 × 89).
Yale University Art Gallery (Be-
quest of Stephen Carlton Clark)*

to Theo: 'I am always in the hope of making a discovery –
to express the love of two lovers by a marriage of two
complementaries, their mingling and their opposition,
the mysterious vibrations of kindred loves.'

But the opposition of complementaries could also be
exploited to give the opposite effect, as Vincent tried to
demonstrate when he painted *The Night Café* (Ill. 64),
'I have tried to express the terrible passions of mankind . . .
the idea that the café is a place where one can ruin oneself,
go mad, commit crimes.' The café becomes a place
where the powers of darkness are at work, an ante-room
of Hell, filled with sulphurous vapours. We may go
further and suspect that for Vincent it was an arena of
human struggle, a picture of what life was really like
for someone with an increasingly tenuous grip on reality.
One wonders, however, whether *The Night Café* can in
fact bear such an interpretation? That it is a more ugly,
agitated and disturbed picture than, for example, the
Boats on the Beach is apparent, but is not this because
Vincent, who was awaiting Gauguin's arrival with
excitement and apprehension, was in an agitated and
disturbed state of mind? The dilemma that faces the
painter who wants his work to transmit such emotions as
'the terrible passions of mankind' is that a picture can
only convey the emotions the artist himself feels. How-
ever hard Vincent tried to make the paintings of his
bedroom in the Yellow House 'suggestive of rest and of
sleep in general', they convey only the same tension and
unease (formally expressed by the perspective of the
floor and the enclosing function of the walls) that we
find in *The Night Café*.

Perhaps Vincent appreciated the difficulties of making
painting more expressive, and looked to Gauguin for
help and advice. Artistically it was a master-pupil
relationship. Psychologically too, Vincent was depen-
dent on the older man, who already had a reputation as a
painter and had only come to Arles to please Theo and
escape penury in Paris or Brittany.

Gauguin brought with him, not *The Vision after the
Sermon* (Ill. 56) which had been sent to Theo Van Gogh
in Paris, but Bernard's *Breton Women in a Meadow* (Ill. 52).
Vincent was most impressed. He took up his favourite
subject of the sower once more, but Gauguin made him
adopt a close-up view which cut the figure at the waist,
and introduced a strong diagonal across the picture

surface, exactly as in *The Vision after the Sermon*. The two men painted the same subjects, but neither seemed at ease. Vincent couldn't understand why Gauguin should have introduced Breton women into a painting of a vineyard at Arles. Gauguin found himself increasingly irritated by Van Gogh: he wrote to their mutual friend Bernard: 'He likes my paintings very much, but when I do them he always finds faults. He is a romantic and I am rather drawn towards the primitive. In regard to colour, he likes the accidental quality of impasto . . . and I detest messiness of execution.'

In a number of paintings Vincent tried very hard to adapt himself to the new style. Perhaps the most successful was the *Promenade at Arles: Souvenir of the Garden at Etten (Ill. 65)*. The setting is the public garden at Arles, opposite the Yellow House, but the women promenading remind Vincent of his mother and sisters walking in the garden at Etten where he had grown up. He wrote about this work to Theo: 'Gauguin gives me courage to work from the imagination, and certainly things imagined take on a more mysterious appearance.'

Unfortunately, Vincent was trying to paint in a manner alien to his personality. Gauguin's insistence that he should work from memory and not from nature was making the very act of painting impossible, and his constant emphasis on the bold cutting of forms in a picture upset Vincent's natural desire for a central, near-symmetrical placing of any figure or object. Even worse perhaps, Vincent was being urged to abandon that characteristic expressive brush stroke and adopt instead heavy contour lines around flat areas of colour. This was altogether too artificial a way of painting for Van Gogh. As he later wrote to Bernard: 'When Gauguin was in Arles, as you know I once or twice allowed myself to be led to abstractions. At the time this road to the abstract seemed to me a charming track. But it's an enchanted land, my dear friend, and soon one finds oneself up against an insurmountable wall.'

Vincent's 'insurmountable wall' was of course a mental breakdown, and from Christmas Eve 1888 until his suicide on 29 July 1890 his life was darkened by a long succession of collapses, some of them much more severe than others. The cause seems to have been an inherited epileptic condition, aggravated by Vincent's self-neglect and the events of his life, but breakdown was

65 VINCENT VAN GOGH (1853–90) *Promenade at Arles: Souvenir of the Garden at Etten, 1888. Oil on canvas, 28¾" × 36¼" (73 × 92). The Hermitage, Leningrad*

probably his inevitable fate, whatever he might have chosen to do. It would be as wrong to pretend that Vincent's illness did not affect his painting as to dismiss all his work as that of a madman. At times painting became a kind of therapy for him, occupying his hands and thoughts and staving off the next crisis. As soon as he was well enough to work again he began to make copies of the picture he had been painting at the time of the first breakdown – La Berceuse (Ill. 66) – the portrait of the postman's wife, Madame Roulin, rocking a cradle. She had become for Vincent an archetypal mother figure, a consolation for those isolated and in danger, like the Icelandic fishermen in Pierre Loti's contemporary novel of that name, which both Van Gogh and Gauguin read with such enthusiasm. As Vincent said: 'the idea came to me to paint such a picture that sailors, who are at once children and martyrs, seeing it in the cabin of their boat, should feel the old sense of cradling come over them and remember their lullabies . . .' As it had been for Gauguin, regression was necessary for the regeneration of Vincent's art.

Vincent made five versions of the red and green Berceuse and still more of the yellow and blue Sunflowers. He envisaged the pictures all hanging together as a decorative whole, serving the function of stained glass windows in a church. Like Monet in the 1880s he had begun to feel a dissatisfaction with easel painting, and a longing for some more all-embracing monumental context for art, a longing that he was never to realize.

Life in Arles had become impossible for him, and on 8 May 1889 he moved twenty miles eastwards to the hospital at Saint Rémy, where he stayed for exactly a year. At first the change of landscape was a stimulus; in the new motifs that he painted Vincent found an equivalent for his turbulent emotions. The flame-like forms of the cypress trees and the undulations of the corn swept by the wind combined to make an irresistibly poignant image; no other modern art has rivalled the popular appeal of Van Gogh's.

But things were literally closing in on him, and a note of resignation creeps into his work. He no longer had faith in his artistic destiny; just to stay alive and sane was difficult enough. After another breakdown in the summer, Vincent wrote to Theo: 'I am struggling with a canvas begun some days before my indisposition, a

66 VINCENT VAN GOGH (1853–90) La Berceuse, 1889. Oil on canvas, 28¾" × 36½" (72 × 93). Rijksmuseum Kröller Müller, Otterlo

Reaper (*Ill. 67*); the study is all yellow, terribly thickly painted, but the subject was fine and simple. For I see in this Reaper – a vague figure fighting like a devil in the midst of the heat to get to the end of his task – I see in him the image of death, in the sense that humanity might be the wheat he is reaping. So it is, if you like, the opposite of that sower I tried to do before. But there's nothing sad in this image of death, it goes its way in broad daylight with a sun flooding everything with a light of pure gold.'

Often Vincent did not feel well enough to go out of the hospital in search of subjects to paint. It was difficult and depressing to find models among his fellow patients. He took instead black and white reproductions of prints by artists he admired, Millet and Delacroix in particular, and copied them, using the colours that he thought best suited the subject. He justified this practice in a letter: 'We painters are always asked to *compose* ourselves, and be *nothing but composers*. So be it, but it isn't like that in music. If some person or other plays Beethoven, he adds his personal interpretation. I let the black and white by Delacroix or Millet . . . pose for me as the subject. And then I improvise colour on it, not, you understand, altogether myself, but searching for reminiscences of *their* pictures. But the memory – that vague consonance of colours that are at least right in feeling – that is my own interpretation . . . I started (copying) accidentally,

and I find that it teaches me things, and above all it sometimes gives me consolation.'

Van Gogh's improvisations after Millet led him to explore strangely beautiful combinations of colours, subtler than the complementaries of the Arles paintings. The range is muted and muffled: ochres, browns, dull purples; very pale greens and pinks; lilac, saffron, turquoise. Often the colour is chalky, with a great deal of white mixed with the pigment; sometimes it becomes almost pallid and insipid. But the effect is exactly what Vincent intended: when he copies the peasant family seated by the child's bedside at evening (*Ill. 68*) he reinterprets Millet's subject for our own time. This picture too is a 'parable, as in the teaching of Christ'. Art, to Van Gogh, was a moral force for the betterment of man; he needed some such justification for having devoted his life to it.

Both his life and painting testify to the courage and endurance of a man who created something against all possible odds, in the face of every disadvantage, and with the absolute minimum of encouragement. Small wonder that Van Gogh and Gauguin should have been such an inspiration for the young painters who came after them. It took a little time to understand the significance of their art, but the impact that it ultimately made was all the greater.

68 VINCENT VAN GOGH (1853–90) *La Veillée (after Millet)*, 1889. *Oil on canvas, 28½″ × 36¼″ (72.5 × 92). Van Gogh Foundation, Amsterdam*

Up to this point the story of modern painting has been largely told in terms of the activities of a dozen men whose art, like their lives, interlocks. Each extended the body of art as he found it in some new direction, and each extension changed that art irrevocably, so that young painters in 1900 confronted a very different situation from that which faced those in the 1860s.

There can be no doubt that the line already described from Courbet, Manet and the impressionists to Gauguin, Seurat and Van Gogh is the central stream of modern artistic development and that nothing can challenge its overriding importance. Yet a great deal of interesting painting was being done in the later 19th century, and not only in France. The wide influence of Millet's peasant painting has already been mentioned, but other realist and naturalist and early impressionist manners attracted adherents in every European country. By a kind of dialectical necessity, the realists always seem to be accompanied by idealist (or symbolist) painters, as if every Holman Hunt needed a Leighton, and every Menzel a Feuerbach. The manifold complexities of this general tendency for art to divide may depend on certain basic temperamental differences among artists – on, for example, the degree to which the painter or sculptor can envisage the finished work of art before he starts to make it. Does creation reside in the idea or in the action?

This chapter is devoted to artists of many nationalities working in several different countries; the evident common ground cannot, however, be explained by any such idea as the *Zeitgeist*, or the spirit of the age. The art of the immediate past will look much the same to artists wherever they may be, allowing, of course, for the local bias. The possible paths open to artists at any one point in time are limited, and it is no surprise to find painters in widely separated places producing similar work. But

69 JAMES ABBOT MCNEILL WHISTLER (1834–1903) *The White Girl*, 1862. Oil on canvas, 7′ × 3′6″ (214.5 × 108). The National Gallery of Art, Washington D.C. (Harrie Whittemore Collection)

70 SIR JOHN EVERETT MILLAIS, BT. (1829–96) *Autumn Leaves*, 1856. Oil on canvas, 41″ × 29″ (104 × 74). Manchester City Art Galleries

very often what seem to be coincidences can be traced to the network of personal and artistic contacts surrounding any creative person, for however lonely and private creative activity may be, no artist works in isolation.

A good example of this cultural phenomenon is the picture that, after Manet's *Déjeuner sur l'herbe* (*Ill. 1*) made the greatest impact at the 1863 *Salon des Refusés*. This was Whistler's *White Girl* (*Ill. 69*). James Abbott McNeill Whistler (1834–1903) was American-born, but his painting career was entirely spent in Europe, and to English eyes he is as British a painter as is the half-German Sickert. Admittedly he began as an art student in Paris, but many of his friends there were English, and he kept close contact with London, where part of his family were living.

The *White Girl* herself is a perfect example of the Anglo-French basis of Whistler's art. A portrait of his red-haired Irish mistress, Joanna Heffernan, the composition and handling are not far removed from the work of Whistler's French contemporaries – Manet, Degas, and his particular friend, Henri Fantin-Latour (1836–1904). All these painters, like their British contemporaries, had a special enthusiasm for Velasquez, whom, together with Rembrandt, they regarded as the greatest of all painters. We have already noticed Velasquez' influence on Courbet and Manet; it is equally clear in early Degas portraiture, for example, the *Belleli Family* (*Ill. 38*).

But the *White Girl* has other qualities which cannot be attributed to the Velasquez-derived naturalism prevalent in Paris in the early 1860s. Before being refused by the Paris Salon, the picture had been turned down by London's Royal Academy – otherwise more generally receptive to Whistler's work than its companion body across the Channel. And the *White Girl* would in no way have looked out of place in England, because it is, up to a point, also a Pre-Raphaelite picture, as shown by reference to two characteristic Pre-Raphaelite works, Millais' *Autumn Leaves* of 1856 (*Ill. 70*) and Rossetti's *Annunciation* of 1850 (*Ill. 71*).

That mysterious, poetic, withdrawn expression of Whistler's *White Girl* certainly owes a great deal to John Everett Millais (1829–96) – and there are illustrations made by the two men in the early 1860s which are difficult to distinguish. Even the light touch of Whistler's

picture resembles Millais' handling, for the Englishman remained a sensitive artist even though his ideas were so quickly cheapened by popular success. And it is hard not to believe that the strange whiteness of the *White Girl* – later to be retitled *Symphony in White* – does not in part derive from Rossetti's *Annunciation*, the 'blessed white eyesore' as it was irreverently called in Pre-Raphaelite circles. Although it was in an Irish private collection where Whistler could not have seen it, its reputation as Rossetti's last exhibited picture was such that he would almost certainly have known about its appearance.

Whistler decided to settle permanently in London, and in 1862–63 he became the intimate friend of Rossetti, who quickly saw to it that the naturalistic elements disappeared entirely from his art. For Dante Gabriel Rossetti (1828–82) thought he knew exactly what painting should be concerned with, though putting the ideas into practice proved almost impossible for him. He was against the poetic use of naturalistic detail, which had been exploited so successfully by Millais and Holman Hunt. The *Annunciation* is almost stripped of symbolic detail; instead the message of purity and innocence which the picture conveys is expressed through the abstract means of colour and form.

In the 1860s Rossetti was experimenting with colour symbolism. When he painted *Beata Beatrix* (Ill. 72) in memory of the death of his wife in 1862, it was to 'embody symbolically' the death of Dante's Beatrice, with whom he identified her. The painting shows the moment of Beatrice's ascension to heaven: she sits at a balcony overlooking the city as if in a trance. For Rossetti each colour used has an explicit meaning – red for the bird messenger of death and the figure of love, white for the poppy which brings sleep, the purple and green of Beatrice's garments a combination of suffering and hope respectively.

Other Rossetti paintings of the 1860s show him exploiting another kind of symbolic language – that of line. The sinuous curve of falling tresses of hair is echoed in the folds of a dress, creating a distinct feeling of sensuality and luxury. The chaste flame and volute forms of another painter-poet, William Blake, are utilized to express the voluptuous eroticism of half-length female enchantresses bearing the names of Venus or Lilith or Astarte.

71 DANTE GABRIEL ROSSETTI (1828–82) *The Annunciation, 1850. Canvas mounted on wood, 28½" × 16½" (72 × 42). The Tate Gallery, London*

72 DANTE GABRIEL ROSSETTI (1828–82) *Beata Beatrix, 1863–64. Oil on canvas, 34" × 26" (86 × 66). The Tate Gallery, London*

73 JAMES ABBOT MCNEILL
WHISTLER (1834–1903) *Three
Figures: Pink and Grey, 1867–68.
Oil on canvas, 4′7″ × 6′1″ (139 ×
185.5). The Tate Gallery, London*

74 SIR EDWARD COLEY BURNE-
JONES, BT. (1833–98) *The Mill,
1870. Oil on canvas, 3′ × 6′6″
(90.5 × 197.5). The Victoria and
Albert Museum, London*

Rossetti's particular kick appealed less to Whistler than it did to Swinburne and Burne-Jones, other members of his circle. But in the *Six Projects*, or in *Three Figures: Pink and Grey* (*Ill. 73*) Whistler attempted the kind of painting of which they would all approve. The *Three Figures* was to be the fourth *Symphony in White*, and as the musical title suggests, it is a mood picture; the subject-matter has virtually no importance. The girls are abstracted figures, removed from time and place into a dream world, which carries a suggestion of the Japanese, and of the decadent classicism of Tanagra figurines.

After 1870 Whistler abandoned multi-figure compositions to concentrate on landscape – and it is not easy to say whether this was a confession of defeat, or a recognition of his particular strength. He was still concerned, however, with mood and atmosphere, and not with description. With a scrupulous regard for tone, he painted the Thames by night and called the result a *Nocturne in Blue and Silver* (*Ill. 75*), borrowing his title from music. Debussy repaid the compliment a few years later when, remembering Whistler's paintings, he called an orchestral piece *Nocturne*. The 19th century was a great age for asserting the connections between the arts – for music as descriptive poetry, or poetry as visual imagery, or, as we have seen, painting as music. And one of its greatest achievements, Wagnerian music-drama, effected a combination of such imaginative splendour that few artists could escape its spell.

Whistler didn't carry forward Rossetti's introduction of an abstract symbolism into painting; after Rossetti's death, it was his close follower Edward Burne-Jones (1833–98) who pursued this line of thinking. For him, paintings were 'beautiful romantic dreams', and he

created an ideal world of legendary figures in a strange unworldly landscape. At its best, Burne-Jones's vision can be a captivating one, and a picture like *The Mill* (*Ill. 74*) is no mere literary illustration, but a work that depends as completely on its visual impact as do Gauguin's Tahitian paintings.

Burne-Jones had a considerable reputation among advanced circles on the continent for a few years after 1889, when he scored a striking success at the Paris international exhibition. Certain older French painters like Puvis de Chavannes (1824–98) and Gustave Moreau (1826–98) and Odilon Redon (1840–1916) had long felt out of tune with their times – they could not accept the dominant realist-impressionist tendency, but neither were they conservative reactionaries. By the late 1880s things were changing – and the moment for a new art seemed to have arrived.

Parallel dramatic changes were taking place in French literature, changes associated with the names of Mallarmé, Rimbaud, Huysmans, Proust, Gide, Moréas and others. The naturalism which had dominated the mid-19th century gave place to symbolism, just as in philosophy positivism and materialism began to be questioned by Bergson and others. All over Europe the new attitudes of a younger generation made themselves felt. The bases of science were questioned: no sooner had Freud begun to introduce his revolutionary new concept of the human personality than Einstein postulated new theories of the nature of the physical world. And the religious revival at the end of the 19th century was another aspect of a shift from material to spiritual values.

76 PUVIS DE CHAVANNES
(1824–98) *The Poor Fisherman*,
*1881. Oil on canvas, 5′1″ × 6′4″
(155 × 192). Louvre, Paris*

The uncertainty of values is nowhere more clearly expressed than in the fluctuating reputations of certain painters in late 19th century France. Puvis de Chavannes, for example, found his work criticized by Paul Mantz in 1863 because 'the women's bodies are pure abstractions.' But it was precisely this quality in paintings like *Le Doux Pays* (*Ill. 45*) and *The Poor Fisherman* (*Ill. 76*) that so attracted the younger artists. Puvis remained curiously unconcerned with the subjects of his pictures: 'I know nothing of philosophy, of history, or of science. I just get on with my job,' he told someone who asked what his painting meant. *The Poor Fisherman* contains no message, not even a symbolic one; it is a subjectless picture, which evokes a mood and offers the spectator the possibility of private reverie and association. Everyone could find something to admire in Puvis, and the great artistic event in Paris of the '90s was the banquet given in his honour, with Rodin presiding, and 550 painters, sculptors, poets and critics as guests.

Puvis' contemporary, Gustave Moreau, occupied a similar position. He makes franker use of symbols than Puvis does, and is not afraid to tackle the most portentous subjects. His *Young Girl carrying the head of Orpheus* of 1865 (*Ill. 79*) is a painting about the role of the artist, who, like Orpheus, continues to sing after his physical death. The conflict of the sexes, the enigma of life and death, the meaning of good and evil – these are the only subjects Moreau thought worth painting.

In the later '60s, Moreau was ridiculed by the critics, and withdrew into a private world, no longer exhibiting his work. But he won a reputation as a man of high ideals and strange learning, a visionary and a recluse. Mellowing with recognition, he became, in his last years, an inspiring teacher, whose pupils included Matisse and Georges Rouault.

Moreau's transfigured head of Orpheus caught the imagination of Odilon Redon, who used the same image in his own work. Redon, though an exact contemporary of the impressionists, could not share their attitudes. For the first part of his career he even eschewed the use of colour, as if their preoccupation with it had invalidated it for him. Restricting himself to black and white, he explored the recesses of the soul, presenting us with a lightless, timeless world – that same kingdom of the night that fascinated Arthur Rimbaud.

77 ODILON REDON (1840–1916) *The Marsh Flower, 1885. Charcoal on paper, 19¼″ × 13″ (49 × 33). Rijksmuseum Kröller Müller, Otterlo*

There is a logic about Redon's fantasies, even when they are as strange as *The Marsh Flower* (*Ill.* 77). The unfamiliar mixture of elements may disconcert, but it also carries conviction. One of Redon's early sets of lithographs was entitled *The Origins*, and a Darwinian search for the connection between animal and vegetable life fascinated him. Everything lives and suffers in Redon, even rocks and plants. Such mythical figures as centaurs, satyrs, Pegasus and Cyclops people Redon's universe: as for Man, he is the prisoner (*Ill.* 78), the one hidden behind the mask, the noble fool. Redon admired those who seek knowledge of mysteries, but he knew the risk of failure, and accepted human suffering as its price.

Redon cast Man in a subsidiary role, but the generation of painters who were born in the 1860s seem preoccupied with a consideration of Man's estate. This is the common ground that brings together such otherwise diverse talents as Munch and Bonnard; Lautrec and Vuillard. In their hands, the questioning initiated by Gauguin and Van Gogh is continued.

Edvard Munch (1863–1944) was a Norwegian who came to share Redon's concern for human suffering. He began as a naturalist, but a visit to Paris in 1889 and the impact of modern French painting, particularly the work of Gauguin, changed the direction of his art. 'No more interiors with women knitting and men reading', he declared. 'I want to show men who breathe, feel, love, suffer. I want to paint such pictures in a cycle. I want to

78 ODILON REDON (1840–1916) *The Fool (or Intuition), 1877. Charcoal on paper, 15 × 13 (39 × 33). Collection René Malamond, Zürich*

bring home to the spectator the sacred element in these things, so that he takes his hat off, just as he would in church.'

Munch never painted a picture-cycle as such, but most of his works can be loosely related to each other, and they represent a consistent and very pessimistic view of life. As with Gauguin, childhood experience was decisive. Munch's mother had died of tuberculosis when he was five, and he could never free himself from the identification of sex and love with death and disease. Relationships between man and woman were impossible, because each sought to dominate. In *The Dance of Life* of 1900 (*Ill. 80*), the female figure is shown in successive roles of the innocent – withdrawn, virginal and unattainable; the temptress – lascivious and domineering; and the experienced – ravaged and diseased and now undesirable.

In such an existential situation, Munch could only relapse into melancholy resignation. 'My path has always been along an abyss,' he said, 'my life has been an effort to stand up.' Racked by alcoholism and mental instability, he saw painting only as another illness and intoxication. It could be turned to use as a means of self-analysis, and eventually Munch did achieve a precarious balance, partly through the assuaging powers of nature.

Munch was a friend of the Swedish dramatist Strindberg, who shared his gloomy view of the sexual relationship. His connection with Søren Kierkegaard, the Danish religious philosopher, and with Dostoievsky, whose great novels transformed European sensibility at the end of the 19th century, is also apparent.

Munch's work was disseminated not so much by his oil paintings as by his graphic work. He translated his images into lithographs and into woodcuts, finding, like Gauguin, that the crudeness of the medium enhanced the message and gave it a new force. This dissatisfaction with traditional media was common to artists of the 1890s. There was a remarkable revival of interest in every kind of graphic art, which affected book illustration and poster design as well as the production of prints. Fine artists who had hitherto neglected such ancillary activities now found them almost more gratifying than painting easel pictures.

This is certainly true of Henri de Toulouse-Lautrec (1864–1901), an artist whose real character has been all

79 GUSTAVE MOREAU (1826–98) *Young Girl carrying the Head of Orpheus, 1865. Oil on canvas, 5′ × 3′ (154 × 99.5). Louvre, Paris*

but submerged by his popular image. Admittedly Lautrec had his naturalist beginnings, and his connec⁄tions with impressionist painting – with Degas in particular – are fundamental. Yet the philosophy behind his art, and the way he lived, brought him closer to Munch. He too was fascinated by life – as an outsider, an observer, not a participant. His work expresses no moral judgment, only a search for moments of intense physical and psychical experience before the inevitable annihilation. Lautrec was a great Anglophile, and the aestheticism of Walter Pater had clearly impressed him, chiefly through the influence of their mutual friend, Oscar Wilde. He could almost envisage himself as the hero of Wilde's *Dorian Gray*, which was published in 1891. Wilde's prefatory aphorisms provide a perceptive commentary on the nature of Lautrec's art: 'An artist can express everything . . . vice and virtue are to the artist materials for an art. . . . It is the spectator, and not life, that art really mirrors.'

Thus when Lautrec paints the lesbians embracing in *Le Lit* (*Ill. 82*), we are concerned with morality or immorality only to the extent that we introduce the issue. The picture has neither the self⁄conscious bravado of Courbet's splendid painting of the same subject, nor the cold objectivity displayed by Degas when he tackled such subjects. Lautrec's private defence against the intrusions of life was to surround himself with the warmth of a family; his humanism is limited, not universal, but it embraces his friends – and this category can include anyone. With aristocratic disdain, Lautrec chose to

elevate to his social and human level pariahs like the inhabitants of the brothel.

Lautrec is an inescapably class-conscious artist, and so in a different way are his slightly younger contemporaries, Bonnard and Vuillard. They represent for us an apogee of the French bourgeois culture to which they so clearly belong – an observation made in no pejorative sense. Their social origins differed little from those of many another French artist, most of whom (unlike Lautrec) came from the middle class – but Bonnard and Vuillard, instead of accepting the social mobility granted by artistic creativity, seem quite deliberately to have chosen to preserve their specifically bourgeois identities. In a sense they were defending the position that both Munch and Lautrec found so alien.

As very young painters, both Bonnard and Vuillard were members of the Nabis, a semi-secret society of Parisian art students. One of the Nabis, Paul Sérusier, had in 1888 brought to Paris from Brittany the revolutionary message of such Gauguin paintings as *The Vision after the Sermon* (*Ill. 56*); plain, simple colours and increasingly abstract flat compositions are the hallmarks of the Nabis' style. Edouard Vuillard (1868–1940) in particular was for a few years around 1890 a bold and inventive painter of near-abstract small oils, yet he seems to have been unable to move forward along these lines and in the mid-1890s he abandoned experiment altogether. There was a general feeling at that time that the

81 ÉDOUARD VUILLARD (1868–1940) *Interior at l'Etang-la-Ville, 1893. Oil on millboard panel, 12½″ × 14½″ (34.5 × 36.5). Smith College Museum of Art, Northampton, Mass.*

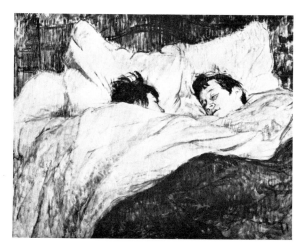

82 HENRI DE TOULOUSE-LAUTREC (1864–1901) *Le Lit, 1892–95. Paper on panel, 31″ × 27¾″ (54 × 70.5). Louvre, Paris*

arts had produced enough innovation, and that the moment had come for a pause and a chance to assimilate the changes. In the decade between 1895 – the year of Oscar Wilde's trial – and 1905 – the year of the fauve Salon – few new ideas or new talents in painting emerged.

Vuillard chose to return to his bourgeois background, which henceforth provided his subject-matter. Again and again he painted the sitting-room at home, with his mother and sister working at their needlework, usually under artificial light (*Ill. 81*). He treated this setting with humour, tender affection and a sense of almost religious tranquility. Munch may have categorically rejected exactly this kind of subject, but for Vuillard it was the still centre of the universe, and he was unwilling to stray far away from it, or to introduce any alien or disturbing elements. Instead he progressively adorned and embellished it, transforming the stuffy, over-furnished interiors into richly patterned tapestries of form and colour.

The career of Pierre Bonnard (1867–1947) closely resembled that of his friend Vuillard. As a young artist he was perhaps less imaginative, but he continued to paint right up to his death with an easy assurance that Vuillard had long since lost. Vuillard could never free himself from his artificially-lit Parisian interiors, but Bonnard moved from Paris to the South of France, and luxuriated in its warm colours and life-enhancing light. He came to feel a part of an ancient and living Mediterranean tradition, and *The Abduction of Europa* (*Ill. 85*) of about 1925 reinterprets an archaic legend in a timeless fashion. Landscape was important for him, though it remained subsidiary to the figure, the undertones of which were so much more profound.

Consider one of Bonnard's many pictures of a girl in her bath (*Ill. 84*). It is a subject that we connect with Degas (*Ill. 83*) but the feeling could not be more different. Where Degas observed the model clinically, Bonnard painted his wife, Marthe – but always as he remembered her when a young girl. Such pictures are meditations on the nature of existence, in which the past and present intermingle, just as they do in Marcel Proust's great novel; the work of art is at once a part of our world and yet removed from it on to an altogether more spiritual level. For the uxorious Bonnard, the girl is the paradigm of the sexual relationship as he experiences it – very differently from Munch, but every bit as humanly valid.

83 EDGAR DEGAS (1834–1917) *The Tub, 1886. Pastel on paper, 23½″ × 32½″ (60 × 83). Louvre, Paris*

84 PIERRE BONNARD (1867–1947) *Nu dans le bain, 1937. Oil on canvas, 3′1″ × 4′10″ (93 × 147). Musée du Petit Palais, Paris*

85

The mundane setting should not disguise the fact that she is surrounded by her natural element; she is a Venus rising from the waters.

The psychological implications of Bonnard's greatest paintings are accompanied by formal qualities of comparable depth and subtlety. The very touch of his brush on the canvas is an affectionate one, and his choice of colour is inexhaustibly inventive, as though no end could ever be found to the riches of life. Similarly his compositions are coherent, self-contained worlds which we are invited to enter and explore, relishing their strange ambiguities and familiar passages.

More than any other single painter, Bonnard bridges the 19th and 20th centuries. On the one hand he is clearly the heir of Monet and Renoir, yet he was to inspire the abstract painters of the 1940s, and in his attitude to art and to life he is close to Matisse, who was to set in train the re-making of painting in the early years of this century.

85 PIERRE BONNARD (1867–1947) *The Abduction of Europa, c. 1925. Oil on canvas, 3′10″ × 5′ (117.5 × 153). The Toledo Museum of Art, Ohio (Gift of Edward Drummond Libby, 1930)*

That Matisse should be the principal figure of a chapter entitled 'expressionism' may at first appear to be stretching a definition too far. But all labels attached to art movements are to a certain extent arbitrary and unsatisfactory. With rare exceptions, works of art are not made to fulfil aesthetic programmes; and artistic 'movements' are the generalizations of journalists when confronted by the existence of new work that cannot be fitted into any convenient pigeon hole. Such terms survive only because they have a certain historical validity, and also because they help to confer some sort of order on the apparent anarchy that the contemporary art scene has, ever since Romanticism, seemed to present.

Expressionism, as an art label, originated in Germany around 1910, and is now often restricted to central European art. It is not easy to define, except negatively in relation to impressionism, but in its original German usage it included what Roger Fry was at about the same time to call post-impressionism. The essential idea was that art should not be limited to the recording of visual impressions, but should express emotional experiences and spiritual values. As Franz Marc wrote, 'Today we seek behind the veil of appearances the hidden things in Nature that seem to us more important than the discoveries of the impressionists.' So defined, expressionism would of course embrace almost all the artists whose work has been discussed in the two preceding chapters, but this would extend a definition to the point of complete vagueness. The justification for applying it to the artists now to be considered is that they belong more or less to the same generation, and share some common ground.

The particular association of expressionism with Matisse is justified by the passage in the text of his *Notes of a Painter*, published in Paris in 1908 and immediately translated into German and Russian. Matisse declared:

'What I am after, above all, is expression . . . I am unable to distinguish between the feeling I have for life and my way of expressing it.

'Expression to my way of thinking does not consist of the passion mirrored upon a human face or betrayed by a violent gesture. The whole arrangement of my picture is expressive. The place occupied by figures or objects, the empty spaces around them, the proportions, every-thing plays a part. Composition is the art of arranging in a decorative manner the various elements at the painter's disposal for the expression of his feelings. In a picture every part will be visible and will play the rôle conferred upon it, be it principal or secondary. All that is not useful in the picture is detrimental. A work of art must be harmonious in its entirety; for superfluous details would, in the mind of the beholder, encroach upon the essential elements.'

To understand what Matisse meant by this statement we must consider it in relation to the development of his work.

Henri Matisse (1869–1954) began painting in the 1890s, which was, as we have seen, a decade of assimila-tion and retrenchment. As a young man in Gustave Moreau's studio at the École des Beaux-Arts, Matisse was almost totally unaware of the revolutionary implica-tions of impressionist and post-impressionist painting. This should be a reminder that any sequential view of artistic development (such as that presented in this book) is inevitably a historian's generalization imposed long after the events. In the 1890s the real significance of recent advanced painting was far from clear; it was for Matisse's generation to make it so.

Not until 1905, when he was 35, did Matisse come before the public as the leader of the new painters. He needed first to make his own synthesis from the innova-tions of his predecessors. He had begun by copying the Old Masters; then in succession the major influences on his work were those of Corot, Manet, Monet, Pissarro, Cézanne, Gauguin, Seurat. As Matisse told Apollinaire in 1907: 'I never avoided the influence of other artists. I should have thought it a form of cowardice and a lack of sincerity towards myself.'

Carmelina of 1903 (*Ill. 86*) demonstrates Matisse's ability to draw together diverse influences. The subject

makes us think at first perhaps of Vuillard or of Lautrec – then we realize that the girl is presented without any strongly personal associations, except for the blue bow in her hair. She is simply a model, posing in the artist's studio, and in the mirror we glimpse not only her back but also the artist himself at work on the picture. Thus Matisse reminds us of the artifice of picture-making, as did Manet and Courbet before him, or Velasquez in *Las Meninas*, the ultimate source of this particular reference.

The artifice extends to the composition: everything fits into place. The background architecture of rectangular shapes sets off the fully-modelled forms of the nude girl. The structure of the picture is further emphasized by Matisse's control of tone – a subtle gradation from dark to light, manipulated in order to throw the figure into relief. There is a sharp contrast of complementaries provided by the painter's red shirt and the blue jug standing before it – a lesson learnt from Corot – but otherwise the colour is generally monochromatic: an ochre base that moves between a warm reddish-brown and a cool grey-green.

Matisse had not in fact come to terms with the bright colours of the post-impressionists – this was indeed one of the problems that beset him as a young painter. It was the systematic approach of the Seurat followers, and in particular of Signac, whom he got to know well in 1904, that gave Matisse the key he sought.

After Seurat's early death, Paul Signac (1863–1935) had assumed leadership of the little group of neo-impressionists. They formed a militant minority who, like the abstract artists of the 1920s, believed that they alone had achieved true vision. Delighted with his new convert, Signac encouraged Matisse to paint an ambitious figure composition which he immediately bought, and which remains to this day in the possession of his family.

This was *Luxe, Calme et Volupté* (*Ill. 87*), a work so programmatic in its adherence to neo-impressionist precepts that Maurice Denis called it 'the diagram of a theory'. But another painter, the youthful Raoul Dufy (1877–1953), was deeply impressed: 'I understood all the new principles of painting, and impressionist realism lost its charm for me as I contemplated this miracle of the imagination introduced into design and colour. I immediately understood the new pictorial mechanics.'

86 HENRI MATISSE (1869–1954) *Carmelina, 1903. Oil on canvas, 32″ × 23½″ (81.5 × 59.5). Courtesy Museum of Fine Arts, Boston (Arthur Gordon Tompkins Residuary Fund)*

In comparison with *Carmelina*, *Luxe, Calme et Volupté* is little concerned with tone; Matisse concentrates instead on colour and composition. The local colours, the colours of light and shadow, the complementary contrasts are all observed, and related in the brick-like dabs of paint on canvas. The lines of the composition and the placing of each key figure are calculated according to geometrical formulae; the emotional resonance of directional lines is observed. Thus, Matisse uses formal means to express a mood of joyous harmony.

In its subject matter, *Luxe, Calme et Volupté* extends beyond neo-impressionism, without contradicting it. For the neo-impressionists were in general political optimists, believers in a golden future, and this assurance is what Matisse paints. The title is a quotation from Baudelaire, the repeated couplet of the poem *L'invitation au voyage* :

> *Là, tout n'est qu'ordre et beauté*
> *Luxe, calme et volupté.*

So that although the subject is the bay at Saint Tropez, with a group of nude figures reposing after a swim, it is clear that more than a simple summer afternoon scene is being depicted: this is a vision of an ideal existence, the *Doux Pays* of Puvis (*Ill. 45*) or the *Golden Age* of Ingres – or for that matter the idyllic world of Cézanne's *Bathers* or Gauguin's imagined Tahiti.

87 HENRI MATISSE (1869–1954) *Luxe, Calme et Volupté, 1904–05. Oil on canvas, 5′9″ × 7′10″ (174 × 238). Private Collection, Paris*

Matisee was a highly intelligent painter who did nothing without forethought and calculation, and these references were unquestionably intended. He needed to place himself firmly in a certain pictorial tradition, yet he also needed somehow to break with that tradition. This is precisely what he did in the ten years from 1905 to 1915, the high plateau of his art.

First he needed to abandon his rigid adherence to neo-impressionism, and in this he was helped by a younger painter, André Derain (1880–1954). The two men worked side by side at Collioure in the summer of 1905, and together created what was at once recognizable as a new way of painting. When their work appeared at the autumn Salon of this same year it was to be labelled 'fauve' – wild – and fauvism became the label attached to the style. It was not inappropriate.

What fauvism essentially represents is both a restatement and a combination of those qualities of post-impressionism which seemed particularly relevant to the younger generation. If Matisse brought an understanding of Seurat to Collioure, Derain, like his friend Maurice Vlaminck (1876–1958), was entirely under the spell of Van Gogh. To Matisse's intellectual discipline, Derain brought an emotional charge, and the result was the explosion of colour represented by pictures like *Portrait with a Green Stripe* (*Ill. 89*). Matisse extended his bricks of paint into flat areas of colour, thinly painted, and in doing so created a new kind of space and light in painting.

The culmination of this tendency may be seen in Matisse's largest painting to date, *Joie de Vivre* of 1905–06 (*Ill. 88*). In a sense it repeats the message of *Luxe, Calme et Volupté*, but on a much grander scale. Elation is matched with calm, Bacchanal with Pastoral. The forms are translated into free-flowing linear rhythms; the colours are liberated from any descriptive function – 'they sing together, like a chord in music,' said Matisse.

The musical analogy is a significant one: Matisse was pushing his painting in that direction as hard as he could go. He was ready to sacrifice everything else, everything but harmony, melody, rhythm. It led him, four years later, to paint the two great mural decorations for the Moscow collector, Shchukin, *Dance* and *Music*. In them, simplification of pictorial means is taken to an extreme in the attempt to create a more expressive pictorial language.

At the same time that he simplified, Matisse made his art more complex. There was a richness about life as he experienced it, which he wanted to capture in his painting. He was fascinated by Oriental art – by Arab rugs and textiles, as well as by Persian miniatures and Japanese prints. In the portrait of *The Painter's Family* of 1911 (*Ill. 90*), the figures are painted in simple flat colours and set off against a richly patterned background. One's spatial expectations are reversed: the background seems to force the figures forward into the spectator's world.

For Matisse, the flatness of the picture was always the first consideration. Every form is related in some way to the picture surface, and reversal plays a key part in this. Rectangular forms may describe voids, not solid objects; a colour may extend over the whole picture, uniting top and bottom, back and foreground in an effortless way. With flat, unmodulated planes of luminous colour, Matisse achieved that reconciliation of surface and space which his contemporaries were seeking.

Matisse pursued a path of experiment until the end of 1916, and then, quite suddenly, stopped. He moved from Paris to Nice, and in the relaxing atmosphere of the South of France began to paint frankly hedonistic pictures, the most characteristic being of scantily-clad odalisques in sumptuous interiors. He had many years earlier declared that his only ambition was to create an art 'devoid of any troubling subject-matter . . . as relaxing as a comfortable arm chair', and now he did exactly that.

89 HENRI MATISSE (1869–1954) *Portrait with a Green Stripe*, 1905. *Oil on canvas, 15¾″ × 12½″ (40 × 31.5). Statens Museum for Kunst, Copenhagen (J. Rump Collection)*

Though he painted great canvases in the later part of his long career, and the pasted paper works that he made shortly before his death in 1954 have a serene, magisterial quality, Matisse never recaptured the excitement and creative intensity of the ten years from 1905 to 1915.

By his resolute elimination of the dark side of existence as something unsuitable for transmutation into art, Matisse had posed a challenge to his contemporaries. How was it possible to live through the holocaust of the 1914–18 war, so unexpected in its destruction and human cruelty, and yet show no reflections of it in one's art? As we shall see later, Picasso, for one, constantly considered himself in relation to Matisse, and reacted against a certain unfeeling coldness in the Frenchman. For there is a paradox here: the man who could say, 'While working I never try to think, only feel', does at times strike us as a calculating intellectual, devoid of feeling. One has only to compare a Matisse nude with a Bonnard to realize this. This is not to denigrate Matisse's achievement – only to attempt to define it more exactly. He saw his art as having a universally cathartic value, and too personal a content was for him a hindrance. Although his *Souvenir d'Océanie* (*Ill. 91*) is a recollection of his visit to Tahiti in 1930, the message is expressed impersonally in the abstract language of colour, form and composition. This evokes a sense of purification and freedom from care, as Matisse wished it to do. This is still the vision of the Golden Age of his earlier pictures, but now all the inessentials have been eliminated and the language of painting alone carries the message.

It has already been asserted that Matisse's work between 1905 and 1915 has an exceptional quality: this is perhaps because those years coincided with that stage in his career when he needed – as any artist does – to make an extra effort to rise above his contemporaries. And it is also true that this particular decade, like the comparable decade in the 16th century, was one of those short, intensive seminal periods in the history of art. Little that is really new has, in fact, happened since then.

Matisse established himself as the leader of the avant-garde when he exhibited his fauve pictures at the autumn Salon of 1905 and *Joie de Vivre* in the spring of 1906. For a year or so his position was undisputed: then Picasso painted *Les Demoiselles d'Avignon* (*Ill. 109*) as, I believe, an explicit challenge to Matisse, though, as

the picture was not publicly shown at the time, the
challenge was of a private nature.

More significant, and soon to affect Matisse's position,
was the rising star of Cézanne. The years from 1900 to
1913 were years of great exhibitions – new Salons, a
succession of retrospectives of all the major figures of
19th century art, and then, outside France, the mammoth
expositions which revealed the whole development of
modern painting – the best known being the Sonderbund
in Cologne in 1909, the post-impressionist exhibitions
in London in 1910 and 1912, and the Armory Show in
New York in 1913.

Well-timed and well-planned exhibitions have an
educative value, on artist as well as general public, and
they frequently affect the course of art. The Cézanne
retrospective at the autumn Salon of 1907 is a case in
point. It was not that Cézanne was unknown or dis-
regarded, but his death and the memorial exhibitions
served to draw the attention of young painters to those un-
resolved qualities in his art which seemed to demand a
solution. No young painter in Paris could escape his
influence – in Matisse, Derain, Vlaminck, Picasso,
Braque, Delaunay, Modigliani, it is clearly to be seen.

The conversion of Derain and Vlaminck, Matisse's
co-workers in the evolution of fauvism, was the most
dramatic. One moment they were painting brightly-
coloured, loosely-handled pictures; the next everything
was tightened up, the colours sombre and near-mono-
chrome, the brush stroke disciplined and directed.

91 HENRI MATISSE (1869–1954)
*Souvenir d'Océanie, 1953. Gouache
and crayon on cut and pasted paper, on
canvas, 9′4″ × 9′10″ (284.5 ×
286.5). Collection Museum of Mod-
ern Art, New York (Mrs Simon
Guggenheim Fund)*

Vlaminck preserved that passionate intensity of vision
which marks his finest landscapes, thus illuminating
what one is tempted to call the expressionist side of Cé-
zanne: those pictures of nature so charged with personal
meaning that they can be read as self-portraits. Vlaminck
at his best offers us the same quality, and the storm-tossed
trees and clouds in the *Paysage d'Orage (Ill. 93)* repre-
sent a personality similarly buffeted. Vlaminck's problem
was the expressionist's perennial dilemma, already
observed in the work of Van Gogh – an inability
to represent any but the emotions actually felt, that
too-personal basis for painting which Mattisse has so
successfully eliminated.

Derain's reaction to Cézanne was significantly different. More detached and objective than Vlaminck, he was able to take from Cézanne those qualities of construction which had appealed equally to Braque and Picasso. Like them, he too was fascinated by the work of the self-taught painter, Henri Rousseau (1844–1910), called the 'Douanier' because he had once worked at one of the since disappeared toll gates of Paris. *The Sleeping Gypsy* of 1897 (*Ill. 92*), for example, was a totally inexplicable masterpiece to the young painters of the day: how could such a simple man have conceived such a picture? Not only did the subject have a resonance that was to haunt the surrealists, but the formal qualities – in the painting of the pitcher, for instance – seemed to arise from a naïve conceptual vision which suggested an answer to one of the problems of pictorial representation posed by Cézanne.

Out of these two very disparate sources Derain, like Picasso, forged a personal style. With paintings like *The Bagpiper* of 1911 (*Ill. 94*) he achieved a lyrical poetry unusual in French paintings, and the simple kitchen objects in the still lifes of 1911 and 1912 have a remarkable stillness and luminosity. For a year or two Derain was able

92 HENRI ROUSSEAU 'LE DOUANIER' (1844–1910) *The Sleeping Gypsy, 1897. Oil on canvas, 4′3″ × 6′7″ (129.5 × 200.5). Collection Museum of Modern Art, New York (Gift of Mrs Simon Guggenheim)*

93 MAURICE VLAMINCK (1876–1958) *Paysage d'Orage*, 1927. *Oil on canvas*, 31½″ × 39½″ (80 × 100). *Musée National d'Art Moderne, Paris*

94 ANDRÉ DERAIN (1880–1954) *The Bagpiper*, 1911. *Oil on linen*, 6′1″ × 4′11″ (185.5 × 150.5). *The Minneapolis Institute of Arts (Bequest of Putnam Dana McMillan)*

to sustain this intensity of work, but somehow, with the quickening of pace among even younger artists, and then with the outbreak of war in 1914, his concentration faltered. One can only regard the close of his career as a sad coda which has probably undermined the force of his earlier contribution.

This became, unfortunately, all too familiar a pattern for other artists of this generation. A premature death, preferably in romantic circumstances, sometimes seems to have served their reputations better, as in the case of Modigliani. He was typical of many ambitious young men, drawn to Paris in the early years of this century, as the only place where their talents could develop and their dreams be realized. This was something that happened quite suddenly around 1900, and was to last only until 1940.

Amadeo Modigliani (1884–1920) was born in Italy but, like most of the artistic immigrants to Paris, he was Jewish. For a time he was undecided whether to concentrate on painting or on sculpture, and the issue was decided for him only when the outbreak of war put an end to his supplies of material for sculpture. But Modigliani's paintings, like the *Portrait of Lipchitz and his wife* (*Ill. 95*), have a sculptural quality that prevents the best of them from lapsing into a mannered prettiness.

There is at times an anguish about Modigliani's work, a direct appeal to compassion for the subject, and by implication for the artist. This is perhaps the most obvious aspect of expressionist painting; inherited from

such artists as Van Gogh and Munch, this emotionalism reaches a pitch of neurotic intensity in the work of another Parisian immigrant of a slightly younger generation, the Lithuanian Jew, Chaim Soutine (1894–1943). A Soutine landscape (*Ill. 96*) burns with a fevered emotion: the paint seems to have been poured out on to the canvas, and never loses its very tangible reality. This is the same South of France that was painted by Corot, by Cézanne, by Bonnard, but whereas the French painters can feel at home and at ease in the landscape, Soutine finds it strange and alien, though still a salve to his bruised and battered self. Trees, bushes, houses, – all come close to being out of control in the *Landscape at Céret*. They are tenuously held within the pictorial composition, as Soutine could only tenuously hold his grip on life and sanity.

The external pressures on artists of this generation seemed somehow to be even more extreme than those which had faced their predecessors. Mallarmé had seen poetry as a defiant gesture made in a void: man's only possible answer to the relentless passage of time in a meaningless, godless world. Such a view of artistic creation was now widely accepted: it made the artist an heroic figure, a visionary with a greater understanding of things than his purblind contemporaries, going about their daily existences unquestioningly. Not many could sustain this role as self-appointed seer, and some sought the support of a Christian faith.

Religious revivals, of one kind or another, were a common feature of the time. In France the mystic

95 AMADEO MODIGLIANI (1884–1920) *Portrait of Lipchitz and his wife, 1916. Oil on canvas, 31½″ × 21″ (80 × 53.5). Courtesy of the Art Institute of Chicago (The Helen Birch Bartlett Memorial Foundation)*

96 CHAIM SOUTINE (1894–1943) *Landscape at Ceret, c. 1920–21. Oil on canvas, 24″ × 33″ (61 × 84). The Tate Gallery, London*

97 GEORGES ROUAULT (1871–
1958) *The Old Clown*, 1917. *Oil
on canvas, 40″ × 29¾″ (101.5 ×
75.5). Collection Niarchos, Paris*

Catholicism of the writers Paul Claudel, Léon Bloy
and Charles Péguy found its counterpart in the painting
of Georges Rouault (1871–1958). Like Matisse, Rouault
had been trained in the studio of Gustave Moreau,
whose favourite pupil he became. During a spiritual
crisis, Rouault became obsessed with evil, which he saw
everywhere, corroding and corrupting the fabric of life.
In his paintings, conventional values are overturned –
judges are seen as ape-like monsters, whores as saintly
women. By degrees, the clown becomes the holy fool
and then Christ himself (*Ill. 97*). Rouault progressively
constricts his vision until his work becomes a meditation
on the life of Christ, the expression of an extremely
narrow-minded view of the world, where landscape, for
example, exists only as the setting for biblical events.
And the jewelled, stained-glass colours, the sombre,
palpitating light and the heavy, brooding forms of his
pictures inevitably suggest the interior of the Church,
which alone for Rouault contains and preserves the
message of Christianity.

Rouault has his Protestant equivalent in the north
German painter, Emil Nolde (1867–1956), and now
we move away from France to the heartland of expression-
ism, central Europe. Nolde's finest paintings are those
in which he paints the life of Christ, and especially the
sequence executed between 1909 and 1912. In *The Last
Supper* (*Ill. 98*), Nolde portrays Christ and his disciples
as German peasants, and the primitive vision is matched
by a primitive manner of painting. Unmixed colours
are laid directly on to the canvas: the composition is crude,
the touch rugged and unrefined. In Nolde's later work,
landscape contains the religious emotion – the flat, dune
landscape of Nolde's home, Seebüll, with its stormy
seas and banks of louring clouds. Such pictures grip
the viewer in the pathetic fallacy, but like other romantic
and expressionist landscape painting, they perform that
same purgative and purifying function that Matisse
wanted his very different art to perform.

Nolde was a solitary by temperament, but he came
successively into contact with two of the centres of
modern art activity in Germany – Dresden and Berlin.
In Dresden in 1907 he met a group of young painters
who had banded together into an artistic community
which they called *Die Brücke* (The Bridge). The leader
was Ernst Ludwig Kirchner (1880–1938); other mem-

98 EMIL NOLDE (1867–1956) *The Last Supper*, 1909. *Oil on canvas*, 34"×42" (86×107). *Statens Museum for Kunst, Copenhagen (Ada and Emil Nolde Foundation)*

bers were Karl Schmidt-Rottluff (*b.* 1884), Erich Heckel (1883–1970) and Max Pechstein (1881–1955). Pechstein had worked in France and had seen the fauve Salon of 1905: the Bridge that the German painters were making was one from provincial Dresden to cosmopolitan Paris, and in particular to the new vision of art revealed by Gauguin and Van Gogh, and now entrusted to the hands of Matisse and Derain.

In their flat unbroken bright colours, their heavy contours, their lack of perspective, *Brücke* paintings show an evident debt to the French fauves. Yet a more clumsy, more subjective quality always sets them apart. Kirchner's painting of himself and his model (*Ill. 99*) in 1909, carries an emotional charge that is absent from Matisse's treatment of similar subjects. Kirchner seems to need to impose some psychological interpretation, to present the scene as something more than an everyday studio occurrence. 'We no longer paint for the sake of art, but for the sake of people', maintained one of the German theorists of expressionism, and it is precisely this shift of emphasis that is observable in these works.

Kirchner and the other *Brücke* painters moved in 1911 from Dresden to Berlin, which was now asserting itself as an intellectual capital of northern Europe. Both Strindberg and Munch had lived in Berlin, and Munch's influence throughout Germany was considerable, and helps explain the *Brücke*'s particular interest in woodcuts

99 ERNST LUDWIG KIRCHNER (1880–1938) *The Artist and his Model*, 1909. *Oil on canvas*, 4'11"× 3'3" (150.4×100). *Kunsthalle, Hamburg*

and lithographs. Kirchner was fascinated by big-city existence, especially its seamy side – the streetwalkers and pimps, the dancers and circus performers. *Brücke* subject-matter was for a time polarized between this night-side, and its antidote, the countryside seen in the fresh light of day. The painters project an open-air cult: if winters are spent in Berlin, then summers must be devoted to the beach and the mountains, where the healing force of nature brings refreshment and balm. Nudity becomes a positive, self-conscious demonstration of health; sun-shine something to be worshipped for its own sake. Some common and characteristic 20th century attitudes have origins in the Germany of this period.

Between 1910 and the outbreak of war in 1914, Berlin's intellectual life revolved round the figure of Herwarth Walden. His art gallery and his literary magazine, both called *Der Sturm* (The Storm), acted like magnets. Delaunay brought his most abstract pictures to show in Berlin in 1913: with him came the poet Apollinaire to talk about new painting in Paris. Marc Chagall hesitated in Berlin and almost decided to settle there permanently; and for a time a young Viennese painter, Oskar Kokoschka (born 1886) actually worked in Walden's office. Here more than anywhere did the public image of expressionism evolve.

Kokoschka's *Self-Portrait with Alma Mahler* of 1912 (*Ill. 100*) makes a striking contrast to Kirchner's *Self-Portrait*; the figures in the Kokoschka have the same vitality, but it is conveyed by graphic rather than painterly means. Kokoschka at this stage in his career was essen-tially a draughtsman – indeed this is why he had found employment at *Der Sturm* – and it is that nervous, all-expressive line which scratches at the picture surface and snakes over it, quivering with life. Kokoschka's portraits at this time also have a probing analytical quality which no sitter can withstand. It was scarcely surprising that his activities as a painter were compared to Freud's as a physician, particularly as psychoanalysis was developed in much the same ground that nurtured Kokoschka.

Apart from Berlin, Munich was the main artistic centre in Germany. It was here that the third organized manifestation of expressionism emerged – the *Blaue Reiter* (Blue Rider). The group came together in 1911; its leading members were the Russian, Vassily Kandin-sky (1866–1944), long domiciled in Munich, and two

100 OSKAR KOKOSCHKA (*b.* 1886) *Self-Portrait with Alma Mahler, 1912. Oil on canvas, 39½″ ×35½″ (100 ×90.5). Collection Professor Edgar Horstmann, Hamburg*

young German painters, Franz Marc (1880–1916) and August Macke (1887–1914). Unlike the *Brücke* artists, the *Blaue Reiter* painters shared no common style – but they did share a common conviction about the need for spirituality in art. Kandinsky's experiments, drawing on multiple sources that included Matisse's fauve manner, led him to abstract art; his work will be discussed in a later chapter. Marc was also on the road to abstraction when he died, but his surviving work falls into the expressionist category and supplies an appropriate conclusion to this chapter.

For Marc, art had a special part to play in a world that had experienced and rejected both Christianity and 19th century materialism. He wanted 'to create symbols, which could take their place on the altars of the future intellectual religion.' How could this be done? Marc tried at first to contrast the natural beauty of animal life with the sordid reality of man's existence: the essential pantheism in his approach descends at times into the sentimental. But in his masterpiece, *The Fate of Animals* of 1913 (*Ill. 101*), Marc uses the new discoveries of

futurism and cubism to give his vision that extra edge. The picture's original title is written on the back: 'All being is flaming suffering.' In an apocalyptic holocaust, a blue deer lifts its head to a falling tree: there are red foxes on the right, green horses at the top left. Colours are used for symbolic reasons: and blue for Marc is the colour of hope. Yet hope is soon to be extinguished in this cataclysmic destruction of animal life.

Shortly before his death in action on the Western Front, Marc sent a postcard of *The Fate of Animals* to his wife. 'It is like a premonition of this war, horrible and shattering,' he wrote. 'I can hardly conceive that I painted it. It is artistically logical to paint such pictures before a war – but not as stupid reminiscences afterwards, for we must paint constructive pictures denoting the future.'

The war took a heavy toll of the expressionist generation. It killed Marc and his young friend Macke. Both Kirchner and Kokoschka were brought to the edge of insanity: Kirchner's health was indeed permanently broken, and he was an invalid in Switzerland until his suicide at the advent of the Second World War. Kokoschka's survival must be attributed to his toughness, and to a final refusal to accept the 20th century at all. For Kokoschka remains the last great 19th century painter, who has been able to carry on during a long and successful career as if the artistic events described in this book had never occurred at all.

101 FRANZ MARC (1880–1916) *The Fate of Animals, 1913. Oil on canvas, 6′5″ × 8′8″ (195 × 263.5). Kunstmuseum, Basle*

Cubism

Of all the revisions of pictorial language proposed in the 20th century, cubism has been the most radical. It led immediately to the conception of the painting as primarily an object, which in turn made possible both a totally abstract art and an extension of painting, first into collage and relief and then into sculpture. The distinction between the arts of painting and sculpture breaks down in the mid-20th century as a result of the cubist revolution.

Cubism was essentially an intellectualization by two young painters, Picasso and Braque, of certain practices that they had noticed in the painting of Cézanne. Cézanne's approach to landscape and still-life was always empirical, in a sense un-self-conscious; and he died without ever feeling that he had found a solution to the problems of pictorial representation that faced him. With all the aggressive assurance of youth, Picasso and Braque simplified the problem and propounded a solution that at least satisfied them. But the solution only raised new questions, which led to fresh innovations.

The moment of crisis came in 1906, the year of Cézanne's death. A small group of his paintings were shown in the autumn Salon, in preparation for the memorial exhibition to be organized a year later; they had a profound effect on Picasso. Other important influences were coming to bear on Picasso's painting at this time, particularly that of archaic and primitive sculpture, and the consequence was that angry masterpiece that he painted in the winter of 1906–07, *Les Demoiselles d'Avignon* (*Ill. 109*).

Picasso's work before 1906 does not prepare us for the explosion of *Les Demoiselles*. Born in Malaga in 1881, the son of an art teacher, Picasso was gifted with extraordinary natural talents. He quickly learnt from the Old Masters in the Prado, from the art magazines that circulated in Barcelona where he spent his youth, and

from the new painting which he saw in Paris on repeated visits from 1900 until 1904, when he made his permanent home in the French capital.

Picasso's formation was an eclectic one, and reflects his restless temperament. The influences of Daumier, Lautrec, Bonnard, Puvis de Chavannes, Degas, even Munch and Rossetti are visible in his early paintings and drawings. But by 1903 when he painted *La Vie* (*Ill. 102*) Picasso's individual temperament made itself clearly felt. This was his largest and most ambitious picture to date, and, as the title suggests, was nothing less than a statement about the meaning of life. It is a Gauguinesque allegory, not precisely explicable. The three pairs of figures, like the women in Munch's *Dance of Life* (*Ill. 80*), evidently represent three stages of existence – perhaps first love, experience (and also disillusion?), and then maternity. They are very substantial figures; the one on the right stands like a column, and the draperies instead of concealing the elongated bodies seem to make them even more expressive than the nudes. The picture is monochromatic: nothing but varying hues of blue, the colour that dominates Picasso's work at this time, chosen here because of its associations with melancholy, with infinity – *l'azur* of Mallarmé's sonnets.

In his early studies for *La Vie*, Picasso's setting is clearly the artist's studio – yet another echo of that Velasquez motif which haunted Courbet and Manet and others among Picasso's immediate predecessors. But what is striking about Picasso's variation of the theme is the degree of personal involvement – a passionate, subjective emotionalism that all but swamps the picture.

Picasso may well have been aware of this, because when he settled in Paris in 1904 he began to reduce the sentimental content of his work. Instead of picturing beggars, whores, starving children and their mothers, he takes his subjects from the world of the theatre and the circus – at one remove, as it were, from reality. *The Acrobat Family* of 1905 (*Ill. 103*) is a direct extension of *La Vie*, here with a whole family rather than a couple. Again there is no explicit message, no drama – the stylized figures are caught in a timeless, motionless state of trance. But they are *acrobats*, stoically enduring a drab and insecure existence, very different from that other life, full of tension and excitement, which they present for our entertainment in their circus performances.

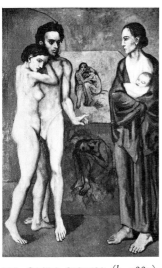

102 PABLO PICASSO (*b.* 1881) *La Vie, 1903. Oil on canvas, 6'6" × 4'2" (197 × 127.3). The Cleveland Museum of Art (Gift of Hanna Fund, 1945)*

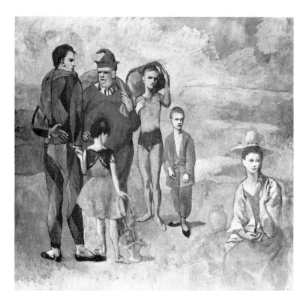

Picasso delights in this duality, which of course lies at
the heart of every theatrical performance. He has remained
fascinated by the theatre throughout his career, even to
the extent of writing plays, and he is always projecting
himself as an actor, clowning about, playing different
parts in his own painting. When he painted *The Acrobat
Family*, however, he surely intended us to see the fate of
circus performers, condemned to a rootless occupation
and unstable relationships, as symbolic of the fate of
humanity. This, at any rate, is how the German poet,
Rainer Maria Rilke, interpreted the picture. It hung in
the castle at Duino where he was staying at the time the
First World War broke out, and in his fifth Duino elegy
Rilke begins by meditating on Picasso's picture:

> *Wer aber* sind *sie, sag mir, die Fahrenden, diese ein wenig*
> *Flüchtigern noch als wir selbst, die dringend von früh an*
> *wringt ein wem – wem zuliebe*
> *niemals zufriedener Wille?*

'But tell me, who *are* they, these acrobats, even a little
more fleeting than we ourselves, so urgently, ever
 since child-hood,
wrung by an (oh, for the sake of whom?)
never-contented will?'
 (translated by J. B. Leishman and Stephen Spender.)

For Rilke, even the composition underlined his interpretation: the figures are grouped into an enormous Dshape, D being the first letter of the German *Dasein*, an untranslatable word meaning existence in its most real and tangible form.

In *The Acrobat Family*, Picasso exchanged his bluedominated palette for a pinkdominated one. This was part of his search for a less emotional, more objective art. He was now looking closely at Greek vase painting and Etruscan and archaic Greek sculpture in the Louvre. His interests quickly expanded to include ancient Iberian carving, and, even more revolutionary, African sculpture. The evidence of the assimilation of this new material can be seen in *Les Demoiselles d'Avignon*.

Les Demoiselles marks a new beginning for Picasso. Up to this point he had been working on the margins of modern art. He was a latterday symbolist, with affiliations with the humanist tradition of sociallyaware realist painting. The line of pictorial experiment followed by Manet and Cézanne and Seurat had left him indifferent. This was 'pure painting', and as such irrelevant to the great issues with which Picasso wanted to concern himself. Yet he found that he needed contact with 'pure painting' in order to be able to express those ideas. Two French painters, Matisse and Braque, showed the Spaniard how this could be done.

Matisse was the rival, Braque the collaborator and friend. Matisse's *Joie de Vivre* (*Ill. 88*) was exhibited only months before Picasso began work on an even larger canvas; it had brought Matisse to prominence as the leader of the avantgarde. *Les Demoiselles* was in some respects a reaction to it – the revelation of that violent, dark side of life which Matisse thought unsuitable for artistic representation. It is a night picture, contrasting with the sunfilled daylight of the *Joie de Vivre*.

The title, *Les Demoiselles d'Avignon*, was an afterthought, given to the picture years later by one of Picasso's friends, who had been told that the women where whores depicted in a brothel in Carrer d'Avinyo (Avignon Street), Barcelona. This may be true, but it is not the point of the picture. What Picasso intended originally was some kind of allegory. In his early studies for the painting a sailor is the central figure, surrounded by nude women; a second sailor enters from the left, pulling back a curtain. He is carrying a skull – evidently intended as a

memento mori, the classic reminder of the transitory nature of human life.

All this theatricality disappeared when Picasso tackled the big canvas. He suppressed the sailors to concentrate on the nudes. As he painted them, the form of their figures began to seem more important than their symbolism. Iberian figures of the pre-Roman period had strongly attracted Picasso by their massive strength and directness, and the second and the third women, their heads especially, are based on this source. The first figure on the left was also begun in this style, but later altered; and the fourth and fifth women, on the right, show the direction in which he was moving. For here the influence of masks from the French Congo is overt – in the elongation of the faces, the concavities below the eyes, and the hatched striations on the cheeks.

African sculpture was a new enthusiasm of the young painters in Paris. First Vlaminck, then Derain and Matisse, began to look at it in the ethnological museums and to buy examples for themselves. Picasso followed suit in 1906–07, exactly at the time he was working on *Les Demoiselles*. Hitherto nobody had considered such sculptures works of art: they were curious specimens, without aesthetic value. The revolutionary change was in seeing qualities in them that made them art-objects, equal to any produced by civilized peoples. Two aspects of African sculpture were to be particularly relevant. One was their social function – their use as magic tokens in ritual ceremonies; the other was more formal – the fact that the artist who carved them was evidently not concerned with recording visual appearance, but rather with expressing an idea about it. Thus non-representational forms are given a representational character only by means of a symbolic arrangement.

At first, neither of these aspects was fully appreciated. Picasso liked Negro sculpture because it seemed to corroborate something he had observed in Cézanne and was now attempting in his own painting – a new way of representing three-dimensional forms on a two-dimensional surface. Why should one be constricted to a single viewpoint in painting a figure? Why not try to make on the canvas a synthesis of different views? Cézanne had begun to move around a figure, around the objects in a still life – as in the *Woman with the Coffee Pot* (*Ill. 31*). Picasso, in the squatting figure of *Les*

Demoiselles, took this practice much further, and, with the analogy with African art in mind, broke away from what he could *see* and painted instead what he *knew* must exist. Thus emerged the simultaneous vision of the cubists, expressed at its most dramatic by the head that combines full-face and profile, such a common feature in Picasso's later work.

In colour and composition, *Les Demoiselles* is indebted to Cézanne's *Bathers* pictures. Certain poses are echoed, almost to the point of quotation. The shallow space-construction, and the way figures are related to background are equally derivative from Cézanne. This is not a criticism of Picasso: he was after all one of the first to recognize the supreme greatness of Cézanne, and this was a way of demonstrating his personal allegiance. But in the last resort there remains something unresolved about *Les Demoiselles*, as if the disparate elements had not been welded together, as if the tremendous artistic struggle which the picture represented had not been without casualty. Picasso certainly considered the work unfinished, for he made no attempt to exhibit it until 1937.

Yet the work soon acquired a subterranean reputation. Apollinaire, the poet who wrote about art and enjoyed the company of painters, brought a young painter to meet Picasso, and his first sight of the *Demoiselles* changed his life. This was Georges Braque (1882–1963). His early painting had been in the fauve manner of Matisse, very brightly coloured and directly painted. Thinking about Cézanne had changed all this, but Braque was still unsure of his new direction. Picasso showed him the way, and the *Grand Nu* (*Ill. 104*) that Braque painted in the winter of 1907–08 is in effect a variant of one of the *Demoiselles* figures. It differs from the Picasso picture, however, in that no African influence is discernible; the debt is exclusively to Cézanne.

Braque's understanding of the implications of Cézanne's work was more complete than Picasso's. Both young painters had read the recently published letters of advice that Cézanne had written to Emile Bernard, and brooded on the meaning of the exhortation to 'treat nature by the sphere, the cylinder, the cone.' Did this mean that one should search for geometrical forms behind natural appearances? In the summer of 1908 both painted landscapes in which they attempted this. Braque's *Trees*

104 GEORGES BRAQUE (1882–1963) *Grand Nu*, 1907–08. Oil on canvas, 4′8″×3′4″ (140×99). Collection Madame Cuttoli, Paris

at Estaque (*Ill. 105*) was one of the group of pictures in which the regularity of natural forms was so pronounced that a critic, Louis Vauxcelles, described the landscapes as being made up of 'little cubes'. Out of this casual and condescending remark the term 'cubism' was to spring.

A more significant feature of Braque's painting, however, is its treatment of space. Anything illusionistic seemed inappropriate: Braque wanted a new kind of pictorial space, which he called 'tactile' or 'manual'. The suggestion of an infinitely extensible depth was now replaced by a tentative faceting of forms so that every element could be clearly expressed and related to the picture surface. Braque changed his palette too, because colour had a new part to play; its function was now no longer to be descriptive, but constructive.

The marriage of Braque's spatial concern to Picasso's formal ones was consummated in such pictures as Picasso's *Dryad* of 1908 (*Ill. 106*). One might say that Picasso's nude is here let loose in Braque's forest. For Picasso this represented a diminution of the African element and a greater concentration on Cézanne. But the primitive character of the painting is unaltered, though it displays Picasso's admiration for the Douanier Rousseau (*Ill. 93*) as much as it does for any more exotic example.

Working together 'rather like mountaineers roped together', Braque and Picasso pushed these pictorial innovations to a logical conclusion. The faceting of figures and objects was extended to the space around them, so that space and volume formed a continuous whole and the picture took on a tangible surface. Colour remained severely restricted to a monochromatic palette of greys and browns and ochres: it was for the moment the least important pictorial element.

Picasso's *Girl with Mandolin* (*Ill. 107*) is still recognizable, but the figure begins to disappear into the picture. There is a paradox here. Picasso wanted the analytical precision in his treatment of the subject offered by the process of combining multiple viewpoints. He told his dealer, Daniel-Henry Kahnweiler: 'In a painting of Raphael's you can't measure the exact distance from the tip of the nose to the mouth. I want to paint pictures in which this would be possible.' Yet at the same time he could not resist the general feeling that matter was insubstantial, so that these geometricized forms are extended

105 GEORGES BRAQUE (1882–1963) *Trees at Estaque*, 1908. Oil on canvas, 28¾" × 23" (73 × 60). Statens Museum for Kunst, Copenhagen

106 PABLO PICASSO (*b.* 1881) *Dryad*, 1908. Oil on canvas, 6' 1" × 3' 7" (188 × 107). The Hermitage, Leningrad

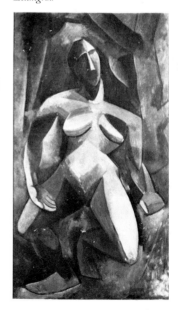

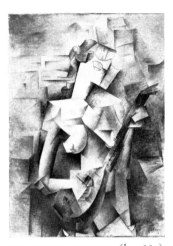

107 PABLO PICASSO (*b.* 1881) *Girl with Mandolin,* 1910. *Oil on canvas,* 39½″ × 28¾″ (100 × 73). *Private Collection, New York*

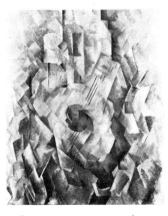

108 GEORGES BRAQUE (1882–1963) *Mandolin,* 1909–10. *Oil on canvas,* 28½″ × 23½″ (72.5 × 59.5). *The Tate Gallery, London*

into the space around them. Bergson's concept of life as flux, and Einstein's denial of the fixed state and the solidity of objects are relevant here: such ideas did not necessarily have a direct influence on Picasso and Braque, though they were perhaps more aware of them than is realized.

There is a further consideration: why should the nude girl in Picasso's picture hold a mandolin? It is not an instrument one would expect to find in a studio or an artists' café – the social context of early cubist painting. The answer lies partly in the comparable subject-matter of Corot's studio interiors, partly – and more revealingly – in the poetry of Mallarmé. Kahnweiler tells us that Mallarmé was very important for the cubists after 1907, and the mandolin is a favourite symbol in his poems. It offers a multiplicity of allusions – the instrument makes music and thus creates art; it is shaped like a womb, and this suggests another, analogous creation. Braque too paints the *Mandolin* at the same time (*Ill.* 108), and in this still-life Mallarmé's poetic technique of fragmenting experience and then reordering it in the work of art finds a close parallel in cubist painting. Mallarmé had also asked questions about the role of chance in artistic creation: the painters were not yet ready to take up their implications, but they were soon to do so.

Braque's dissolution of forms was more extreme than Picasso's, perhaps because he felt less inhibited when painting still-lifes, which he preferred to figure subjects. In the *Mandolin* light is diffused, the broken, faceted planes are tipped now in this direction, now in that, echoing one another across the picture surface. For Braque the fragmentation 'was a means of getting closer to objects within the limits that painting would allow. Through fragmentation I was able to establish space and movement in space, and I was unable to introduce objects until I had created space.' This kind of painting has been called *analytical* cubism, but the term is misleading. Picasso and Braque began by adapting Cézanne's analytical approach, but they soon found it too empirical and unsystematic. 'There was no question of *starting from* an object; we *went towards* it,' said Braque. 'And what concerned us was the path one had to follow in order to be able to *go towards* objects.'

Following such a path meant imposing an abstract structure on the picture, and making the object conform.

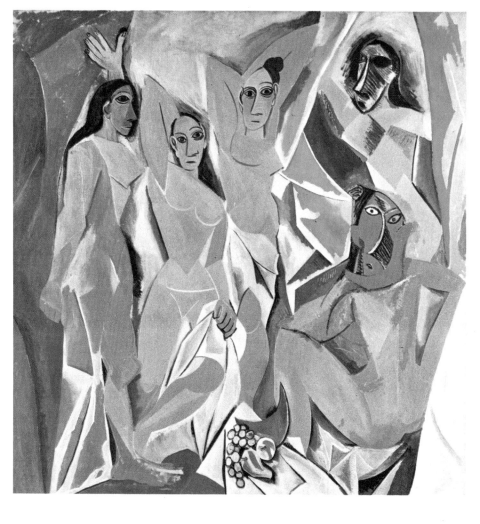

We can see how this works in Picasso's figure paintings
of 1910 and 1911, where the body is articulated like a
piece of scaffolding. Contours are rejected as unreal and
restraining, the closed form of the figure is decisively
pierced, at times even a suggestion of movement is
introduced. In Picasso's *Mandolin Player* of 1911 (*Ill. 110*)
a pyramidal construction is imposed on the painting, and
the forms have now lost any suggestion of volume. They
are flattened into planes of colour, which merge and
overlap; the only linear definition is given in the form of
straight lines and arcs. Yet to counteract the increasing

109 PABLO PICASSO (*b.* 1881)
Les Demoiselles d'Avignon, 1906–07.
Oil on canvas, 8′ × 7′10″ (244 ×
234). Collection The Museum of
Modern Art, New York (Lillie P.
Bliss Bequest)

abstraction of their paintings, both Picasso and Braque had introduced a new compensatory element – a different kind of reference to the object, made by the introduction of such devices as a *trompe-l'œil* nail, simulated lettering, a passage of wood-graining. The idea may initially have been to emphasize the flatness of the surface, but its philosophical implications could not now be ignored.

The fact was that by the end of 1911 Picasso and Braque had taken cubism to the point where they were faced with a dramatic choice. Only the initiated could discern any subject in their pictures, so hermetic had they become. Either they must abandon the link with the object altogether, and allow the painting to establish its own logic and meaning, or they must establish a new relationship between painting and the external world. They chose the latter course.

In a sense the solution, for Braque and Picasso, was inescapable. They could not conceive of an objectless, *i.e.* an abstract, picture. It would simply be a pattern, a piece of decoration – what other meaning could it have? It is only because Mondrian took a different view that we, wise after the event, can propose the existence of such a dilemma at all.

In any case, the introduction of *trompe-l'œil* passages, with their built-in implications, provided the cubists with an answer. Picasso early in 1912 made the *Still-life with Chaircaning (Ill. 112)*, in which he pasted onto his canvas a piece of oilcloth that simulated the split-cane weaving of a chair seat. A length of rope was added as a frame. This use, first of pasted paper (*papier collé*), then of attached objects (*collage*), revolutionized painting. Illusionism was now so totally abandoned, and the flat surface of the painting so paramount, that such additions became aesthetically acceptable. But the method blurred the division between painting and object to the extent that one could conceive a situation in which it would be impossible to decide which was which. This was the significance of Marcel Duchamp's exhibiting signed ready-made objects in 1917.

In the *Still-life with Chaircaning* Picasso offered a statement of the stage reached in 1912. Objects in painting can be treated in a number of different ways, he seems to say. They can be analyzed, as in an engineer's working drawing which gives us a precise specification and measurements. They can be presented as painted

110 PABLO PICASSO (*b.* 1881) *Mandolin Player*, *1911*. *Oil on canvas*, *39½" × 27" (100 × 69)*. *Collection M. F. Graindorge, Liège*

equivalents – the shell in the picture, for example – or they can be their actual selves. Painting can be crammed with allusions; jokes can be made – puns such as the use of the first three letters of *journal* to suggest *joujou* or *jouet*, the French words for a toy or plaything. Picasso begins again to use colour after all those years when it had been banished as a difficult and potentially disruptive element. After all, how can a lemon be painted except with lemon paint?

This new development of cubism called for a revised label, and Picasso's friend Kahnweiler proposed 'synthetic'. He wrote: 'Instead of an analytical description the painter can if he prefers also create in this way a synthesis of the object, or, in the words of Kant "put together the various conceptions and comprehend their variety in one perception".' To put it another way, using the same terminology, it was, like African sculpture, a *con*ceptual and not a *per*ceptual art, in which the idea of the object comes before any attempt to record its appearance.

By 1912 the aesthetic argument that had begun on the death of Cézanne six years earlier had reached a conclusion. The logic according to which Picasso and Braque had progressed so unhesitatingly now seemed to have reached its term. It was entirely in character that Braque should settle down in 1913 and 1914 and paint a series of stilllifes with musical instruments in the now definitive cubist style, whereas Picasso should suddenly grow restless again and begin to branch out in different directions.

One was the extension of collage into fully threedimensional construction, involving the use of scrap wood, cardboard boxes, anything that came easily to hand (see p. 180). He also reintroduced bright colours, painting in dots and dabs, to increase the decorative content of his pictures. He also seems to have wanted to bring back the passionate, emotional quality of the early precubist period and in the *Woman in an Armchair* of 1913 (*Ill. 111*) the disturbing, disruptive element reappears, with the added force of Picasso's new pictorial language.

The outbreak of war in the summer of 1914 upset the rhythm of Picasso's development – not completely, as with Braque who was at once mobilized into the French army, but profoundly enough to make one suspect that

111 PABLO PICASSO (*b.* 1881) *Woman in an Armchair*, 1913. Oil on canvas, 4′10″ × 3′2″ (146 × 97). Collection Dr Ingeborg Eichmann

he was never again able to work with quite the same conviction. It is the same melancholy phenomenon observable in Matisse and in the work of the expression, ists, for art cannot withstand a society in total turmoil, and although unrest can be stimulating, the collective insanity of total war is doubly destructive. What Picasso and Braque had achieved in the cubist revolution and its aftermath was to remain both an inspiration and a touchstone.

The discoveries of Braque and Picasso did not go un, remarked, despite their disinclination to exhibit in public. At the 1911 *Salon des Indépendants* a group of young painters showed cubist work, and this was the first of a series of manifestations that lasted until the war. The most remarkable paintings at the 1911 exhibition were the *Nudes in the Forest* of 1909–10 (*Ill. 113*) by Fernand Léger (1881–1955) and one of the Eiffel Tower pictures by Robert Delaunay (1885–1941). These two men were friends, and like Braque and Picasso they too were able to extend the language of painting.

Léger's *Nudes in the Forest* at first seems alarmingly mistitled. No idyllic pastoral here: are not these naked figures at work felling trees? That Léger should choose an everyday scene that deliberately eschews any poetic interpretation is typical. So is the way in which the human bodies are reduced to machine,like tubular shapes. Léger was later to elaborate his aesthetic, but its essentials are already present in this early work.

Delaunay's choice of the Eiffel Tower as a subject is equally characteristic. Ever since its appearance at the great exhibition of 1889, this miracle of engineering ingenuity posed a challenge to artistic judgment. Was it a hideous piece of useless machinery or a new kind of sculpture? Douanier Rousseau had taken a positive attitude to the Tower and included it in his paintings, but Delaunay's choice of subject is more provocative, coming as it did after his pictures of the Gothic cathedrals of Saint,Séverin and Laôn.

The machine now became a live issue for painters, as for architects, joining the associated problem of the representation of movement that had interested them for some decades. It was at this point – February 1912 – that the Italian futurists first exhibited in Paris; their impact was immediate and sensational.

Futurism began as a literary movement, with the first manifesto launched in 1909 by the poet, Filippo Tommaso Marinetti. It was followed a year later by the two manifestos of futurist painting signed by five young Italian artists, of whom Umberto Boccioni (1882–1916) was the most important. The futurists knew what they wanted – to get rid of the stultifying weight of the Italian past, and to use their art to celebrate modern urban existence. In Marinetti's phrase, 'a roaring automobile, which seems to run like a machine-gun, is more beautiful than the *Victory of Samothrace*.' The futurist painters proclaimed themselves 'the primitives of a new and transformed sensibility.'

But although the futurists wanted their paintings to express speed, violence, dynamic movement and the passage of time, their technique was inadequate to the task. In search of a pictorial language, they turned to Paris and discovered first the neo-impressionism of Seurat and Signac, then the cubism of Picasso and

112 PABLO PICASSO (*b.* 1881) *Still-Life with Chaircaning*, 1912. *Oil and waxed canvas glued on canvas*, 10½″ × 13½″ (27 × 35). *Collection the Artist*

113 FERNAND LÉGER (1881–
1955) *Nudes in the Forest, 1909–10.*
Oil on canvas, 3′11″ × 5′7″ (120 ×
170). Rijksmuseum Kröller Müller,
Otterlo

Braque. This taught them how to break through the
surfaces of objects and show them moving in space.
Boccioni's *The Street enters the House* of 1911 (*Ill. 114*) is
one of the first successful futurist paintings: it was among
those shown in Paris in 1912. The artist's mother stands
at the balcony of her apartment, looking down at the
street below: all the bustle and activity of the city street
rise up to meet her. Boccioni expresses this by such
devices as shifting viewpoints, and a fragmentation of
forms to represent the light and noise of the street entering
the building. Although he is here heavily indebted to
Delaunay's Eiffel Tower paintings, in the months that
followed, Boccioni went on to develop a mature futurist
art. This is more evident in his sculptures than in his
paintings, and they will be considered in a later chapter.

The futurist contribution to the artistic dialogue in
Paris was to draw attention to two particular lines of
investigation – that of the representation of movement,
and that of devising a pictorial equivalent to the machine.
And through their interest in neo-impressionism they
contributed to the revival of interest in colour.

These three strands are interconnected, as can be seen
in the pre-war work of Léger and Delaunay. In a series of
experimental paintings executed in 1912–13 both artists
carried these ideas very close to total abstraction, without
venturing to commit themselves completely. Léger
wanted to find a new pictorial means of reflecting modern
life. He pushed the already machine-like forms of his
paintings, derived from human bodies, limbs, trees,
clouds, smoke, etc., into still less recognizable shapes,

calling the results *Contrasts of Forms,* or even *Geometric Elements.* The abstracted forms in these pictures begin to take on a life of their own: Mondrian, for one, was impressed by their use of primary colours, black linear structure, rhythmic movement and simple contrasting shapes.

As far as Léger was concerned, however, these pictures were experiments which he thought neither self-sufficient nor worth exhibiting. But we can see how he used the pictorial knowledge gained in his first great painting, *The City* of 1919 *(Ill. 115).* This enormous canvas succeeds where futurist paintings failed. It lifts the everyday activity of city life onto the timeless plane of art, effecting a reconciliation of restless movement and crude shapes and colours in a composition of unmistakably grand design. Like other Léger paintings of the period, *The City* appears to be constructed out of interchangeable machine parts. The artist, Léger held, has only to reassemble a collection of given objects: 'I have no imagination,' he once asserted. All the human figures are reduced to robots: there is an explicit philosophical devaluation of the person in this phase of Léger's work, a prerequisite to the new vision of the last great compositions.

114 UMBERTO BOCCIONI (1882–1916) *The Street enters the House, 1911. Oil on canvas, 39½″ × 39½″ (100 × 100). Niedersächsische Landesgalerie, Hanover*

Delaunay's dedication to modern life was less extreme than Léger's. His series of Eiffel Tower pictures became studies of views through windows, with only vestigial traces of the Tower itself. Delaunay had become fascin-ated with colour theory, believing, reasonably enough, that it was time to bring such ideas to bear on cubist theory and practice. 'Colour is *form and subject*', he wrote at the end of his life, and he believed that art should be confined to the rhythmic interplay of contrasting areas of colour. In 1912–13 he painted a series of *Discs* (*Ill. 116*), based on the colour wheel. Such pictures have been called the first entirely non-objective paintings created by a French artist, and in his later career Delau-nay himself was inclined to look back on them as major pioneering statements. But their exact status must remain in doubt. Were they more than demon-stration pieces, experiments, like Léger's *Contrasts of Forms*? It is by no means clear that Delaunay regarded them at the time as complete and resolved works of art. His more considered paintings of the pre-war period celebrate the city of Paris, the Cardiff football team and Blériot's first flight across the Channel. Even the discs,

115 FERNAND LÉGER (1881–1955) The City, 1919. Oil on canvas, 7′7″ × 9′10″ (231 × 293.5). The Philadelphia Museum of Art (A. E. Gallatin Collection)

when exhibited in Berlin, were entitled *Sun* and *Moon*, as though to suggest some cosmic symbolism. For Delaunay's so-called early abstractions are essentially paintings of light – light as the source of all life and energy, as it is of all colours. Thus they belong in that transitional category between symbolism and abstraction which will be discussed in the next chapter.

One other pre-war derivation from cubism remains to be considered. In the winter of 1911–12, Marcel Duchamp (1887–1969) painted the second, larger, version of his *Nude descending a Staircase* (*Ill. 117*). Almost certainly conceived independently of futurism, it incorporates movement and a machine analogy more completely and effectively than any Italian picture. Duchamp's interest in slow-motion photograph helped him translate his interpretation of body movements into a quasi-mechanical drawing. He developed this mechanistic anatomy in *The Bride Stripped Bare by her Bachelors, Even*, which was conceived in 1912, begun in New York in 1915, and abandoned in an unfinished state in 1923 (*Ill. 118*). Here, with wire, oil paint and lead foil applied to glass panels, Duchamp translates the act of copulation into a diagram of pseudo-machine parts working

116 ROBERT DELAUNAY (1885–1941) *Discs: Sun and Moon, 1912–13. Oil on canvas, diam. 4′ 5″ (135). Collection Stedelijk Museum, Amsterdam*

117 MARCEL DUCHAMP (1887–
1968) *Nude descending a Staircase II,
1911–12. Oil on canvas, 4' 10" ×
2' 11" (147 × 89). The Philadel; ,ia
Museum of Art (Louise and Wal ,r
Arensberg Collection)*

together harmoniously. The implications of this erotic masterpiece will be considered later: it is important here to stress its source in cubist painting of the immediately pre-war period. For if we reflect that Mondrian's development of a totally abstract art, and the revolutionary movements of suprematism and constructivism in Russia are also dependent on paintings that were done in Paris between 1910 and 1914, the claim that almost all of 20th century art has its roots in this particular moment would seem to be justified.

Because of the total nature of the war that broke out in the summer of 1914 and the resultant large-scale mobilization, the development of art was affected as never before. Twenty-five years later, with World War II, European painting was again dealt a blow from which it has yet to recover. On both occasions, for most young men painting simply stopped, and often they faced insuperable problems in starting again. A few were able to put their war-time experience to good effect – Léger claimed to have found a new reality in his contacts with ordinary French people, and in his enforced familiarity with military equipment, but he was the exception. For too many good painters, whether they were actively involved or not, the war was a disaster, after which they were never able to paint so well again.

Innovations in art usually come from young men, and with the French, Germans, Italians and English serving in their respective armies, little could be expected from them. This caused the first major dispersal in the history of modern painting. Now that Paris was engaged in war, it was from Mondrian in Holland, Malevich in Moscow, Duchamp in New York, and Arp and the Dadaists in Zürich that the new ideas came.

Indeed in Paris there had already begun the retrenchment which was to become a widespread tendency in the 1920s. Picasso, as a Spaniard, was not directly involved in the war, and in a mood of escapism entered into a love affair with the Diaghilev ballet company, like himself rootless and aristocratic refugees from the war. His life and his work were affected in many different ways: most fundamental, perhaps, was the sharpening of his concept of the artist as actor, playing a succession of often antagonistic parts, which dominates all of his post-cubist activities.

It was another Spaniard who, with the sculptor Lipchitz, made the only real contribution to cubism in the war years – Juan Gris (1887–1927), a friend and protégé of Picasso's. Gris came into cubism in 1912 at the synthetic stage, which was a way of painting perhaps temperamentally more sympathetic to him than to either Braque or Picasso. He at once began to use such mathe-matical formulae as the golden section in the planning of his still-lifes. It was clear that abstract proportions played a greater role in such pictures as the *Chessboard* of 1915 (*Ill. 119*) than actual shapes; or rather that he chose objects, like the chessboard, for abstract reasons.

Gris's description of his own practice is the classic definition of the final phase of synthetic cubism: 'I try to make concrete that which is abstract . . . Mine is an art of synthesis, of education . . . Cézanne turns a bottle into a cylinder, but I begin with a cylinder and create an individual of a special type: I make a bottle – a particular bottle – out of a cylinder. That is why I compose with abstractions (colours) and make my adjustments when these colours have assumed the form of objects.'

This statement of Gris's first appeared in 1921 in the magazine *L'Esprit Nouveau*, which was edited by Amédée Ozenfant (1886–1966) and the Swiss painter-architect Charles-Edouard Jeanneret, better known as Le Corbusier (1888–1965). They had reacted against the pretty, rococo cubist still-lifes and the disturbing figure subjects (e.g. *Ill. 111*) that Picasso was painting around 1914, and against the way in which cubism was becoming a mannered, decorative style in the hands of its minor practitioners. Only Gris's obsession with mathematics and Léger's fascination with the machine seemed to point the way forward. Out of this situation purism was born. A typical purist still-life of 1920 by Ozenfant (*Ill. 120*) is impersonal in form and content. That picturesque selection of café and studio properties that satisfied Picasso as the raw material for still-life paint-ing is here replaced by a careful choice of obviously machine-made utensils. And the design, with its careful arrangement of shapes and its precise contours, demon-strates the same concern for order and rationality that industrial design, in theory at least, ought to possess. The purists were every bit as idealistic as the abstract painters of De Stijl (see Chapter Seven), whose work they para-doxically found so inhuman.

119 JUAN GRIS (1887–1927) *Chessboard, 1915.* Oil on canvas, 36¼″ × 28¾″ (92 × 73). Courtesy of the Art Institute of Chicago (Gift of Mrs Leigh Block with a contribution from the Ada Turnbull Hertle Fund)

(Opposite)
118 MARCEL DUCHAMP (1887–1968) *The Bride Stripped Bare by her Bachelors, Even, 1915–23.* Oil and lead wire on glass, 9′1″ × 5′9″ (277.5 × 175.5). The Philadelphia Museum of Art (Louise and Walter Arensberg Collection, Bequest of Katherine S. Dreier)

120 AMÉDÉE OZENFANT (1886–1966) *Flask, Guitar, Glass and Bottle on a Grey Table, 1920.* Oil on canvas, 32″ × 39¾″ (81 × 101). Kunstmuseum, Basel

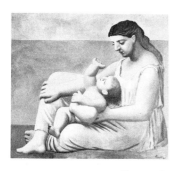

121 PABLO PICASSO (b. 1881) *Mother and Child*, 1921. *Oil on canvas*, 4'8½" × 5'4" (143.5 × 162.5). *Courtesy of the Art Institute of Chicago (Mary and Leigh Block Charitable Foundation; Maymar Corporation; Mrs Maurice L. Rothschild, Mr and Mrs Edwin E. Hokin, Hertle Fund)*

122 PABLO PICASSO (b. 1881) *Guernica*, 1937. *Oil on canvas*, 11' × 23'4" (351 × 872). *Collection Museum of Modern Art, New York (On extended loan from the Artist)*

Both movements were a part of the neo-classicism that affected all the arts in Europe after the end of World War I. A recall to order was the rallying cry. Experiment, as had been practised so avidly in the ten years from 1905 to 1915, was out of fashion; what was needed now was calm, logic, an absence of rhetoric. For a few years until the disruptive advent of surrealism, order was all.

Nobody was more sensitive to this new mood than Picasso himself. Given to playing several roles as an artist, he not only continued to design post-cubist still-life and figure compositions which possess greater clarity and less passion than before; he also painted a series of frankly figurative 'classical' paintings, which at first seemed like a renunciation of all his experimentation from 1906 onwards. In the over-life-size *Mother and Child* of 1921 (*Ill. 121*), the woman, wearing a simple shift, rests on a timeless anonymous shore: the child's gesture responds to her tender glance. The forms of the colossal figures are given great amplitude, so that the mother and her child become not just a portrait of Picasso's wife and infant son but an image of maternity; Picasso here succeeds in raising his private emotions to the level of universal human statement.

This happened again in 1937, when Picasso was invited to paint a mural for the Spanish Republican Government pavilion at the Paris exhibition. Outraged by the bombing of the Basque town of Guernica he made a public declaration (*Ill. 122*) that is unmistakable in its meaning, its message of outrage and of compassion for the victims of violence. Picasso here drew the disparate strands of his work together – the intense emotionalism of the early blue period, cubist disintegration and re-ordering of form in a new spatial context, the monu-

mental quality of the classic figures, and the private and in part subconscious symbolism that utilizes bullring imagery, which he was to develop alongside the surrealists in the later 1920s and 1930s. The artistic innovations of 20th-century art are here provided with what might be called a moral justification.

In general, however, Picasso's later work confronts us with a bewildering profusion of ideas that can both delight and make us despair. No great artist has been so prolific, so un-self-critical, so self-indulgent. 'I use things as my passions tell me,' he has said, and this is just the trouble, for everyday passions can be as trivial and as superficial as many of the later paintings, which are crude and insensitive in colour and design. But there are always shining exceptions, and as a draughtsman with pen or burin or lithographic crayon Picasso remains without equal. He displays such constant inventiveness and humour – qualities equally present in his sculpture – that for a moment one forgets the problems of evaluation raised by all his post-cubist work. For Picasso is like an

123 GEORGES BRAQUE (1882–1963) *Studio II, 1949. Oil on canvas, 4′5″ × 5′4″ (130 × 162). Kunst-sammlung Nordrhein-Westfalen, Dusseldorf*

125

old actor for whom the distinction between reality and illusion has become obscured: painting remains a compulsive act, but this protean jester leaves us with the uneasy feeling that he is rarely as committed to it as he was when a young man.

All this is particularly evident if one compares Picasso with his great French contemporaries, Matisse, Braque and Léger. They achieved that distinctive late style, in which artists of genius match a consummate technical mastery (albeit subject to physical limitations) with a heightened awareness, to display an artistic vision of greater strength and clarity than before. Matisse's view of life finds its ultimate expression in the cut-out paper designs (see *Ill. 91*) that he could only with great difficulty put together. We are still awaiting evidence that Picasso has reached that state of serenity.

After the exciting years of close association with Picasso, Braque elected for a life of concentration and reflection. Everything was to be subsumed into the act of painting. Braque's late works embody no set of values, avoid symbolism of any kind, and offer us nothing apart from a demonstration of what a painting is, and how it is created in space and time. This is the significance of the sequence of eight *Studio* pictures (*Ill 123*) painted between 1948 and 1955. The setting provides the objects needed to make the picture: they are quite impersonal, as Braque noted in his *Cahiers*, 'Objects do not exist for me except in so far as a harmonious relationship exists between them and also between them and myself. When one attains this harmony one reaches a sort of intellectual non-existence which makes everything possible and right.'

In seeking this harmony, the artist places objects in a space of his own making. This is a constantly changing process, because as the picture progresses all the relation-ships change. Finally, there is nothing more to be said, and one stops. Braque's best paintings are like the sonnets of Mallarmé, works of formal perfection made out of depersonalized fragments of experience, and imbued with a mysterious sense of the impermanence of the world as compared with the permanence of art.

Braque was one of the first painters to attempt to transcend Romanticism, showing how a break can be made with attitudes that have dominated European thought for more than a century. How far this can be

124 FERNAND LÉGER (1881–1955) *Les Loisirs: Homage to Louis David, 1948–49. Oil on canvas, 5′1″ × 6′1″ (154 × 185). Musée d'Art Moderne, Paris*

achieved is still an open question, given human inability to unlearn what had already been experienced, but that it is worth a try, perhaps Picasso's dilemma makes plain.

When Léger gave *Les Loisirs* of 1948 (*Ill. 124*) a subtitle: *Homage to Louis David,* he too suggested a return to the painting that immediately precedes Romanticism as a prime objective of his art. For Léger was a communist, and the magisterial figure compositions of the last years – *The Cyclists, The Construction Workers* (1950), *The Country Outing* (1954) and *The Grand Parade* (1954) – proffer a vision of a new and socially just society: the view of man given here is an explicitly post-Romantic one. We understand now that the obsession with the machine was a means to an end – a way of getting rid of the idea of the artist as an isolated man of genius, a hero figure, cut off from society and cultivating his own personality.

Léger's ordinary people, at work and at play, show the same freedom evinced by the dissociation of colour and form in the paintings. But paradoxically, for all its theoretical proletarianism, Léger's remains a sophisticated, intellectual art. This is in no way to denigrate its quality, or to belittle Léger's major contribution to the development of cubism. In certain mural paintings at least he carried cubism into pure abstraction, though it was left to Mondrian to make the decisive step in this direction, and to offer in his work a clearer vision of a new society than Léger was able to attain.

125 VASSILY KANDINSKY (1866–1944) *Study for Composition IV*, 1911. Oil on canvas, 3′1″ × 4′5″ (95 × 128). The Tate Gallery, London

126 KASIMIR MALEVICH (1878–1935) *Suprematist Composition: Airplane Flying*, 1914. Oil on canvas, 23″ × 19″ (56.5 × 48.5). Collection The Museum of Modern Art, New York

Abstract art was the inevitable result of the reaction against naturalism that began in the 1880s. As we have seen, it took two main directions, according to whether the emphasis was placed on content or on form. In the first category were the symbolists, with their emphasis on the spiritual meaning of painting; in the second were the post-impressionists, who did not deny art its spiritual rôle but thought that a renewal of pictorial language should come first. It needed a particular conjunction of both streams for abstract art to emerge.

It is perfectly clear that art grew more *abstracted* in the last decades of the 19th century and the first of this, but that is not quite the same thing as a totally *abstract* art, which for all this time was no more than an unattainable idea. An original concept is unthinkable until it occurs to somebody: from that moment on it tends to be a commonplace. This is what happened with abstract art, and the two men who can really be said to have invented a new kind of painting were Kandinsky and Mondrian. Unlike Picasso and Braque in the making of cubism, they worked independently and their painting has nothing in common stylistically. But Kandinsky provided the philosophical justification for an abstract art and Mondrian showed what it could look like.

The story begins with the exhibition in Moscow in the late 1890s of one of Monet's *Haystack* paintings. It was seen by a young Russian intellectual, Vassily Kandinsky (1866–1944), on whom it left a lasting impression. As he said many years later: 'Deep inside me was born the first faint doubt as to the importance of an "object" as the necessary element in painting.' Kandinsky suspected what now seems plain, that in the *Haystack* pictures, like the contemporary series of *Cathedrals*, Monet was more concerned with recording his own changing perceptions than with depicting the object.

It was not until 1910, however, that Kandinsky felt ready to postulate the objectless picture. He had left Russia to settle in Munich, and soon became a leader of the German *avant-garde*; he spent some months in Paris, where he was able to familiarize himself with French developments up to and including the fauve paintings of Matisse. This gave him the further necessary clues; he realized that colour had been the first constituent of painting to be 'liberated', particularly in the work of Gauguin and Van Gogh, who had found it easier to paint grass red than to distort the forms of a house or a figure. He also perceived that lines as well as colours could have symbolic meanings, and it is likely that he made a serious study of Seurat's ideas in this area. In fact, Seurat's theorizing about the different elements of painting – colour, line, tone, composition, rhythm – almost adumbrated an abstract art.

In his own paintings, Kandinsky concentrated on colour, which he saw as the prime liberating factor, with its own expressive power. He painted landscapes of the countryside around Munich, like the *Painting with Houses* of 1909 (*Ill. 127*). It was this picture, or one very like it, which gave rise to another decisive moment in his development. He has told us in his own words what happened:

'I was returning from my sketching, deep in thought, when, on opening the studio door, I was suddenly confronted with a picture of indescribable incandescent loveliness. Bewildered, I stopped, staring at it. The painting lacked all subject, depicted no recognizable object and was entirely composed of bright patches of colour. Finally I approached closer, and only then recognized it for what it really was – my own painting, standing on its side on the easel . . .

'One thing became clear to me – that objectiveness, the depiction of objects, needed no place in my paintings and was indeed harmful to them.'

The main problem, however, was how to create a non-objective picture that was not simply pattern or decoration. What form would it take, and what would it mean? These were the two questions that now preoccupied Kandinsky.

As far as the picture's appearance was concerned, Kandinsky determined to push the abstracting process

as far as it would go, hoping that in doing so he would evolve an independent and abstract pictorial language. The *Study for Composition IV* of 1911 (*Ill. 125*) shows him at the mid-way stage, where every shape in the picture still has a recognizable source. The subject is a battle between Russian warriors in mountainous country – a dream-like fairy-tale setting which had always fascinated Kandinsky. At first glance perhaps the picture looks as abstract as the one on Kandinsky's easel, but after a little contemplation it can easily be deciphered. In the centre are two horsemen, armed with lances, locked in conflict; on the right are red-hatted pike-men; in the background a castle with a great entrance; in the sky a flock of birds; sun and falling rain account for the rainbow; and so on.

127 VASSILY KANDINSKY (1866–1944) *Painting with Houses,* 1909. *Oil on canvas,* 3′ 2″ × 4′ 6″ (97 × 130). *Collection Stedelijk Museum, Amsterdam*

Kandinsky also introduces some interesting innovations. He suppresses the line of the horizon, which is the dominant line in landscape painting; the mountain scenery gives him an excuse to break it up into diagonals. This immediately affects the whole space of the painting – gone is that ever-present, restful, dividing horizontal, which is so familiar that we overlook its psychological significance; instead, there is pictorial space organized on an all-over basis, as in cubist painting.

Line and colour begin to take on an independent existence. Lines break away, creating dynamism and setting up rhythms which act and interact across the surface. Colour alone expresses form, in terms of flat planes, parallel to the picture surface, hovering in an indeterminate space. Objects and landscapes are no longer lit from an outside source: the light comes from the colour itself. Composition is the all-important unifying force. Kandinsky had begun to give all his pictures abstract musical titles: *improvisations, studies,* and *compositions* for the seven major pictures of the 1910–14 period.

By the time he had reached the enormous *Composition VII* (*Ill. 128*), late in 1913, Kandinsky considered himself at the threshold of abstraction. Yet subject-matter persists. For this is a resurrection painting, the culmination of a series of *Last Judgments, Deluges, All Saints' Days* and similar compositions in which Kandinsky's apocalyptic, visionary imagination is at work. Like the contemporary *Fate of Animals* (*Ill. 101*) of his friend Franz Marc, *Composition VII* seems prophetic of the

128 VASSILY KANDINSKY (1866–1944) *Composition VII,* 1913. *Oil on canvas, 6'7" × 9'10" (200 × 300). Tretyakov Gallery, Moscow*

impending war: there is both a desperate unease and a cry for spiritual revelation in the painting, as if it were an image of the struggle between good and evil.

Kandinsky was a man of great energy and drive. He was interested in the relationships between all the arts, and explored equivalence between colour and sound and action in short plays entitled *Green Sound* and *Yellow Sound.* He was a natural leader, and in Munich organized one *avant-garde* art society after another, culminating in 1911 with the expressionist group, the *Blaue Reiter.* The name comes from the title of one of Kandinsky's early pictures: it was chosen because he liked the image of the horseman, which for him symbolized the artist's aspirations, and because Marc liked the colour blue.

Most important of Kandinsky's extra activities was his theoretical writing, and in particular his essay of 1910–11, *Über das Geistige in der Kunst* (*Concerning the Spiritual in Art*), which in effect justified the development towards the abstract which he was contemplating in his painting. His argument is more emotional than rational, and can easily be faulted, but it does give us Kandinsky's definition of a non-objective painting, and thus answers the question posed earlier in this chapter.

Kandinsky considers the meaning of the painting from two angles – psychological and spiritual. He discusses at some length the effects that colours have upon us, inviting general agreement for the proposition that blue is a heavenly colour; that green is restful, 'lacking any undertone of joy, grief and passion'; that yellow is aggressive and dynamic; and so on. Like Seurat,

he goes on to associate colours with linear directions, and later, in another essay, with forms, because colour in painting must assume some form. Kandinsky believed that these 'form and colour combinations' had intrinsic expressive significance. In such paintings as *With the Black Arch* (1913, *Ill. 129*), he tries to isolate them without reference to the forms from which they derive: as we have already seen this is not completely successful, and only later in his career was he able to invent totally abstract forms.

In both painting and writing in these years, 1910–14, Kandinsky was a man struggling in the dark. He was aware of this – it is part of his historic importance that he admitted that neither the creation nor the appreciation of a work of art is an exclusively conscious process. The artist's urge to make the painting comes from what he called 'inner necessity'. Thus the artist is a kind of visionary, or seer, offering, through his work, glimpses of a reality more profound than the material world we know.

Kandinsky, a Russian Orthodox Christian of strong religious convictions, had, like so many of his generation, come to believe in the need for a spiritual revival in the materialistic West. He went further to feel, as did both Mondrian and Brancusi, that this could come about only through the study of the ancient teachings of the Hindu and Buddhist religions, which accepted the inter-penetration of physical and spiritual. After all, if the material appearance of nature was an illusion (and contemporary science was confirming this supposition), was not the artist justified in trying to discover some super-reality? Thus Kandinsky's attempt as a painter to break away from representation assumed tremendous importance – it had to be a way to a new kind of religious art of far greater human significance than anything hitherto practised. Hence Kandinsky's later remark that Michelangelo's Sistine ceiling depiction of God creating Adam was eclipsed for him by the meeting of a triangle and a circle.

Other artists were thinking along these same lines. Every late 19th-century artistic development seemed to point towards increasing abstraction, but, as we have seen, the implications of this could be interpreted in different ways. It was from the conjunction of French post-impressionism with a symbolist belief in the spiritual

129 VASSILY KANDINSKY (1866–1944) *With the Black Arch, 1913. Oil on canvas, 6′2″ × 6′5″ (188 × 195.5). Collection Madame Nina Kandinsky, Paris*

133

130 FRANK KUPKA (1871–1957)
Amorpha, Fugue for two Colours,
1912. Oil on canvas, 6′11″×7′3″
(211 × 220). National Gallery,
Prague

131 GIACOMO BALLA (1874–
1958) *Mercury passing before the
Sun,* 1914. Tempera on canvas,
39⅜″ × 47¼″ (100 × 120). Col-
lection Mattioli, Milan

values of art that abstract art emerged. One without the
other was not enough, as Kandinsky saw very clearly.
Artists primarily concerned with formal problems, like
Picasso and Braque and Matisse, could not conceive of
an objectless painting except as pure decoration, whereas
many late symbolists, particularly in France and Russia,
were ambitiously and unsuccessfully trying to paint
pictorial equivalents of music or architecture, or repre-
sentations of the origins of life and of the universe.

Working in Paris, in contact with Delaunay and
Duchamp, the Czech painter, Frank Kupka (1871–
1957), pursued all these ideas, calling the results *Fugue,
Philosophic Architecture, Creation, Cosmic Spring* and the
like. But the few pictures that he exhibited at this time –
for example *Amorpha, Fugue for two Colours* (1912, but
subsequently repainted: *Ill. 130*) at the Autumn Salon
of 1912 – attracted no public attention and influenced no
other painter. In any case, the forms of the *Amorpha,
Fugue* painting can be easily traced back to Kupka's
earlier pictures of a girl with a multi-coloured ball; and
slightly later work, like *Vertical Planes III* and *Solo of a
Brown Line,* shown in 1913, probably confirmed the
universally-held Parisian belief that a wholly abstract art
could only be meaningless pattern-making. Even De-
launay's *Discs* (*Ill. 116*), like certain contemporary works
of the Italian futurist, Giacomo Balla (1871–1958;
Ill. 131) are properly regarded either as cosmic symbolism
or as straightforward pictorial exercises, but not as true
abstract paintings.

It is important to make this distinction, and to establish
clearly the difference between abstracted and abstract
(i.e. non-representational) paintings, if only to appreciate
the crucial historical position of Mondrian. Kandinsky's
uncertainty about the practical application of his
theories was demonstrated during his return to Russia
during the war, when he found other painters experiment-
ing with abstraction and fell under their influence.

The outstanding personality in Moscow was Kasimir
Malevich (1878–1935), who by 1913 had worked
through impressionism, symbolism, primitivism, cubism
and futurism to reach the stage of what he called 'non-
sense realism'. In the *Woman beside an Advertising Pillar* of
1914 (*Ill. 132*), Malevich is in process of converting a
playful use of cubist collage and *trompe-l'œil* into some-
thing more rigorous by the introduction of painted squares

and rectangles. These later became the elements of supre-
matism, the ultimate destination of Malevich's pictorial
development, allegedly first demonstrated in the back-
drop of a futurist opera, *Victory over the Sun*, performed
at St Petersburg in December 1913. The first suprematist
pictures, including *Black Square on a White Ground*, were
exhibited in December 1915: the date of their actual
execution is uncertain.

Malevich's rejection of the objective world was much
more thoroughgoing than Kandinsky's. He defined
suprematism as 'the supremacy of feeling in art', and
invented a vocabulary of regular shapes to serve as
equivalents for physical sensations. Suprematist paintings
can be attempts to define and extend this new formal
vocabulary, or to represent feelings; for example, a
painting with a diagonal arrangement of slim rectangles
across the canvas is called *Airplane Flying* (*Ill. 126*).
The sensation paintings can be quite elaborate in design,
presumably attempting a pictorial analogue for complex
feelings, but Malevich must have been immediately
confronted with the intractable problem of interpretation.
Can there be an objective reading of such works?

Malevich's younger followers, like El Lissitzky (1890–1941), were inclined to think not, but could see how such formal arrangements might be usefully adapted to serve architecture and design (see p. 208).

Malevich himself clung to a mystical view of art. A devout Christian, his paintings aspire to the form of the cross, and to the virginal purity of the colour white. Thus the culmination of suprematism (and apparently Malevich's last picture) is the *White Cross on a White Ground* of 1918. After this there was nothing more for Malevich to paint, so he stopped. In the early 1920s he made some abstract architectural models (*Ill. 198*) which unquestionably helped to shape the developing international style in architecture, but his contribution to fine art was at an end.

Almost all the painters who launched out at some kind of abstraction in the years after 1910 found themselves in a similar impasse. Formally they were confronted with a limited and sometimes arbitrary pictorial vocabulary, and it became difficult to justify the assertions made for the meaning of abstract pictures. There was an evident relevance for design and architecture, as the Russians and later the Germans realized, but this seemed to be the only possible application of the abstract experiments of 1910–18. And had it not been for the persistence of the Dutch painter, Piet Mondrian (1872–1944), abstract art might have disappeared entirely.

The pattern of Mondrian's career is very similar to Kandinsky's: he follows a parallel course with a comparable end in view. As a young artist he had been attracted by both naturalism and symbolism, each of which had a strong following in the Netherlands. Then his work had an expressionist phase when nature was charged with the painter's emotions, conveyed in the colours and forms of clouds, trees, haystacks and sand dunes. Windmills, lighthouses and church towers stand isolated yet illuminated, emblems of the painter himself. Mondrian went through a religious crisis, and came into contact with Rudolf Steiner and the theosophists. Like Kandinsky, he shared their interest in Oriental religion, and their belief that this source alone could nurture the great spiritual rebirth of the West.

The *Evolution Triptych* of 1910–11 (*Ill. 133*) is a theosophical altarpiece: it has that magic triadic structure that other symbolist painters made use of – for example,

Munch in his *Dance of Life* (*Ill. 80*). A figure stands in a
state of trance, attaining spiritual illumination; the
dominant colour is a heavenly blue, with yellow stars
and passion flowers. It is a most curious picture, which
marked for Mondrian the turning-point from symbolism
to abstraction. The title, *Evolution*, is a cryptic one –
Mondrian throws some light on the reasons for his choice
in a 1914 notebook entry:

'Two roads lead to the spiritual: the road of doctrinal
teaching, of direct exercise (meditation, etc.), and the
slow but certain road of evolution. One sees in art the
slow growth of spirituality, of which the artists them-
selves are unconscious.

'To approach the spiritual in art.'

Paradoxically, the triptych does not in fact illustrate the
slow road of evolution: it is an attempt to get quick
results, a doctrinal picture, an immediate incentive to
meditation. Mondrian found that he had to take another
path if his aims were to be realized.

He began by making a special study of the paintings
of Cézanne and, early in 1912, moved to Paris so that

*133 PIET MONDRIAN (1872–
1944) Evolution Triptych, 1910–11.
Oil on canvas, each 5'10" × 2'9"
(178 × 85). Gemeentemuseum, The
Hague*

134 PIET MONDRIAN (1872–
1944) *Tableau No. I, 1913. Oil on
canvas,* 37¾″ × 25¼″ *(96 × 64).
Rijksmuseum Kröller Müller, Otterlo*

he could identify with that progression of French painting
which leads from impressionism to analytical cubism. No
outsider ever painted such convincing cubist pictures:
some are so close to Braque and Picasso's work of 1910–12
as to be almost indistinguishable. It was the hermetic,
most abstracted phase of analytical cubism that interested
Mondrian; so too did the experimental *Contrast of Forms*
pictures that Léger was painting, with their primary
colours, rhythmic movement and simple contrasting
shapes.

Mondrian's work in this first Paris period is abstracted,
not abstract painting. True, cubist analysis is taken to an
extreme, where the subject all but disappears into the
texture of the painting. But there are always clues left
behind, and the pictures can be grouped together
according to the limited number of subjects from which
they formally derive – the single tree, the church façade,
the Paris buildings with hoardings or scaffoldings. The
painting that Mondrian called *Tableau No. 1 (Ill. 134)*
is based on a façade: the structural elements are empha-
sized by exaggeration of horizontal and vertical lines.
The composition fades at the corners: it seems to grow
outward from the centre, an effect that is later to assume
great importance in Mondrian's work.

Mondrian exhibited *Tableau No. 1* in Amsterdam in
the autumn of 1913. He kept in close touch with
Holland, and was at home in the summer of 1914 when
war broke out. Prevented from returning to Paris, and
away from the stimulus of its intensive artistic activity,
Mondrian now had time to consider the position he had
reached. Living by the sea, he painted the *Pier and Ocean*
pictures *(Ill. 135)*. Traditional perspective is here
eliminated in favour of a new concept of space in which
atmospheric effects disappear and the picture surface
pulsates with a rhythmic pattern of linear forms. The
Pier and Ocean pictures are also known as *Plus and Minus
Compositions,* for the very good reason that the formal
elements begin to take on a life of their own.

Even so, Mondrian was still not satisfied. As he later
wrote: 'Looking at the sea, sky and stars, I represented
them through a multiplicity of crosses. I was impressed
by the greatness of nature, and I tried to express expansion,
repose, unity . . . But I felt that I still worked as an
impressionist, and expressed a particular feeling, not
reality *as it is.*'

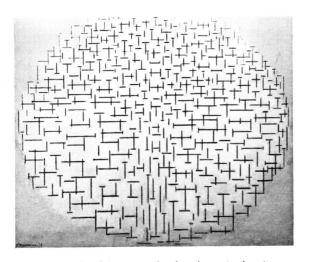

135 PIET MONDRIAN (1872–1944) *Composition No. 10: Pier and Ocean, 1915. Oil on canvas, 33½" × 42½" (85 × 108). Rijks-museum Kröller Müller, Otterlo*

In 1916 Mondrian completed only a single picture. He told a friend that he considered his work finished; his artistic development seemed to have come almost to a halt. If one took the abstracting process to its logical end, but one remained an impressionist, as Mondrian admitted he was, what could the next step be? He was in precisely the position that Braque and Picasso found themselves at the end of 1911, when analytical cubism reached the point at which they had to choose between giving up the link with the object altogether, or making some new connection between painting and reality.

Mondrian, however, still believed in the possibility of an objectless picture that was not a pattern or a piece of decoration. Just at this point he happened to meet a former Catholic priest turned theosophist, M. H. J. Schoenmaekers, who was propounding a neo-Platonic system which he called Positive Mysticism, or Plastic Mathematics. Schoenmaekers claimed that his system would enable its initiates 'to penetrate, by contemplation, the hidden construction of reality'. Plastic Mathematics depends on the resolution of a fundamental pattern of contradictions – active and passive, male and female, space and time, darkness and light, and so on – in its geometrical reduction of horizontal and vertical. These in turn were related to cosmic forces – the vertical to the rays from the sun, and the horizontal to the earth's constant movement around the sun. Schoenmaekers also concerned himself with colour: he recognized the

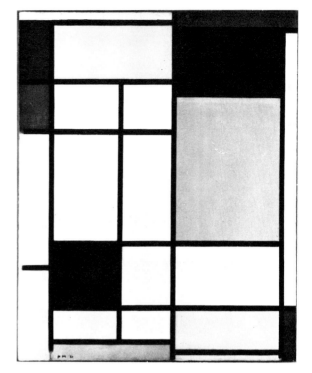

136 PIET MONDRIAN (1872–1944) *Composition in Red, Yellow and Blue, 1921.* Oil on canvas, 31½″ × 19½″ (80 × 50). Gemeente-museum, The Hague

existence of only the three primaries. Yellow for him was the radiant movement of the sun's beam and blue the infinite expanse of space; the contrasting colour, red, was the median, mating colour.

Schoenmaekers had no more interest in the visual arts than the theosophists, Mrs Annie Besant and the Rev. C. W. Leadbeater, who had provided abstract thought forms to meditate upon. But for Mondrian these ideas were a revelation, because they provided what all the other near-abstract artists had been unable to discover – a way of investing a painting with spiritual significance without external reference. The symbolic meaning that prevents abstract art from being no more than aimless pattern-making is inherent in the work itself. This is because, according to Schoenmaekers, the spiritual is best expressed in such pure plastic terms as the primary colours, and the contrast of darkness and light, of horizontal and vertical.

It took Mondrian a year or two to apply these ideas to his own painting, with results that can be best described as the invention of abstract art. He suspended coloured

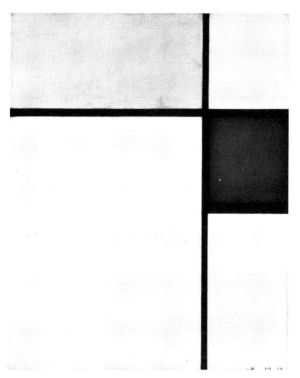

137 PIET MONDRIAN (1872–
1944) *Composition with Blue and
Yellow, 1932.* Oil on canvas,
16¼″ × 13″ (41.5 × 33). The Phila-
delphia Museum of Art (A. E.
Gallatin Collection)

rectangles against a white ground; he made the forms
overlap, and then held them with a grid that covers the
entire picture surface. In the lozenge pictures of 1919 he
broke away from the traditional rectangular picture
format, only to revert to it almost immediately. Finally,
by 1921, he had found the kind of composition that
adhered to his basic principles: three primary colours,
three tones (black, grey, white), and the symbolic
opposition of horizontal and vertical. The lines inevitably
produce rectangular planes, and whether a Mondrian
painting like the *Composition in Red, Yellow and Blue*
of 1921 (*Ill. 136*) is a pattern of coloured rectangles on a
black ground or a grid of black lines against coloured
space is part of the essential ambiguity, the ultimate
mystery of any work of art.

Like Kandinsky, Mondrian felt it necessary to use
words to defend his artistic position. In a series of articles
he defined neo-plasticism, as he called his new kind of
painting, adapting a term from Schoenmaekers. Neo-
plasticism transcends romanticism and expressionism,
because it takes art beyond the personal, and one of

Mondrian's main objectives is to eliminate the ego in art. It is the universal force within us all that art should be concerned with: our deep, unconscious responses to the world we inhabit. The aim of neo-plastic art is to achieve harmony and balance: disequilibrium creates tragedy, which is 'a curse to mankind'. Thus Mondrian's art is revealed as essentially utopian. As he said, 'The new way of seeing . . . must lead to a new society, as it led to a new art: a society combining two elements of equivalent value, the material and the spiritual. A society of harmonious proportions.' The paintings proffer this ideal of universal concord; they are balanced, ordered, optimistic, embodying the human values of non-violence, serenity and clarity. 'In the vital reality of the abstract,' Mondrian claimed, 'the new man has out-grown the sentiments of nostalgia, joy, rapture, sadness, horror, etc.: in the emotion made constant by beauty these are rendered pure and clarified.'

As with Matisse, this anti-tragic orientation necessarily limits the emotional appeal of Mondrian's art: it has no purgative function. In the *Composition with Blue and Yellow* of 1932 (*Ill. 137*) there is a suggestion of a cruciform composition, and the absolute simplicity, purity and rightness of the work may invite a religious analogy, but, unlike Malevich, Mondrian was not tempted into regarding his paintings as Christian icons. Clearly one might interpret the meeting of vertical and horizontal as symbolic of salvation and damnation, life and death, light and darkness, male and female or any other pair of oppositions, but the paintings exist as self-sufficient objects, representing nothing but themselves. They are full of ambiguities – for example, though strictly confined to the picture rectangle, the planes and black lines of the compositions are infinitely extendable. Space loses its illusionistic quality, and becomes some-thing inseparable from the forms in the picture, yet we are always uncertain of the relative situation of one element *vis-à-vis* another.

Despite the apparent limitations of his pictorial vocabulary, and the fact that he seemed to have arrived at a final statement in the mid-1920s, Mondrian persisted in defining the law of his own artistic development as 'always further'. After a period of simplicity with the white square dominating the composition, came the repeated black horizontals and verticals of the late Paris

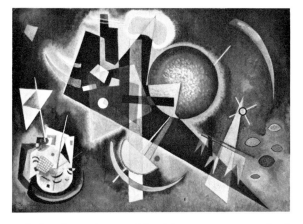

138 VASSILY KANDINSKY
(1866–1944) *In Blue, 1925. Oil on
cardboard, 31½" × 43¼" (49 × 110).
Kunstsammlung Nordrhein-West-
falen, Dusseldorf*

and London pictures. Mondrian was a committed
city-dweller: the greens and browns of nature had no
more place in his life than in his art. He spent his last
years in New York, and *Broadway Boogie-Woogie* of
1942–43 (*Ill. 139*) shows him capable of a new response
to a new situation. Static balance gives way to a more
dynamic equilibrium. That obsession with the rhythmic
throb of existence, evident in the *Pier and Ocean* pictures,
now returns in the rectangles of pure colour that displace
the black lines. Mondrian came to regard his earlier
work as 'drawing in oil', implying that this final
insistence on colour points the way forward for painting.

Mondrian's influence, direct and indirect, has been
considerable, possibly greater than any other 20th-
century artist. In 1917 it was already obvious to Theo
van Doesburg (born C. E. M. Küpper, 1883–1931)
that the principles of the new abstract painting and the
new plastic awareness were applicable to both archi-
tecture and design. He conceived of an all-embracing
modern style, entirely devoid of ornament, and based on
three primary colours and on the right angle – and thus
on rectangles and cubes. It was a fundamental enough
conception to be called simply *De Stijl* (style), and this
was the name of the movement and of the monthly
magazine through which the indefatigable van Doesburg
disseminated his ideas.

In post-war Europe there was an irresistible attraction
in this revolutionary new beginning which swept aside
the now-tarnished romantic individualism of expression-
ist art and architecture with a vision of an ideal and

universal just society. In 1920–21 van Doesburg trans-ferred his activities to the aesthetically fertile, war-scarred soil of Germany, and for a time *De Stijl* was published from Weimar. In 1923 he exhibited projects for *De Stijl* architecture in Paris, which caught the interest of Léger and Le Corbusier. Van Doesburg soon discovered that his point of view was close to that of the Russian con-structivist followers of the suprematist Malevich (e.g. Lissitzky) who were being driven out of Soviet Russia by an increasingly reactionary artistic policy. How the impact of these combined aesthetic philosophies transformed the most influential art and design school in Europe, Walter Gropius's Bauhaus at Weimar, and thereby revolutionized modern architecture, will be discussed in the last chapter.

The Bauhaus was also important as one of the few places to offer a haven for abstract painters, then and for many years an embattled minority facing public apathy and artistic hostility. Another Soviet refugee, Kandinsky, joined the teaching staff in 1922 and remained there until the school was closed by the Nazis in 1933. Kandinsky's Russian years (1914–21) had been relatively unproduc-tive, and largely occupied with the administration of art schools and museums. When he began to paint again, the influence on his work was clearly that of the younger suprematists and constructivists, Malevich in particular. The informal elements of the pre-1915 pictures are now disciplined into neat, geometric shapes – straight lines, regular curves, parallel bars, squares, circles, triangles.

Kandinsky's Bauhaus paintings, like such theoretical essays as *Point and Line to Plane* (1926), are the direct extension of his expressionist, Munich, period, and they continue to parallel Mondrian's development. But the later compositions conspicuously lack the serene simp-licity of Mondrian's neo-plasticism: they resolutely persist in their latent symbolism, offering suggestions of mysterious rituals and the movements of strange worlds. In the toy-like harbour and boats of *In Blue* (1925) (*Ill. 138*) Kandinsky shares the fantasy of his Bauhaus colleague, Paul Klee (see p. 159), but within the context of what might otherwise be regarded as an abstract composition they are a curiously disturbing element.

In his final period in Paris, from 1933 to 1944, Kandinsky also developed a distinctive decorative style, which revived certain art nouveau mannerisms (a whip-

lash line, for example), and drew on patterns and symbols from such exotic cultures as those of Egypt and pre-Columbian America. His rich and convoluted pictorial vocabulary becomes increasingly difficult to interpret: the personal isolation of his last years is reflected in this private hermetic language that altogether lacks the universality of Mondrian's abstract art.

Mondrian himself kept somewhat detached from van Doesburg's activities on the part of De Stijl – though he by no means disapproved of this radical extension of his ideas, which he thought equally applicable to literature, to the dance and to every field of human endeavour. Living in Paris from 1920 to 1938, he lent his support

139 PIET MONDRIAN (1872–1944) Broadway Boogie-Woogie, 1942–43. Oil on canvas, 4'2" × 4'2" (127 × 127). Collection Museum of Modern Art, New York

to those groups of abstract artists, like *Cercle et Carré* (Circle and Square) and *Abstraction-Création*, which offered the only real *avant-garde* opposition to the surrealists in the 1930s. Mondrian was always the outstanding painter member of such groups, though the sculptors associated with them included Brancusi, Arp and Gabo, whose work will be discussed later.

Slowly Mondrian's ideas spread to a younger generation, who found it possible to accept abstract art for itself, without needing to justify its existence as the emanation of some kind of spiritual force. Thus the abstract painting was seen as the embodiment of abstract qualities – vitality, serenity or what you will – that were consequently held up for our admiration. In a series of white reliefs in the 1930s, Ben Nicholson (born 1894) manipulated circles and rectangles on subtly carved shallow planes (*Ill. 140*), setting up a mysterious spatial movement that carries a poetic message of harmonious relationships. Nicholson had painted his first abstract pictures in 1924, but, like Mondrian himself, found that he needed the discipline of a study of Cézanne and of cubism before he could make the kind of statement he wanted.

140 BEN NICHOLSON (*b.* 1894) *White Relief, 1935. Oil on board, 3'4" × 5'6" (101.5 × 166.5). The Tate Gallery, London*

Though his meeting with Mondrian in 1934 was a revelation, Nicholson never saw the necessity for an exclusive commitment to an abstract art. Abstraction meant liberation for him, and he has felt free to continue to paint post-cubist still-life compositions, often imbued with the light and texture of landscape. Pursuing such an undogmatic approach, he has done much to show that abstraction is an extension, not a replacement of existing ways of painting. The same lesson is to be learned from Jean Dubuffet (born 1901), a very different kind of painter.

Though Mondrian had some close disciples in the United States, his influence was, again, more generalized and all-pervasive. Despite the superficial similarity between paintings by Jackson Pollock (1912–56) and those of Kandinsky executed between 1910 and 1914, it was Mondrian and not Kandinsky who had the respect and admiration of the so-called abstract expressionists. And Mondrian was of course one of the European wartime refugees present in New York when American art assumed international status. Even his final insistence on colour in painting seems to have found a response in the achievements of Mark Rothko (1903–70), Ad Reinhardt (1910–65) and Barnett Newman (1905–70), who all regarded painting as an heroic religious act. Rothko's paintings (*Ill. 142*) are about the working of colour in space, but they are, at a fundamental level, icons for contemplation and meditation. Reinhardt was a life-long student of Oriental art and philosophy, and his dark paintings (*Ill. 141*) adopt the symbolic cruciform composition, sometimes mystically translated into three-times-three squares of identical size. And Newman did not hesitate to call a sequence of enormous, spare, abstract canvases, each with a single vertical stripe on a plain ground, the *Stations of the Cross* (1960).

The spiritual ambitions of Kandinsky and Mondrian indeed spawned a continuing progeny.

141 AD REINHARDT (*b.* 1913) *Abstract Painting, Blue, 1952*. Oil on canvas, 29½″ × 11″ (75 × 28). *Museum of Art, Carnegie Institute, Pittsburgh*

142 MARK ROTHKO (1903-70) *Two Openings in Black over Wine*, 1958. Oil on canvas 8' 0" × 12' 6" (226 × 381). The Tate Gallery, London.

Exactly parallel with the development of abstract art runs another line of attack on the painting of the material world, one which begins with the work of visionary painters like Chagall and de Chirico, assumes a violently anti-art character in Dada, and finally emerges as a part of the international surrealist movement. Surrealism itself, it must be made clear, was neither an artistic style nor an aesthetic doctrine; it is best described as an attitude to life, a sort of religion, that if understood and accepted would bring about, it was believed, the economic and spiritual liberation of man. Its ideas were every bit as revolutionary and utopian as those of the abstract artists. But surrealism appealed to painters of a different temperament, and was romantic rather than classical in spirit, putting qualities of passion, intuition, feeling above reason, harmony and order.

Chagall and de Chirico arrived in Paris in 1910–11, young painters attracted by the reputation of modern French painting. They remained until the outbreak of war, and both caught Apollinaire's attention, for although he was a personal friend of the cubists, Apollinaire at heart preferred a more poetic, visionary art; he looked for artists who shared his ambitions and could find some way of transcending the everyday to reach the supreme state of what he called *sur-réalisme*. Apollinaire even called his farce, *Les Mamelles de Tirésias*, 'une drame Surréaliste', and by the time of his premature death in 1918 had sown the seeds of a new literary movement.

Me and the Village (1911; *Ill. 143*) was the kind of picture Apollinaire admired. Marc Chagall (born 1887) filled his canvases with images of his Russian-Jewish childhood – the wandering pedlar, the bearded rabbi, his eccentric violin-playing uncle, the farmhouses and farm animals. An immense nostalgia pervades his work; also a feeling that this world, left so far behind, expressed

in all its aspects a God-given joy that Paris could neither rival nor replace. It is of course the lost world of child-hood, a moment of innocence and revelation. Memories flood back in no rational order, nor are they submitted to any logic. Upside-down and truncated figures, mundane objects in unusual associations, enormous disparities of size and space – all are freely permitted.

If Chagall's early painting is inspired day-dreaming, Giorgio de Chirico (born 1888) presents us with the dream itself. The world he created in his Parisian years lacks the childlike ingenuousness of Chagall: in 1913 Apollinaire had already commented upon 'these strange landscapes full of new intentions, of powerful architecture and of great sensibility'. De Chirico had trained in Munich and knew the work of the German symbolists. He was also familiar with the philosophy of Nietzsche, and in his paintings tried to capture a particular Nietz-schean sense of foreboding and apprehension – the feeling that the superficial appearance of the exterior world concealed a different and a deeper reality. This was something enigmatic, something surprising to the artist himself. Yet he too drew on early memories: of Italian *piazze*, of Greek sculptures, of the railways which his father had engineered. The title alone of *Nostalgia of the Infinite* (1913; *Ill. 145*) reveals its intentions, as does the irrational juxtaposition of objects – visual metaphors designed to disturb.

André Breton, the theorist of surrealism, saw in these early paintings of de Chirico a remarkable representation of that state of inescapable loneliness and irremediable anxiety which he believed to be part of the human condition. In accordance with Freud's theories, Breton was later to interpret the towers and arcades, the trains and stations, as sexual symbols. But de Chirico himself had used the imagery in all innocence, and, as if frighten-ed by such interpretations, he has at times denounced his early works. After 1915 and the return to Italy he could never paint in the same way again.

During the war years de Chirico practised another kind of painting which he called metaphysical; in these works the images are moved beyond the physical, into a world where mannequins replace human beings, and banal *trompe l'œil* objects – matchboxes, fish, biscuits and loaves of bread – impose themselves unexpectedly on the pictorial space, blurring any distinction one tries

143 MARC CHAGALL (*b.* 1887) *Me and the Village, 1911. Oil on canvas,* 6′4″×5′ (193×152.5). *Collection Museum of Modern Art, New York (Mrs Simon Guggen-heim Fund)*

to make between illusion and reality (*Ill. 144*). Such objects are obsessions: the logic is that of the dream, outside of measurable time and in an inescapable menacing present that is about to disintegrate at any moment. Then, around 1919, the vision died, and, like Chagall, de Chirico was left to grow old with an essentially commonplace imagination.

Both Chagall and particularly de Chirico came to be regarded as precursors of surrealism because of their emphasis on the dream and the irrational. At the same time, certain works executed by Picasso in these immediately prewar years carried a comparably disturbing message. The *Woman in an Armchair* of 1913 (*Ill. 111*) marked the return of the assertive feminine image in Picasso's work after its neardisappearance at the height of hermetic cubism: it could only be regarded as a violent and erotic portent of the compulsive beauty to be sought by the surrealists. The cubist invention of collage and its extension into constructivism offered another way of approaching reality, carrying undertones of equivocation.

As we have seen, it was Marcel Duchamp who first asked awkward questions about the implications of these cubist practices; his scepticism was to culminate in his exhibiting signed readymade objects, like a hatstand or a urinal, which challenge us to deny that they are art at all. Such anarchic gestures were appropriate at the height of a world war, when civilized nations seemed to have plunged into an escalating lunacy in which all regard for the very human values they were meant to be defending had been lost. What could the artist do but protest? Duchamp had transferred his disruptive activities from Paris to New York, but in other neutral cities, Barcelona and Zürich in particular, other exiled poets and painters were meeting in the cafés, planning their antiwar, antibourgeois, antiart demonstrations. It was in the Cabaret Voltaire in Zürich, early in 1916, that Dada was born.

'Dada', said its inventor, the Rumanian poet, Tristan Tzara, 'signifies nothing'. But this initial nihilism was inevitably superseded by the positive action of art activity, and thus Dada began to develop as both protest movement and artistic philosophy. The most considerable artist associated with Zürich Dada was the Alsaceborn Hans (Jean) Arp (1887–1966), who had before 1914 been acquainted with both the French cubists and the

144 GIORGIO DE CHIRICO (*b.* 1888) *Grand Metaphysical Interior*, c. 1917. Oil on canvas, 37¾″ × 27½″ (96 × 69.5). Collection James Thrall Soby, New Cannaan, Conn.

145 GIORGIO DE CHIRICO (b. 1888) Nostalgia of the Infinite, 1913. Oil on canvas, 4′5″ × 2′2″ (135.5 ×64.5). Collection of Modern Art, New York

proto-abstract Munich *Blaue Reiter* painters. A refugee from the haphazard unreason of total war, Arp was, not surprisingly, preoccupied with the question posed by Mallarmé in his poem, *Un coup de dés n'abolira le hasard* – should we not allow for accident in artistic creation? Tearing up strips of coloured paper, Arp let the fragments fall at random; or he dropped a coil of rope upon the ground. It is clear from the *Collage with Squares arranged according to the Laws of Chance* of 1916–17 (*Ill. 146*) that the accidental did not altogether determine the composition: the squares are too neatly ordered for that. But Arp wanted to assert the principle that the laws of chance must be recognized as an essential part of the creative act. With an awareness of new thinking in psychology denied to Mallarmé he could be the more dogmatic. Exploitation of accident was one way of achieving the vital step of placing the unconscious in a fruitful relationship with art.

146 JEAN ARP (1887–1966) *Collage with Squares arranged according to the Laws of Chance, 1916–17. Collage of coloured papers, 19⅛″ × 13½″ (45.5 × 33.5). Collection Museum of Modern Art, New York*

Between 1918 and 1920 Dada spread from Zürich into Germany. In Berlin, racked by inflation and revolution, it assumed a political role: 'Dada is German Bolshevism' was the cry. The Berlin Dadaists were immediately responsive to the artistic manifestations of the new Soviet regime, and helped make Berlin the Russian channel to the West. Their original contribution was the extension of collage into photography with the invention of *photo montage*. This technique was at once used by John Heartfield (born Helmut Herzfelde, 1891–1968) for direct political ends, but its artistic effectiveness was quickly to be irrevocably diluted by commercial exploitation.

Most of the artists involved with Berlin Dada found that their desire to use art for social criticism led them inevitably to adopt more realistic styles, as if this were the only way of reaching a large audience. This is particularly clear in the case of George Grosz (1893–1959), who became a savage satirical cartoonist, pillorying the Prussian ruling caste of army officer, capitalist and priest with drawings redolent of violence, cruelty and degraded sexuality. At the same time, Grosz, like his contemporary Otto Dix (born 1891), adopted an exaggeratedly naturalistic style of portraiture in the manner of the German primitives (*Ill. 147*). Two labels were coined to describe this way of painting: *Neue Sachlichkeit* (New Objectivity) and Magic Realism. Both stress the return

147 GEORGE GROSZ (1893–1959) *Portrait of the Poet Max Hermann-Neisse, 1924. Oil on canvas, 39½″ × 36¾″ (100 × 93). Städtische Kunsthalle, Mannheim*

to the object, to content rather than to form, but in a suggestive, somewhat mysterious context which underlines the subterranean connexion with nascent surrealism.

In Hanover, Dada found a lone adherent in Kurt Schwitters (1887–1948), who abandoned expressionism to, as he saw it, free art from the tyranny of traditional materials. Anything served Schwitters for the making of a work of art, any sort of old rubbish, picked up from the street or out of the dustbin. In his constructions and collages (*Ill. 150*), Schwitters handled this discarded refuse with affection, selecting it for its formal qualities of shape, colour, texture, etc., but not hiding its original identity in any way. Thus a fragment of the letter-heading 'Kommerzbank' (Commercial Bank) provides a nonsense generic title – *merz* – for all of Schwitters' artistic activities, which include Merz poetry, Merz building and a Merz review.

Schwitters made Merz into a way of life. He was committed to the practice of his art, but to nothing else; it was a private business without any broader implications, resolutely anti-utopian, anti-idealist. His artistic sympathies lay not with the surrealists, but with the second, pragmatic, generation of abstract artists, and it was to van Doesburg and Lissitzky that he opened the pages of the Merz review. The formal aspect of Schwitters' work reflects this position; and, although accident is introduced into the artistic process, it is subjected, as with Arp, to a logical ordering on the artist's part. Seeking a quiet place to work, Schwitters moved from Germany to Norway in 1935, and in 1940 to London and then to the English Lake District, where he died in the obscurity that his exquisite art seemed to invite.

Cologne Dada was dominated by the personality of Max Ernst (born 1891). His wartime experiences in the German army had induced him to abandon academic study of philosophy and psychology (he already knew of Freud's theories) in order to 'find the myths of his time'. The only way Ernst could conceive of expressing these myths was by means of symbolic images, as in *The Elephant Celebes*, 1921, and *Oedipus Rex*, 1922 (*Ill. 148*) which possess undeniable hallucinatory power. The only precedent for such dislocation of the expected was set by de Chirico, whom Ernst revered, but from the beginning he was more successful in appealing to a collective unconscious, less trapped in private obsessions.

Ernst had had no training as a painter, and in a sense this would have been irrelevant to his art, which is a combination of esoteric book learning and autobiography, projected impersonally. He conceived of art as being 'beyond beauty and nature, beyond questions of good and bad taste.' Images exist everywhere to be used: thus art can as easily be made by the creative displacement of illustrations cut out of sale catalogues, scientific treatises, 19th-century pulp fiction, as it can by the spreading of paint over canvas. Self-analysis allowed Ernst an insight into his own motivations, and led him to concentrate upon that area hitherto almost forbidden to art, namely explicit sex. His early use of machine forms as analogues of male and female sexual organs confirms the pervasive influence of Marcel Duchamp in Dada circles immediately after the war.

148 MAX ERNST (b. 1891) Oedi-pus Rex, 1922. Oil on canvas, 35″×46″ (89 ×116.5). Private Collection, Paris

Ernst, however, quickly replaced machine by meta-phor, and, like Rossetti, sometimes added a poetic exegesis to the picture to make his intention absolutely clear. As if the visual imagery were not explicit enough, the prose poem pasted on the back of Les hommes n'en sauront rien (Of this men shall know nothing) of 1923 (Ill. 149) tells us that this is a picture about the harmon-ious balance of the sexes:

'The crescent (yellow and parachutic) stops the little whistle falling to the ground.
'The whistle . . . thinks it is climbing to the sun.
'The sun is divided into two so that it can revolve better.
'The right leg is bent . . .
'The hand hides the earth. Through this movement the earth takes on the importance of a sexual organ.
'The moon runs through its phases and eclipses with the utmost speed.'

Les hommes n'en sauront rien is dedicated to André Breton, who had first heard of 'Dadamax' in 1920, and arranged to show his work in Paris. Ernst's reputation spread quickly in French literary circles, and in 1922 he left Germany to settle in Paris. To old Dada friends like Arp and Tzara new ones were added – the poets Paul Eluard, Philippe Soupault, and above all André Breton. From this circle surrealism was born.

Its inventor and high priest, André Breton (1896–1966), was a complex character; like Marinetti he was a better publicist than poet. As a wartime medical auxiliary

149 MAX ERNST (b. 1891) Of this men shall know nothing, 1923. Oil on canvas, 31½″×25″(81 ×64). The Tate Gallery, London

150 KURT SCHWITTERS (1887–1948) *Merz 83 (Drawing F)*, *1920. Collage of cut paper wrappers, announcements and tickets, 5¾″ × 4½″ (14.5 × 11.5). Collection Museum of Modern Art, New York (Katherine S. Dreier Bequest)*

he had discovered that Freud's concept of the unconscious gave a demonstrably better explanation of the human psyche than anything previously offered; and in 1921 he called on Freud in Vienna. Not that their ideas were identical; for one thing, Breton already believed that the dream is paramount and has its own objective reality. A whole life-style was crystallizing in his mind. Despite his personal commitment to experimental poetry and his involvement in Dada manifestations in Paris, Breton was an earnest and serious-minded man. Even nihilism and anarchy finally succumb to the French desire for clarity and order. So reason is put to the service of unreason and out of anti-art comes the new art of surrealism.

The Surrealist Manifesto of 1924 can simplistically be regarded as a restatement of Romanticism, brought up to date by Breton's awareness of Freud. For Breton believed that the balance between reason and imagination, between conscious and unconscious, had been upset with deleterious results – most apparent in the 1914–18 war, which he had been fortunate enough to survive.

151 MAX ERNST (b. 1891) La Grande Forêt, 1927. Oil on canvas, 3′9″ × 4′10″ (114.5 × 146.4). Kunstmuseum, Basel

157

'Surrealism', he said, 'is based on the belief in the superior reality of certain forms of association hitherto neglected, in the omnipotence of the dream, in the disinterested play of thought.' He wished to give primacy to the feminine qualities of feeling and intuition, placing them above reason and logic: hence the anti-classical bias.

To achieve his aim, Breton proposed the systematic exploration of the unconscious, which is most obviously revealed in dreams. 'I believe in the future resolution of these two states, apparently so contradictory, which are dream and reality, into a kind of absolute reality – a super-reality, if one may call it such.' He suggested a technique for achieving this super-reality, this union of dream and reality: 'pure psychic *automatism*, by which it is intended to reveal the actual process of thought . . . in the absence of any control exercised by reason, and outside all aesthetic or moral preoccupations.' This idea had been adopted from Freud's use of automatic writing and of word association in the course of his psycho-analytical investigations. Breton had himself employed the technique on shell-shocked patients during the war, and realized that the images so obtained could be used to provide raw material for the artist.

With his poet friend Soupault, Breton from 1920 onwards experimented with automatic writing, and it soon became clear to them that – as in Coleridge's *Kubla Khan* – it is the visual imagery of dream-inspired or associational poetry that carries the power. Thus Breton, who conceived of surrealism as essentially a literary and philosophical movement came, a little unwillingly, to an acceptance of 'that lamentable expedient', painting.

No painter or sculptor signed the 1924 Manifesto, but several were mentioned as being surrealist, and with some others showed at the first surrealist exhibition in November 1925. Breton associated with the movement the names of Picasso, Duchamp, de Chirico, Klee, Ernst, Arp, Masson and Miró. By 1930 Tanguy, Magritte and Dali had come into Breton's orbit, and the first circle of surrealist painters was complete.

As we have seen, Picasso kept himself somewhat apart from surrealist activities, as befitted a person of his generation and artistic status, but there is no doubt that he found the surrealist eruption a stimulating one, and that it helped shape the direction his art took in the late 1920s and early 1930s. It gave him a new insight into

152 PABLO PICASSO (*b.* 1881) *Design for Monument: Cannes Bather, 1927. Charcoal drawing, 11¾″ × 8½″ (30 × 22). Collection the Artist*

153 PAUL KLEE (1879–1940)
Angel of Death, 1940. Oil on canvas,
20″ × 26½″ (51 × 67). Collection
Felix Klee, Bern

his own personality, and encouraged him to pursue suggestive, even irrational, associations, and to be less inhibited about expressing private feelings in his art. The idea of metamorphosis, fundamental to surrealism, fascinated Picasso, with such extraordinary results as his transformation of the nude figure into a colossal bone- or stone-like monument designed to celebrate the memory of Apollinaire (*Ill. 152*). Such pictures provided a point of reference for the younger surrealist painters: very few of them escaped the influence of Picasso.

Duchamp had apparently given up painting alto-gether by 1924, to concentrate on chess and some discreet art dealing in the support of old friends. De Chirico jeopardized Breton's enthusiastic admiration for his earlier work with his continued neo-classical paintings of prancing horses in landscapes strewn with improbable ruins. But Klee remained the joker in the surrealist pack, keeping his distance, geographically as well as spiritually, inviting inclusion and yet rejecting it.

Paul Klee (1879–1940) indeed offers the same problem of fair assessment as does his Bauhaus colleague, Kan-dinsky. His Swiss birth, musical talent, poetic tempera-ment, early facility as an etcher and contact with the *Blaue Reiter* (and Franz Marc in particular) all helped to shape a singular artistic personality. His art was endlessly inventive, but cold to the point of inhumanity, as Klee admitted when he confessed: 'what my art lacks is a kind of passionate warmth . . . I seek a distant point at the origins of creation, and there I sense a kind of formula

154 JOAN MIRÓ (*b.* 1893) *Person throwing a Stone at a Bird, 1926. Oil on canvas, 29" × 36¼" (73.5 × 92). Collection Museum of Modern Art, New York*

for man, animal, plant, earth, fire, water, air, and all circling forces at once.'

This philosophy led Klee to attempt to subject art to the laws of nature – to allow the work to grow in the artist's hands, starting without preconception in as primitive a state as possible, and seeing what emerges: in a celebrated phrase of Herbert Read's, 'letting a line go for a walk'. Though Klee never abjured the rational, it was this dependence on a semi-automatic process that so interested the surrealists. Klee's insistence on art as a way of reaching through to a primordial super-reality places him firmly between the surrealist and abstract camps, on the common ground that exists between them.

The irrational forces of the unconscious were very real to Klee, never more so than in the paintings of his final years. The charm and humour of the little Bauhaus pictures begin to cloy, even the fertile experiment looks trivial in the political situation of Germany in the 1930s, and Klee's work takes on a new dimension, both physically and in emotional content. The *Angel of Death*

of 1940 (*Ill. 153*) is a hieroglyph for those Rilkean guardian figures that Klee felt were watching and waiting for him, heralds of impending death. Yet it transcends Klee's personal situation with the power of a universal image, and reminds us of the strange durability of the visual symbol, rooted in some sort of human pre-consciousness.

Klee's semi-automatic techniques, and later his invented signs and symbols offer a close parallel with surrealist practices in the 1920s and early 1930s respectively. Soon after his arrival in Paris, Ernst was encouraged by André Breton to experiment with means of starting work on a picture by recourse to the accidental. The idea was for the artist to 'make a stain' without conscious control, and then exploit the suggestions implicit in that stain. There was a variety of ways of making the stain: Ernst's favourite was *frottage*, or rubbing – that is, taking the imprint of wood graining or a leaf or sackcloth by pressing it into paint or prepared paper. Other methods included *fumage*, which involved utilizing the trail left by the smoke of a candle moved at random under a white canvas; and *decalcomania*, or making a blot with a paint-laden brush, and then smudging it by pressing another sheet of cloth or paper on top.

Ernst used these techniques most successfully in the pictures of *Forests* which he made between 1927 and 1933 (*Ill. 151*). Pieces of wood have been pressed into the paint, so that natural textures provide a metaphor for the trees of the forest. The inevitable compass-drawn moon has a patently artificial quality, but the result is the creation of a secret, haunted place, alien to man. Ernst's pictorial world is slowly taken over by natural forces, and in the Arizona paintings of the 1940s rocks and desert vegetation exclude human participation. Always Ernst's search for 'the myths of his time' is paramount: painting is the making of symbols, and questions of aesthetic quality are irrelevant to the meaning of art.

The most enthusiastic surrealist practitioner of automatic techniques was André Masson (born 1896). He adapted Breton's automatic writing to a kind of abstract calligraphy, where the rhythm of the fast-moving brush-stroke generates an extraordinary violence and vitality on the picture surface. Already in *Battle of Fishes* of 1927 (*Ill. 155*), coloured sand is spattered over canvas ran-

domly daubed with glue: as the title indicates, animal violence is used as a metaphor for human passion. After quarrelling with Breton in 1929, Masson was expelled from the surrealist movement. For a time he pursued metaphorical painting in search of a way of expressing his view of man's relationship to nature: like Ernst (and Redon before him), Masson was preoccupied with the idea of germination, of blossoming – the awakening of life in nature, in the human personality, and in the work of art. Restless experiment, constant changes of style, and a diminution of passion in the late work has somewhat tarnished Masson's reputation, and his decisive contribution to the development of Jackson Pollock's abstract expressionism has gone largely unremarked.

Of all the painters showing at the 1925 surrealist exhibition, Joan Miró (born 1893) was, according to Breton, 'the most surrealist of us all'. As he had come from Barcelona with a chance to meet Picasso, Miró had a swift introduction to modern art. Yet, arriving in Paris as he did in the very early 1920s at a moment of reaction against extremism, Miró was affected by the search for a new kind of realism. His first mature paintings are nostalgic evocations of his childhood in Catalonia, in which the objects and occupants of the family farm are depicted with a scrupulous over-sharp realism that verges on the hallucinatory. Regressing into a child's world, Miró, now influenced by surrealist ideas, began to paint in a childlike manner. The *Person throwing a Stone at a Bird* of 1926 (*Ill. 154*) is half-recollection, half-

dream, with the enormous foot shape assuming the form of the person. Free play is given to irrational (and often erotic) associations. The picture has a spontaneity and a gaiety arising from an innocent eye and a knowing, even sophisticated, exploitation of form and colour.

Miró was breaking down pictorial conventions. For a time he introduced words into paintings to indicate his belief in the equivalence of poetry and painting, and like the other surrealists, Ernst in particular, he sought and found a way of depicting explicit sexuality. Simply drawn figures and animals, often with grotesquely exaggerated genitalia, cavort in the deep blue light of the stars and crescent moons (*Ill. 156*). Some sort of magic harmony is presumably intended, as though to say that we are released from inhibitions only in darkness, when sleep and dream displace the waking reality. But how far the naive and comic ideograms can be made to carry such a cosmic message is open to question. It was a perilous equation that Miró himself could not sustain for more than a year or so.

The whole character of surrealism changed very quickly in the 1930s. Faced with the Spanish Civil War and the spread of Fascism, the issue of whether or not a commitment to communism was a necessary condition of membership split the movement in two. But the ideas of Marx were less stimulating to the visual artist than those of Freud, and these new dissensions had little effect on painting. In any case, the four major artists associated

156 JOAN MIRÓ (*b.* 1893), *Painting, 1933. Oil on canvas, 4′3″ × 5′3″(129.5 × 161.5). Kunstmuseum, Bern*

with the movement from the beginning – Arp, Ernst, Masson and Miró – wanted the kind of independence they admired in Picasso. The adherence of other surrealist painters – Tanguy, Dali and Magritte – emphasized only that there was no surrealist style, no aesthetic, only certain vague preconceptions about the priority of imagination over reason, of pictorial content over form.

Yves Tanguy (1900–55) invented an eerie abstract landscape, inhabited by amorphous objects and presences, half-organic, half-mechanistic, but never identifiable as things seen in the waking world. Salvador Dali (born 1904), on the other hand, in dream pictures such as *The Persistence of Memory* (1931; *Ill. 157*), painted soft watches hanging over walls and on the boughs of trees. Such images are at once disturbing, and meant to be so. Breton always maintained that 'Beauty will be convulsive, or it will not be', and Dali, with perhaps more calculation than creative passion, developed his 'paranoiac-critical' method of assuming a state of hysteria and consciously elaborating the delusions of the insane. Thus familiar objects change their forms: Dali tells us that the idea of the soft watches came to him as he sat eating a ripe Camembert cheese. Whether the picture is intended as an allegory of time is unclear: what is certain is the resonance of such imagery in 20th-century painting and sculpture.

Dali's later religious pictures have served only to show the basic coarseness of his technique: as in the case of

Ernst, this is the Achilles' heel of surrealist painting. The Belgian, René Magritte (1898–1967), also isolated the object in a hallucinatory setting, but depicted it as though he were a naive painter attempting *trompe l'œil* realism (*Ill. 158*). We do not feel, as with Dali, that we are encountering someone else's obsessions: things so commonplace might appear like this to any of us. Magritte's pictures are often conceived as riddles, asking teasing questions about the nature of objective reality and the implications of man's desire to master it by naming objects and painting them. They assume pretensions of commenting upon the human predicament, but one wonders whether Magritte's ingenuity did not sometimes lead him to turn pictures into visual puns that, once familiar, lose much of their point. It is as if imagery of stupefying banality could be defended simply on the grounds that the banality was intended.

For all its enduring dissensions, surrealism was a spectacularly successful *avant-garde* movement that injected a much-needed life-giving serum into all of the arts in the period between the wars. Despite a literary bias, and a lack of concern for aesthetic values that in the end proved prejudicial to its viability, surrealism had ensured that art must recognize the unconscious, whether revealed by the exploitation of accident or by the creative juxtaposition of irrational images. Such innovations were quickly absorbed into the fabric of art. And though it was apparently so bitterly opposed to the contemporary development of an abstract art, surrealism in fact shared much in common with it, as the perspective of time will surely show.

Surrealism spread beyond Paris in the early 1930s, to Belgium and in particular to England, where it was at once welcomed as a restatement of Romanticism, and spurred that re-interpretation of man's relationship to nature which is embodied in the paintings of Paul Nash (1889–1946), Ceri Richards (1903–1971) and Graham Sutherland (born 1903), and in the sculptures of Henry Moore (which will be discussed later, see p. 189). And in the United States, where almost every leading figure associated with the movement took refuge in 1940, surrealism helped provide the seed-bed from which Arshile Gorky (1905–48) and Jackson Pollock (1912–56) were to spring, with such momentous consequences for the history of art.

158 RENÉ MAGRITTE (1898–1967) *La Condition Humaine*, 1933. Oil on canvas, 39½″ × 32″ (100.5 × 81.5). Collection Claude Spaak, Choisel (Seine-et-Oise)

Postscript: Abstract Expressionism and After

The devastating war that engulfed Europe in 1939 had been foreseen ever since Hitler's seizure of power in Germany in 1933. When it came, however, its effect on art was even more climactic than had been expected. As far as all the younger men were concerned, painting and sculpture simply came to an end for the time being; those older artists who carried on did so in the shadow of events that made their activities seem puny. In most cases, they continued much as before, and the later work of painters established by 1939 has already been discussed. No new movement of any consequence, and few new talents emerged in Europe during the 1940s.

Just as between 1914 and 1918 the action shifted to neutral centres like Holland, Switzerland and Russia (from 1917 onwards), so in 1940 New York replaced Paris as the capital of modern art. The existence of superlative museums, intelligent dealers, rich and un-prejudiced collectors, an informed general public all helped, but it was perhaps the presence there of so many European artists that was decisive. Mondrian, Léger, Duchamp, Lipchitz, Ernst, Masson, Dali – in fact, practically all the surrealist group, including Breton – set a standard of achievement that was to be an inspiration to American painters.

The Americans had followed the dialogue that had been going on in European art since the beginning of the century. With the perspective of time and distance they could now review the arguments and join in, proposing their own contributions to the body of art. As we have already seen, some successfully adopted ways of painting already established in Europe. If the accent was American, how can it be defined? Did it reside in a taste for bigness, for the dramatic gesture, for taking tendencies to extremes?

Of all the New York painters, Jackson Pollock (1912–56), in a short, triumphant and ultimately tragic

career, was best able to answer these questions. Pollock's early works were clumsy, due in part to his choice of models as inept as the Mexican mural painters. But in the early 1940s, immersion in the styles of Picasso and Masson led Pollock to a kind of late surrealism with pictures like *Guardians of the Secret* and *The She Wolf*, both of 1943. Suddenly and decisively in 1947, the erotic symbolism disappeared, the surrealism turned abstract, and for a few years Pollock painted with supreme confidence and conviction. Following the example of Mondrian, Pollock defined the subject of his work as the act of painting itself: in pictures like *Number One* of 1948 (*Ill. 159*) the paint tracks that the artist spattered across the canvas can theoretically be followed, and the experience of making it thus shared. That the result is more than beautiful decoration is due to the nervous intensity of the painter's line and his sensitive manipulation of pictorial space.

Pollock's work can be described as last-ditch Romanticism, in the sense that it dramatizes the concept of the artist as genius, at odds with a hostile world – no doubt this was exactly how an American painter felt in the 1940s. It is also post-surrealist in the artist's use of

159 JACKSON POLLOCK (1912–56) *Number One, 1948. Oil on canvas*, 5'8" × 8'8"(172.5 × 264.5). *Collection Museum of Modern Art, New York*

160 WILLEM DE KOONING (*b.* 1904) *Woman I, 1950–52. Oil on canvas, 6′ 4″ × 4′ 10″ (192.5 × 147.5). Collection Museum of Modern Art, New York*

automatic techniques and his confidence that the unconscious provides a justification for the results. The label most generally attached to Pollock – abstract expressionist – adds two more sources for what is nevertheless a recognizably new style. In particular, the scale of Pollock's work – canvases up to 20 feet across – does radically alter our appreciation of it, though even here some of the effects were anticipated by the aged Monet.

Abstract expressionism, when applied indiscriminately to Pollock's New York fellow-artists, becomes a less satisfactory generic term, and its alternative, action painting, is not much better. Willem de Kooning (born in Holland in 1904) is certainly an expressionist, but comparatively few of his paintings are abstract. The series of *Women* of 1950–53 (*Ill. 160*), for example, generates a powerful emotional charge precisely because of the nature of the subject, and the technique is an extension of Van Gogh's energetic brushwork. Franz Kline (1910–62) and Robert Motherwell (born 1915) painted gestural pictures on an enormous scale, enforcing awareness of the artist's touch and of a kind of muscular energy which has gone into the making of the picture. Unless the gestures crystallize into an image, however, there is a risk of bombastic vacuity, and Motherwell in particular has avoided the danger by developing a repertory of abstract forms around which compositions are built. Pollock faced up to this same difficulty at the end of his life, when figurative images appear in his work with increasing frequency, though not always with complete artistic conviction.

For other New York painters of this generation, touch and gesture mattered less. We have already observed how the work of Mark Rothko (1903–70) and Barnett Newman (1905–70) partakes of the tradition of abstract painting: it is only the enormous scale of such paintings that was new (see *Ills. 141* and *142*). The fanatical concentration on colour to the exclusion of all other possible painterly concerns would be a limitation but for the fact that this has proved to be the central issue in mid-20th-century painting, with a host of younger artists in the United States and England pursuing this particular field of investigation – Morris Louis (1912–62), for example, with his paintings of veils of colour stained into the canvas.

Outside New York, throughout the 1940s and 1950s it was the artist's touch, his brushwork, that attracted attention. It was as if the world political situation had everywhere driven painters back to the fundamental of the mark made on the canvas. On the American west coast, Mark Tobey (born 1890) showed a temperamental affinity with art across the Pacific, adapting Japanese calligraphy to Western use, both on the technical and spiritual levels. Small-scale abstract meditations like Tobey's *Edge of August* of 1953 (*Ill. 161*), for example, were followed up on a larger scale by such younger painters as Sam Francis (born 1923).

In Paris, Hans Hartung (born in Germany in 1904) developed after the war an informal abstract painting that he had tentatively broached in the early 1930s. In reaction against the disciplined, severe, near-geometric abstraction of Mondrian and his followers, this seemed to suit the mood of the years after the end of the war, and many practitioners of *l'art informel* or *tachism* (after the French word for the brushmark) appeared on the scene. It was an opportunity for dramatic gestures (Pierre Soulages, born 1919), for private obsessions (Wols, born Wolfgang Schulze, 1913–51), and for a sumptuous virtuosity in the handling of paint (Nicolas de Staël, 1914–55, *Ill. 162*). Slowly it became increasingly clear that abstract painting was not limited in vocabulary, and could be made to carry all kinds of meanings. Yet its practitioners, almost without exception, seem now to be minor artists, occupying a small territory of their own, and not venturing far from it.

The notable exception among the French painters is Jean Dubuffet (born 1901), a many-sided artistic personality of great complexity and subtlety. In Dubuffet, the 20th-century demand for a return to primitive sources reaches its apogee: he more than anyone could say with Paul Klee: 'I want to be as though newborn, knowing absolutely nothing about Europe, ignoring facts and fashions, to be almost primitive.' Dubuffet successfully sloughed off western European art, and turned for inspiration to *l'art brut* – the art of the insane, the uncultured, the immature. The results can be seen in such pictures as the *Pièce de Boucherie* of 1950–51 (*Ill. 163*), where the naked female body is subjected to unparalleled distortion. The form of the brutalized figure is generalized, but the texture has a particular

161 MARK TOBEY (*b.* 1890) *Edge of August, 1953. Casein on composition board, 4′ × 2′4″ (121.9 × 71.1). Collection Museum of Modern Art, New York*

162 NICOLAS DE STAËL (1914–55) *Roofs, 1952. Oil on canvas, 6′7″ × 4′11″ (200 × 150). Musée National d'Art Moderne, Paris*

163 JEAN DUBUFFET (b. 1901)
Pièce de Boucherie, Corps de Dame,
1950–51. Oil on canvas, 44¼" ×
35¼" (117.5 × 89.5). Courtesy
Sidney Janis Gallery, New York

emphasis, and Dubuffet has sometimes painted nothing
but this *matière* – expanses of thick impasto, ploughed
and scraped, with earth and sand mixed into the paint.
Having left behind him ideas for others to develop,
Dubuffet moved on through one transformation after
another, showing total unconcern as to whether his
pictures could be called abstract or not. And in 1962,
with the *Hourloupe* paintings, he invented a new pictorial
language, cellular in structure, which he has since used
exclusively, not only for paintings but also for three-
dimensional objects.

Dubuffet has had no close followers, but there is some
reason for regarding him as a precursor in that interest in
everyday reality which has attracted so many painters in
the 1960s. There is in fact a sharp break at the start of this
decade, as if the post-war gloom had finally lifted. It is
after all indisputable that the shadow of war hangs

heavily over many artists of the generation of Francis Bacon (born 1909). Bacon, in images of hysterical ferocity (*Ill. 164*), attempts to shock the spectator into an awareness of cruelty and violence. As with the elongated figures of the sculptor Alberto Giacometti (see p. 187), the philosophy of existentialism or some, thing like it lies behind such work.

With the abrupt change of mood in both contemporary painting and sculpture around 1960, the imagery of urban existence floods back into painting, producing a situation of great freedom in which everything seems possible. The actual shapes of paintings are more adaptable than ever before; the distinctions between painting and sculpture or painting and object break down; more use is made of photographic images; a rich

164 FRANCIS BACON (*b.* 1909) *Pope II, 1951. Oil on canvas, 6'6" × 5' (198 × 152). Kunsthalle, Mannheim*

play of associations is exploited. At the same time the barrier between painting and science crumbles, so that optical effects and the physical relations of colour become the subject of art; and kinetic art, for so long contemplated, becomes a reality. Painting spreads beyond the confines of the canvas, or even of the art object, to occupy, even create, an environment – a darkened space filled with light, a room stocked with the detritus of everyday existence, or stuffed with familiar things made from the wrong material and to the wrong scale. Even Marcel Duchamp's demand that the work of art should be a 'brain fact', not an object imitating something else, is realized, and, with the notion of 'conceptual art', painting might seem to have come to an end. And yet, as we have seen, it remains possible to paint pictures; indeed, to describe the rich variety of work being done at the moment would necessitate another book as long as this one.

When all is said and done, however, the number of original contributions to art made since 1925 is probably very small: it seems likely that the remainder of the 20th century will be needed to digest the innovations made in its first quarter. Anyone confronted with the bewildering profusion of present-day art may well consider this a surprising statement; we are always being persuaded that there has never been a more revolutionary period, never an age when art was more experimental. This remark, however, has been made about contemporary art for a great many years now – certainly since Manet exhibited at the *Salon des Refusés*, and probably since the time of the French Revolution and the rise of Romanticism.

So we can either conclude that arts exist in a state of permanent revolution, or, more simply and accurately perhaps, that art continues. In the nature of things, art is the creation of artists, who need to feel that some small originality of vision justifies their existence. And there have always been men and women who use the language of the eye to sharpen our awareness of life: they are just as necessary today as they ever were.

When Rodin showed the *Age of Bronze* (*Ill. 165*) at the Salon of 1877 he initiated the same sort of artistic development that Manet's *Déjeuner* set in train at the *Salon des Refusés*. The first reaction was outrage: the figure was so life-like it seemed that it must have been cast directly from the model. But in fact the sculpture's vitality was the result of art, not of artifice. Rodin had observed how classical and Renaissance sculptors left their body surfaces uneven so that light could play over the slightest undulation, and he attempted something similar. The result was that his figure appeared far more convincing than those of any of his fellow exhibitors.

It was significant that it should have been an awareness of light which singled out Rodin from his fellow-sculptors, for Auguste Rodin (1840–1917) was almost exactly contemporary with Monet, and belongs to the impressionist generation. Like them he worshipped nature, which provided him with such an inexhaustible variety of forms that he never needed to invent any. He found the human figure in particular capable of end-lessly expressive variations.

Yet despite these impressionist connections, Rodin was not an impressionist sculptor. One need only compare the *Age of Bronze* with Degas' *Fourteen-year old Dancer*, executed in 1879 and exhibited in 1881, to see this. Degas' sculpture, with its painted face and real clothes, marks an extreme point of naturalism which could not be surpassed – and which few in any case thought worth attempting. Rodin's young man, stretching as he rouses from sleep, for all his verisimilitude, is clearly not a psychological study, but a symbolic figure. The sculptor's intention was to provide a visual metaphor of arousal, which the spectator is free to interpret in whatever way best pleases him. The casual way in which Rodin added and altered the titles of his works (the *Age of Bronze* was

165 AUGUSTE RODIN (1840–1917) *Age of Bronze*, 1876. Bronze, 5′9″ × 2′ × 2′ (175.5 × 60 × 60). *Musée Rodin, Paris*

at one time called *Man awakening to Nature*) should warn us against a definitive interpretation.

Thus Rodin is a symbolist as well as an impressionist, and combines in his work the two dominant directions of late 19th century art. It is equally characteristic that in the 1880s and 1890s he should at least have agreed to design a series of large-scale public monuments – the kind of commission that the conservative sculptors of the Salon would have envied. Sometimes the results were best-forgotten failures; sometimes they succeeded, even though the studies produced *en route* may have been greater than the final conception; the unfinished, in-complete, nude models for the *Burghers of Calais* (1884–86) have a power and a dignity that the monument itself lacks.

Rodin never managed to complete certain commissions: the ornamental doors that he was asked in 1880 to provide for a new museum of decorative arts became the *Gates of Hell* (*Ill. 166*) and were too precious to Rodin ever to be finished and delivered. Rodin had received this commission at a moment when his head and hands were overflowing with ideas, and he let them pour out, creating almost two hundred figures in the *Gates*, many of which he later enlarged and developed separately. His whole conception changed radically as he worked on the great doors and their surrounding panels. Starting in a mood of Baudelairean disgust which saw Hell in life around us, Rodin was swept off his feet in a *grande passion* that led him to a paean in praise of sex and sensuality. Both ideas co-exist in the *Gates*, making not so much for contradiction as for enrichment, so that Rodin's view of life takes on an Olympian quality.

With the monument to *Balzac* of 1891–98 (*Ill. 167*) Rodin's achievement reaches its climax. Although, like a naturalist novelist, Rodin went to immense trouble to get information about Balzac's actual physical appear-ance, the result is less a portrait of the novelist than of the sculptor himself. Or rather, it is the personification of creative genius, the act of creativity, which Rodin is commemorating. The fact that Balzac was a little fat man is as irrelevant as the tradition of public sculpture which Rodin's monument shatters.

When exhibited at the 1898 Salon, Rodin's *Balzac* was greeted by an unprecedented chorus of hostile criticism. The organization that had commissioned the

166 AUGUSTE RODIN (1840–1917) *Gates of Hell, 1880–88. Bronze, 22′3¾″ × 13′1½″ × 2′9½″ (680 × 400 × 85). Musée Rodin, Paris*

167 AUGUSTE RODIN (1840–1917) *Balzac, 1891–98. Plaster, 9′10″ × 3′11¼″ × 3′11¼″ (300 × 120 × 120). Musée Rodin, Paris*

statue refused to accept it. The extreme freedom with which Rodin had modelled the head, the arrogant pose of the figure, its all-concealing cloak – all this horrified the general public. The work was described as 'Egyptian': a puzzling epithet which indicates primarily that it was outside the expected tradition of classical and Renaissance sculpture of which Rodin's earlier work had seemed part.

Of course Rodin had his defenders, and by the time of his great retrospective exhibition in 1900 it was evident to the informed that Rodin had succeeded in opening up the art of sculpture in a superhuman, titanic way. After that date he was to attempt no ambitious sculpture, only small work and some portrait busts superior to any since Bernini's, and countless delicate drawings of figures in movement. Rodin had retired, leaving the field to others.

It has often been said of Rodin that he invented sculpture, or that he recreated a lost art – an understandable enough hyperbole, given the state of sculpture when he began to exhibit. It was not that there were no admirable sculptors at work in the mid-19th century, but simply that Rodin lifted sculpture on to an altogether more important plane of activity. To Baudelaire and his contemporaries, sculpture was a boring art, very limited in its expressive power. It was too often only a decorative adjunct to architecture, or a means of eternalizing the appearance or the memory of some distinguished personage. As a medium for the expression of ideas, it could scarcely be said to exist.

Rodin changed all this; young men who fifty years earlier would have turned to painting now looked on sculpture as a more rewarding art. Responding to Rodin's reputation, they flocked to Paris, among them Epstein, coming from New York, Brancusi from Rumania, Lipchitz, Zadkine and Archipenko from Russia. In the first quarter of this century a creative explosion took place in the art of sculpture.

In his own day Rodin had only one serious rival, the Italian, Medardo Rosso (1858–1928), who spent most of his working life in Paris. He was more of an impressionist sculptor than Rodin, for not only was he sensitive to light and movement, but he took his subject-matter from the everyday world around him. In the *Conversation in a Garden* of 1893 (*Ill. 168*) we are given a glimpse of

168 MEDARDO ROSSO (1858–1928) *Conversation in a Garden*, 1893. Bronze, 13″ × 26½″ × 16″ (33 × 67 × 40.5). *Galleria Nazionale d'Arte Moderna, Rome*

the momentary, and Rosso would have preferred us to see the sculpture from one viewpoint only, and illumina- ted as he prescribed. For this is the paradox of Rosso: a wilful desire to impose the conditions of painting on sculpture, as if the fact of its being a three-dimensional art was the disadvantage Baudelaire thought it to be. Yet it allows Rosso to doubt the materiality of sculpture, or, more specifically, to allow the subject to merge with the material that embodies it. Thus in the *Conversation* there are passages that are not clearly representational – we are aware only of the modelled surfaces. The clay models were cast in plaster and then coated with wax so that Rosso could have an even more responsive surface to work upon.

With some justification, Rosso felt that Rodin had borrowed the male figure of the *Conversation in a Garden* for his final conception of Balzac. Nursing a grievance, he sank into inactivity, and in the last thirty years of his life produced nothing new. His final works were single heads of women and children in which his ambition to catch a fleeting smile or glance led him to a high degree of abstraction. In the *Head of Madame X* of 1896, the features sink into the soft wax, and the mask of the face takes on a blank, anonymous character. The contrast with the craggy head of the contemporary *Balzac* is pronounced, but both sculptures demonstrate how only a slight move away from naturalism can achieve greater expressive power.

Rodin's genius had crushed Rosso, and it was in fact no easier for the next generation to start work in his wake. In the last years of the 19th century and the first of the 20th it was often the painters who produced the most

169 PAUL GAUGUIN (1848–
1903) *Oviri, the Savage, 1894–95.
Terra cotta,* h. *28¾" (73). Private
Collection, France*

170 ARISTIDE MAILLOL (1861–
1944) *Seated Nude: Mediterranean,
1905. Stone,* h. *45" (114). Col-
lection Oskar Reinhart am Römer-
holz, Winterthur*

interesting sculpture. Renoir and Degas apart, the
impressionists were not tempted to try the three-
dimensional art; and of the post-impressionists only
Gauguin made sculpture. But his example was to be
followed by Matisse, Derain and Picasso, and the quality
and quantity of sculptures by painters in the 20th century
are considerable.

Gauguin was essentially an artist-craftsman who
enjoyed the challenge of every artistic medium and
realized at once its particular possibilities. He was always
happy when carving wood, sometimes decorating useful
objects, sometimes whittling figures – like the old sailor
that he was and liked to be taken for. He modelled
almost a hundred pots, shaping them and decorating
them with such originality that he made a major con-
tribution to ceramic sculpture. And certain of these
works – the carved wood relief, *Be in Love, and You'll be
Happy* of 1889 or the ceramic figure of *Oviri, the Savage*
of 1894–95 *(Ill. 169)* – express Gauguin's aesthetic
philosophy as clearly as do the paintings.

The 'primitivism' of such sculptures was impressive,
and suggested that only by reference outside the western
tradition could the art of sculpture be revitalized. At the
end of his life, Rodin also realized this, though too late
for him to do anything about it. The history of modern
sculpture between, say, 1905 and 1920, is a history of the
western assimilation of exotic influences. Archaic Greek
and Egyptian, Assyrian and Oriental, Cycladic and
Palaeolithic, African and Polynesian, Pre-Columbian
and Amerindian – the bounds of sculpture were extended,
historically and geographically, to take cognizance of
one culture after another. The result was a tremendous
enrichment of the language of sculpture, so that it
became an altogether more eloquent art.

We can mark the beginning of this process by the
appearance of Maillol's large *Seated Nude (Ill. 170)* at
the Autumn Salon of 1905 – the famous fauve Salon.
Aristide Maillol (1861–1944) was a close friend of
Bonnard and Vuillard, and a member of the Gauguin
circle. He had begun as a painter, turned to tapestry
weaving, and then around 1900 made the small terra-
cotta statuettes of young women that provided him with
inspiration for the rest of his life. The *Seated Nude* was
the first enlargement of this conception of the figure to
life-size. It owes nothing to Rodin: the type is in fact

closer to Gauguin's Tahitian women. Maillol later renamed this sculpture *Mediterranean*, perhaps to emphasize its association with the antique culture of the Mediterranean lands. Like Bonnard's *Abduction of Europa* (*Ill. 85*) or Matisse's contemporary *Luxe, Calme et Volupté* (*Ill. 87*), *Mediterranean* is an example of early 20th-century neoclassicism.

Maillol's figure presents a sequence of self-contained, closed forms – no jagged edges or sharp protuberances, as in Rodin: every limb is rounded and turns inward harmoniously upon itself. The well-digested non-European sources are archaic and Egyptian sculpture, balanced by a reassuring reference to Michelangelo's *Night*. There is a family resemblance to Renoir's women – and Maillol certainly admired such figure compositions as the *Bathers* (*Ill. 35*), but Renoir's few pieces of sculpture were all made after Maillol had established his style.

Maillol's sculpture is, for the most part, a series of variants on the *Mediterranean* figure – differently posed, but conveying essentially the same message. These nude females have no psychological content, and carry no symbolic meaning apart from the generalized suggestion of repose, fecundity and harmony between man and nature. When he tried to be more specific, Maillol failed. Nevertheless, such universal images of femininity moved sculpture as decisively towards abstraction as did the late portrait heads of Rosso.

Maillol notably lacked the willingness to experiment that characterized the painter-sculptors. In the early years of this century Matisse spent much time making sculpture, but always as a three-dimensional extension of his painterly interests. He found it helpful to change medium when a problem seemed insoluble, or progress blocked. Most of his sculpture, like Maillol's, is of the single female nude, usually standing or reclining. In *La Serpentine* of 1909 (*Ill. 171*), Matisse shows his readiness to break away from anatomical correctness in search of that same sort of rhythmic line that the figures in paintings like the *Joie de Vivre* (*Ill. 88*) possess. As a sculptor, Matisse had begun as a close follower of Rodin; and the way in which he evidently squeezed the clay with his hands to make the attenuated forms of the figure is an extension of Rodin's freedom in handling material. *La Serpentine* also shows Matisse's interest in African tribal art, not by way of direct borrowing so much as by an

171 HENRI MATISSE (1869–1954) *La Serpentine, 1909. Bronze,* h. *22¼" (56.5). Baltimore Museum of Art*

awareness that a conceptual approach gives the artist liberty to invent and improvise. In *La Serpentine* only those attributes of the woman's body relevant to the aesthetic issues involved are depicted; this ability to omit and to simplify was one of Matisse's great lessons, given equally to sculptors and to painters.

Picasso too made sculpture at times when his pictorial investigations demanded it. Having invented the new style of cubism, he was bound to consider its sculptural application. But the question was: does a means of representing three-dimensional space on a two-dimensional surface necessarily have any sculptural application? Picasso himself made a *Woman's Head* in 1909 in which the surface of an ovoid form is broken up in the faceted manner of cubist painting. It was, however, an isolated example, and not until after the invention of collage in 1912–13 did Picasso again begin to think of sculpture. Then he made constructions of guitars (*Ill. 172*) and other objects familiar from cubist still-life painting, using cardboard, wood, sheet metal, paper and whatever else came conveniently to hand. With such impermanent materials Picasso was implementing the demand made by Umberto Boccioni in the Manifesto of Futurist Sculpture of April 1912, which called for the use of 'glass, wood, cardboard, cement, horsehair, leather, cloth, mirrors and electric light bulbs.' Admittedly this was a programme which neither Boccioni nor Picasso could complete – the use of mirrors and electric light bulbs was left to their grandchildren – but its implications were enormous. After all, why should the sculptor be limited to traditional methods and materials? Could not any three-dimensional art object be regarded as a work of sculpture?

Picasso's constructions were mainly responsible for setting in motion the artistic movement in revolutionary Russia that adopted the name of constructivism. But something more should first be said about Boccioni, and about Parisian developments, for changes were taking place rapidly on every side.

Boccioni was another of the painters who turned to sculpture at a crucial stage in his career. He offers the extraordinary and unparalleled case of an artist who first produces a programme of an art he has never practised, and then makes the works to demonstrate his ideas. Boccioni exhibited his sculpture – in Paris in

172 PABLO PICASSO (*b.* 1881) *Guitar Construction, 1914. Construction in wood,* h. *23½″ (59.5).* *Collection the Artist*

173 UMBERTO BOCCIONI (1882–1916) *Development of a Bottle in Space, 1912*. Bronze, h. 15" (38). Collection Museum of Modern Art, New York (*Aristide Maillol Fund*)

June 1913, just over a year after the publication of the Manifesto – and then promptly returned to painting. Only a few of his pieces survive, and these reveal, not so much a demand for modern materials as the futurist obsession with dynamism. Hence the forms of figures in motion are given a strange fluidity to suggest that no sharp division can exist between the body and the space around it. In the nature of things, however, a sculpture is a static object, and Boccioni's attempts to fuse figure and space were doomed to failure. Yet when faced with the unsculptural subject of a still-life, Boccioni produced the *Development of a Bottle in Space* (*Ill. 173*) which comes closer to making his point that 'objects never end'. The bottle and dish on the table top are treated with the freedom with which Matisse approached the figure, or Picasso the guitar: in particular, the bottle is opened up; its interior placed in a state of balance with the exterior.

Such play of void against solid, of concave against convex surfaces, interested a whole generation of young sculptors who, between 1910 and 1915, began to apply the faceting effect of analytical cubism to figure sculpture. Alexander Archipenko (1889–1964) was the first to make a figure with empty spaces for the head and body, showing that in sculpture a void could have a shape of its own. Unfortunately Archipenko did not pursue this idea, but turned instead to making sculpto-paintings, a bastard mixture of real and illusory, and to the *Medrano* figures, assembled out of wood and glass and wire. Marcel Duchamp's brother, Raymond Duchamp Villon

(1876–1918), made one piece of sculpture, the *Horse* of 1914, which successfully combined a mechanistic image with a dynamic one; otherwise his work shows an uncertain and eclectic talent. It was left to the youngest member of the group of cubist-influenced sculptors to show the true sculptural relevance of the painting style.

This was Jacques Lipchitz, born in Lithuania in 1891. He became the friend of Picasso and Juan Gris in 1914, and during the war years made a series of bathers and harlequin figures which effectively translate synthetic cubism into sculpture. Although the final result is acceptable as some kind of figure, we are aware that the abstract forms have been given primacy. It is as if Lipchitz had started with certain regular elements, and, using them like children's bricks of different shapes, had assembled a figure from them. Lipchitz also discovered that by twisting thin strips of metal he could make 'transparent' figure sculptures. This was clearly a development beyond Matisse's *Serpentine*, although the same idea of drawing a sculpture in line underlies it.

The culmination of these experiments comes in Lipchitz's imposing over-life-size *Figure* of 1926–30 (*Ill. 174*), one of the few pieces of genuinely monumental sculpture made in the 20th century. It started as a decorative work, but in the construction took on a baleful, disturbing presence. Like Picasso, Lipchitz was affected by the development of surrealism without actually becoming a member of the group, and the *Figure* inevitably suggests that the unconscious mind must have played a major part in its creation. It is all but unique in Lipchitz's work: the later sculpture has tended to more baroque forms and a mythological subject-matter that is almost too cerebral to encompass the themes of violence and aggression to which Lipchitz has been drawn. It is entirely understandable that he should have reacted in this way to the rise of Nazism and the persecution of the Jews, but it may be doubted whether images such as Prometheus and the Sacrifice of Isaac can now carry the emotional content Lipchitz tried to impose on them. For in the 20th century certain kinds of sculpture seem to have become impossible, as if to compensate for the new avenues that were opening up.

None of these new avenues was more revolutionary than that of constructivism, largely the invention of Naum Gabo (born 1890) and, to a lesser extent, of his brother,

174 JACQUES LIPCHITZ (*b.* 1891) *Figure, 1926–30. Bronze,* h. 7′1″ *(217). The Solomon R. Guggenheim Museum, New York (The Joseph H. Hirshhorn Collection)*

Anton Pevsner (1886–1962). Gabo's constructed heads of 1915–16 ingeniously opened up the head by defining its position in space, not by the expected outer skin, but by a series of interlocking flat planes that cut through the head at right angles to the surface. The inspiration certainly comes from cubist painting: there is the same ambition to destroy any clear distinction between an object and the surrounding space.

In the atmosphere of revolutionary Russia, Gabo's work became more abstract. He was in sympathy with the view that art should serve society and have a practical purpose. In the *Project for a Radio Station* of 1919 there is a strange mixture of art, engineering and visionary architecture – and more than a hint of the Eiffel Tower (see p. 196). Gabo's development took this path, and in 1920 he wrote the *Realistic Manifesto* to defend the constructions that he exhibited in that year for the first time.

Gabo proposed an enlargement of the cubist preoccupation with space and of the futurist concern with movement. Art, he says, must be constructed out of space and time: no other approach is possible. The traditional three-dimensional art of sculpture, bound up with mass and volume, is a static concept that must be rejected. So must the traditional materials: Gabo demanded a commitment to the new materials of the machine age. The Manifesto was called Realistic because the new art works would be real in the absolute sense: they would represent nothing except themselves. Gabo's early constructions (*Ill. 175*) are abstract, in the sense that Mondrian's post-1916 paintings are abstract. They are in no way abstracted from nature, as are all Brancusi's works, nor are they organic objects, as are Arp's. In the last resort they have no practical function; this led to Gabo's quarrel with the Soviet authorities and his departure from Russia in 1922. There is of course a clear lesson in such constructions for the architect and the designer, but Gabo, unlike Malevich, was not prepared to abandon fine art altogether.

Although Gabo made a kinetic construction with a vibrating metal rod in 1922, he felt that actual movement could not be incorporated in the work of art. Movement must be implied: it must be an integral part of the observer's experience. A Gabo construction has no back or front, and requires the viewer to move around it. It is

175 NAUM GABO (*b.* 1890) *Column, 1923. Metal, wood and plastic,* h. 41½″ (105.5). *The Solomon R. Guggenheim Museum, New York*

176 CONSTANTIN BRANCUSI
(1876–1957) *Sculpture for the Blind,*
1916? Marble, 6″×12″ (15.5 ×
30.5). The Philadelphia Museum of
Art (Louise and Walter· Arensberg
Collection)

transparent, so that one looks straight through it. It is
made of the modern materials, in particular glass, metal,
plastic sheet and plastic thread. It has the logic of a
model demonstrating a scientific equation, and yet it is
manifestly a work of art, which nevertheless somehow
embodies a scientific approach. And although it has
no source in nature, it clearly runs parallel with and does
not deny the natural order.

Gabo lived in Germany, in France and in England
before settling in the United States in 1947. The idea of
the construction was an inspirational one, out of which
there arose a new art form, midway between painting and
sculpture, unreservedly abstract, classical in feeling. This
attracted dedicated practitioners in many countries, but
in particular England, the United States and Holland.
In their three-dimensional relief and free-standing con-
structions, Mary (1907–69) and Kenneth Martin (born
1905), Victor Pasmore (born 1908) and Anthony
Hill (born 1930) have all made an architectural, rhyth-
mic use of space that has no precedent in earlier art.

Gabo's invention of the construction, for all its
influence, lies outside the development of sculpture as
such. The central figure here is unquestionably Constan-
tin Brancusi (1876–1957), born in Rumania, but
resident in Paris from 1904 until his death. For Brancusi,
as for many others, Rodin's *Balzac* was the 'starting
point of modern sculpture', but Brancusi knew that he

177 CONSTANTIN BRANCUSI
(1876–1957) *The King of Kings,*
1920? Wood, h. 9′ 10″ (300). The
Solomon R. Guggenheim Museum,
New York

would have to emerge from Rodin's shadow if he was to achieve anything. In any case Brancusi believed that 'what is real is not the external form but the essence of things,' and his sculpture is best understood as a sequence of essences, concentrated, distilled, magical and fundamentally mysterious. Brancusi would start with a human or animal form, and gradually refine it in search of the essential. The cock, the bird in space, the fish, the seal, the turtle are all reduced to pure forms, usually in polished stone or bronze, which contain the essence of the creature. When it came to the human figure, Brancusi preferred to take a part only – torso, buttocks, head and shoulders, head alone – and follow the same process. The head subject starts with a *Muse asleep*, continues through such abstracted heads as that of *Prometheus* and of the *New-Born*, to culminate in the pure ovoid forms of *Sculpture for the Blind* (*Ill. 176*) and *The Beginning of the World*.

As the titles suggest, Brancusi was affected by the same mystical attitude to artistic experience already noticed in Mondrian and Kandinsky. Like them, he believed in the superior wisdom of the East, and his sculptures are conceived as objects for meditation and contemplation. They are precious concentrations of the artist's experience and a focus for our own. Brancusi was certainly interested in non-European art, even if he denied its formal influence. And although many of his wood carvings have an undeniable primitive feeling, it is difficult to trace their exact sources. *The King of Kings*, alternatively called *The Spirit of Buddha* (1920?; *Ill. 177*), has the crude peasant strength of all Brancusi's wood carvings, in notable contrast to the refinement of the polished stones and bronzes. It is evidently an idol of a kind, standing for a god and assuming some of the qualities of the godhead. The viewer is expected to adopt an attitude of worship before it, something which is not so explicitly required by Rodin's *Balzac*.

Towards the end of his life, Brancusi came increasingly to feel that sculpture is as much environment as object, which was why he bequeathed to the French state the actual studio in which he lived and worked, not only its contents. In 1937 he visited India, to plan a 'temple of meditation' – a pool of water surrounded by repeated images of his bird in space, a sculpture that signifies aspiration and prayer. And in his native Rumania at Tirgu-Jiu Brancusi laid out a garden with stone table

and stools, a monumental gateway based on a kiss motif that symbolizes the union of the sexes, and an endless column, rising to 'fill the vault of heaven'.

Several generations of sculptors felt the strength of Brancusi's personality and the relevance of his art. Even before 1914 he had a beneficial influence on Jacob Epstein (1880–1959) and Henri Gaudier-Brzeska (1891–1915), who together initiated a sculptural revival in England that was extinguished by the war. It was Brancusi, too, who persuaded the young Italian, Amadeo Modigliani (see p. 95) to abandon painting for sculpture between 1909 and 1914.

When Jean Arp (1887–1966; see also p. 153) began, around 1930, to break away from shallow relief sculpture and work in three dimensions it is of Brancusi's work that one is inevitably reminded. The differences are, however, considerable. Arp believed that 'art is a fruit which grows in man, like a fruit on a plant, or a child in its mother's womb,' and the shapes that appear for the first time in his painted low reliefs of the 1920s are recognizably organic forms developed according to some natural order. It was characteristic of Arp to call his sculptures 'human concretions' (*Ill. 178*), and to insist that they were not abstractions. The forms have emerged naturally, drawn out by an artist aware of forces of unconscious inspiration. If the end result suggests the human figure, this is because we are conditioned to read any object, however abstract, as relating to ourselves: a stick in the ground becomes some sort of presence.

Arp in any case wanted to assert the body connection; our response to a work of sculpture works in part at this largely unconscious level, where we identify the forms we see with our own body.

Arp's activity as a sculptor came in the latter part of his career, when his ties with the surrealist group were loosened. Yet just as his sculpture can be viewed as a stage on the way to complete abstraction, so does it also belong to surrealism in its emphasis on the unconscious and on the role of accident in the creative act. But Arp's surrealism is limited: there is much that it excludes – believing that nature is a salve for the roughness of existence, Arp could not accept the violence and aggression that is so much a part of most surrealist painting.

Other sculptors, however, came closer to the ideas of French Surrealism. In a few early pieces, Alberto Giacometti (1901–66) translated the dream vision into sculpture. *The Palace at 4 a.m.* of 1932 (*Ill. 179*) is the most literal and most complex of these: a small-scale construction seemingly assembled from odds and ends of wood, wire and string, it was made in a day, although the idea had been haunting Giacometti for months. The work is disturbing: as memorable for us as the dream must have been for Giacometti. By implication it

179 ALBERTO GIACOMETTI (1901–66) *The Palace at 4 a.m.,* 1932. *Construction in wood, glass, wire and string,* 25″ × 28¼″ × 15¾″ (63 × 71 × 40). *Collection Museum of Modern Art, New York*

questions the whole nature of sculpture, which here becomes something dramatic, like a frozen scene from a play.

Giacometti also made a *Woman with her Throat Cut* (1932), a terrifying assembly of fragmentary pieces, and the *Hands holding the Void; or The Invisible Object* (1934), a stylized, frightened figure which André Breton found so stimulating. After this, Giacometti was unable for a long time to make any more sculpture. He could only begin again with the etiolated figures of the 1940s and 1950s which have already been mentioned as sculptural manifestations of an existentialist view of life.

The problem between the wars was that surrealism, narrowly interpreted, did not encourage the production of sculpture. It lent itself to the unrepeatable demonstration, for example Marcel Duchamp's 'ready-mades', or Meret Oppenheim's *Fur-lined Teacup, Saucer and Spoon* of 1936, but it was not clear at the time how such ideas could be developed. More fruitful was the surrealist awareness of the mysterious power inherent in the 'found object' – perhaps a discarded machine part, or a tree root, which the artist discovered and then placed in an unexpected context. Of course one did not need to be a sculptor to do this, and in any case surrealist objects achieved the status of art only when they were depicted literally in paintings.

Nevertheless influenced by such ideas, Picasso began making sculpture again in the late 1920s. As we have already observed, some of his paintings were virtually pictures of sculptures (see *Ill. 152*), and contact with a fellow Spaniard, the sculptor Julio Gonzalez (1876–1942) led Picasso to experiment in the making of constructions out of welded metal. The nature of the materials – much of it scrap, or standard sections – dicated the form of the resulting sculptures.

It is not easy to distinguish the relative parts played by Gonzalez and Picasso in this development of metal sculpture. That the use of such intractable material was possible at all is due to Gonzalez, but it was Picasso who showed how uniquely suited an assemblage of metal parts is for metamorphic sculpture. Thus in Gonzalez' *Cactus Man* of 1939 (*Ill. 180*) the open-work, transparent nature of the sculpture suggests both a figure and the cactus plant, and this kind of metaphor with arresting associations is to be found in the work of both men.

180 JULIO GONZALEZ (1876–1942) *Cactus Man No. 2, 1939. Iron*, h. *31½" (78). Musée National d'Art Moderne, Paris*

Picasso was inevitably the more inventive in making these metal constructions. At times he has found it unnecessary to do more than place found objects together, turning discarded bicycle parts, garden implements, children's toys and the like into every kind of animal and bird (*Ill. 181*). There is much humour involved, and not a little arrogance. Then, in the 1960s, tiring of such metamorphic inventions, he cut and painted sheet metal to make heads and figures, some for enlargement on a monumental scale. And quite apart from these different uses of metal, Picasso has since 1930 made sculptural objects out of literally everything that came to hand – sand, paper bags, matchboxes, wire-mesh, bones and pebbles. To this one should add more conventional pieces made in plaster for casting into bronze, and an enormous quantity of ceramics – though these are more painting than sculpture. The incredible productivity and breathtaking invention of the man has no parallel in earlier art, and few contemporaries have been tempted to emulate Picasso, even if they had the stamina and temperament to do so. Of course facility is related to facileness, and productivity is no indication of genius. Brancusi completed fewer works in a lifetime than Picasso has turned out in a few months.

Both Picasso and Brancusi contributed to the formation of Henry Moore (born 1898), who more than any other artist has come to personify a continuing central tradition of sculpture. Moore has made no single revolutionary innovation, but has shown a comprehensive understanding of every path open to the sculptor in the mid-20th century. But whether the reference is to archaic or primitive art, to Rodin or Michelangelo, to Arp or Gabo, there can be no mistaking the artistic personality at the centre. Moore has, to a unique degree, the ability to make his sculptures interesting from whatever point they are viewed – he has a sense of three-dimensional form given only to the greatest sculptors. He admits a debt to Brancusi for making him 'form-conscious' – for 'stripping away every surface excrescence from sculpture,' and it is upon this basic awareness that Moore has built. From Picasso and surrealism Moore learned about sculptural metaphor, and it is in this way that the meaning of his own sculptures is enriched.

The central motif of Moore's art is the female figure, usually in a reclining position, but sometimes standing

181 PABLO PICASSO (*b.* 1881) *Baboon and Young*, 1951. *Bronze, h. 21" (53.5). Collection Museum of Modern Art, New York (Mrs Simon Guggenheim Fund)*

or seated, and occasionally holding a child. This image is obviously intended as an archetypal one – timeless, placeless, in no way particularized, and inviting reverence. It is as if the sculptor wants us to pay homage to those qualities which mark the woman's role in any culture, however simple and primitive. Moore starts with an appreciation of the human body, and exaggerates certain parts, emphasizing, for example, the woman's maternal and child-bearing aspects. Then, through a series of metaphors, he introduces references to root and bone forms, to suggest organic growth, and to the shapes of landscape, to suggest that the female is an integral part of the natural order.

Thus, in one of Moore's *Reclining Women* (*Ill. 182*) all these associations present themselves, and the viewer is confronted not by a naturalistic representation of the female figure as much as by some kind of earth goddess. The voids and hollows of the sculpture hint at caves as places for shelter, or at the orifices of the body and the enclosing warmth of the womb. It is such pre-natal experience and the forgotten sensations of suckling at the breast that these sculptures must evoke, and here, as in certain works by Picasso and Arp, is another instance of art appealing to the subconscious. In Moore's case

182 HENRY MOORE (*b.* 1898) *Reclining Woman, 1938. Stone, 2′11″ × 4′4″ × 2′5″ (119.5 × 132.5 × 73.5). The Tate Gallery, London*

183 BARBARA HEPWORTH (b. 1903) *Wave, 1943–44. Plane wood with colour and strings, interior pale blue.* l. 18½" (47). Collection Mr and Mrs Ashley Havinden

this is quite unselfconscious; his art is the working out of a personal obsession, at a level where it becomes meaningful to everyone because of the shared human experience involved.

Moore has at times made abstract sculptures, but rarely have they lacked a strong suggestion of body forms. This is one of the essential differences between his work and that of Barbara Hepworth (born 1903), whose name is so often bracketed with his. It is true that they went through comparable formative periods; that both approach sculpture as carvers, not modellers; and that both have made frequent use of a landscape metaphor in their sculpture – a particularly English contribution. Yet Hepworth is much more of a direct descent of Brancusi than Moore is, and more of a revolutionary as well. She was one of the first sculptors anywhere to produce completely abstract sculpture. Here, as in the case of Ben Nicholson, contact with Mondrian was decisive, and led to a conviction that there is an elemental sculp-

tural vocabulary, as valid as that of neo-plastic painting. The discs and forms of the mid-1930s represent a humanized geometry that is closely related to Brancusi's essences, but without a figurative origin. And this is not sculptural mathematics: the touch of human hand carving the wood or stone effectively prevents any conceptual aridity, although no trace of expressionism is allowed.

Many of Hepworth's later sculptures have been made in response to the landscape of West Cornwall where she has lived since 1939. *Wave* of 1943–44 (*Ill. 183*), for example, is a closed form carved from plane wood, with the interior painted blue and strings stretched across the concavity. For all the purity of the form it is obvious from the title that associations are intended. Not that this is a sculptural representation of a wave – nothing so explicit is imagined. Rather, the work suggests the spatial sensation of the breaking wave and the nature of the human reaction to the movement of the sea, with all that this implies, symbolically and poetically.

Hepworth's many vertical forms are often seen as metaphors for figures in a landscape, possessing some-thing of the magic that still accrues to the menhirs, the standing stones of prehistoric cultures. They are not abstracted from the figure, nor are they organic in the sense of Arp's human concretions, or Moore's women; instead they adhere to an ideal of pure beauty that is classical in origin.

Hepworth's use of painted colour in sculpture, at first so surprising in its originality, has now become common-place. But her devotion to carving has found few followers. Nor has the other traditional way of making sculpture, modelling, been popular with younger men. The use of welded metal, pioneered by Picasso and Gonzalez, and then by the Americans, Alexander Calder (born 1898) and David Smith (1906–65), was better suited to the taste and temperament of mid-20th-century sculptors. Calder's mobiles – constructions of flat forms suspended on wire and rods that move gently in the air – are a genuine invention, and a kind of kinetic sculpture that is delightfully playful if not profound.

Smith is a more considerable talent; he was the only American sculptor whose achievement is comparable to that of the abstract expressionist painters. In certain elaborate early constructions, the surrealist call for an art of dream and fantasy is answered, but Smith's great

achievement was the series of *Cubi* (*Ill. 184*) that he made at the end of his life. These are abstract vertical constructions, made from units of stainless steel welded together. They have a perfect formal unity, yet as they are almost invariably balanced on one point and tied to a base, there is more than a hint of the standing figure about them; we inevitably feel that we are confronted by some kind of presence.

The development of sculpture by the generation younger than Giacometti, Moore, Hepworth and Smith cannot be discussed in a few sentences, any more than was possible with recent painting in Chapter Nine. In certain areas of action, the arts have come together, as we have seen in the case of the assemblage that assumes environmental, space-occupying dimensions, or the idea of a conceptual art that denies the art object altogether. More fruitful for sculptors has been Brancusi's example of extreme concentration, matched by the disintegration of the sculptured object that his Tirgu-Jiu park implies. Thus there are sculptures that spread across the ground, and sculptures made from several parts, sometimes separate in space, sometimes making use of very simple forms, repeated several times. The use of enormous scale has been common, if only in the

184 DAVID SMITH (1906–65) *Cubi XIX, XVII and XVIII, 1963–64. Stainless steel, 9′ (273.3), 9′8″ (294), 9′5″ (287.3). Marlborough Gallery, New York*

attempt to destroy the tendency to read a human presence into an abstract work; so has the utilization of new plastic materials, which have in themselves permitted the making of new shapes. The constant evolution of sculptural expression continues; Rodin's new beginning has brought about an unparalleled burst of creative activity that has made sculpture one of the great arts of the 20th century.

185 CHARLES GARNIER (1825–98) *Opera House, Paris, 1861–74*

At the moment when the *Salon des Refusés* opened its doors in 1863, the very face of Paris was changing, more rapidly and more radically than at any time in its history. Following the instructions of the Emperor Napoleon III, who was anxious to contain any possible civil insurrection in Paris, the Prefect of the Department of the Seine, Baron Haussmann (1809–91), was driving wide new boulevards across and around the city, making the street plan that is familiar today. Along these boulevards block after block of stores, offices and apartments were going up: at the key intersections splendid neo-Gothic churches and public buildings were being erected.

The most dramatic of these was the magnificent new opera house, designed by Charles Garnier (1825–98) and built between 1861 and 1874 (*Ill. 185*). Somehow it exemplified the spirit of the Second Empire – confident, ostentatious, gaudy. Garnier's choice of a neo-Baroque style suits the period, and no doubt it was considered appropriate for a building devoted to the essentially Baroque invention of opera. This was a typical reaction to the architectural problem involved.

'Ornamentation is the principal part of architecture', Ruskin had written in 1853, and it was widely felt that matters of construction and even planning were better left to the engineer. The architect was essentially a designer of façades, a maker of grand effects – and there were plenty of occasions for these. All over Europe throughout the 19th century enormous public buildings were constructed to meet the needs of the totally transformed commercial and industrial societies of the day: parliament buildings, town halls, government offices, courts of law, stock exchanges, municipal theatres and opera houses, public libraries and museums, exhibition buildings, hotels, railway stations, mass housing estates, factories and warehouses – and in no case was there a precedent to be found in the architecture of the past.

Some of these new types of building could safely be left to the engineer: it was Thomas Telford who designed St Katharine's Dock, London, in 1824–28; Joseph Paxton, the gardener, who built the Crystal Palace for the 1851 exhibition; I. K. Brunel, who designed the glass and iron roof of Paddington Station in 1854. This kind of structural engineering, at that time considered separate from architecture, reached its apogee at the Paris exhibition of 1889, with the erection of the great steel and glass Machinery Hall and of the Eiffel Tower. Gustave Eiffel (1832–1923) was primarily a builder of bridges who pioneered the use of the metal lattice-beam: it was essentially because he substituted a three-dimensional open space frame for a solid that his tower later became an inspiration for the generation of Delaunay, Gabo and Le Corbusier.

Meanwhile the architects were enslaved to a historicist approach, attempting to find the correct style for their new buildings. National considerations were often paramount: from 1851 onward the Louvre was extended in the French Renaissance style; the *Palais de Justice* in Brussels (1862–83) adapted Flemish baroque; it was decreed that the Houses of Parliament should be rebuilt in the Gothic or Elizabethan manner, and this Charles Barry and A. W. Pugin handsomely provided. The Greek and Gothic and Italian Renaissance styles were widely employed – any people could happily identify with these vanished golden ages. The results may be seen in Gottfried Semper's neo-Renaissance Dresden Opera House (1838–41), in the 'classical' Capitol at Washington (1855–65), in the Gothic Parliament Buildings in Budapest (1888–1902) and in countless other examples.

The eclecticism and historicism of architecture in the mid-19th century was accepted and even considered a virtue. 'We want no style of architecture', wrote Ruskin in *The Seven Lamps* (1849). 'The forms of architecture already known are good enough for us . . .' Even within the conventions of the day originality was still possible: this is evident from the church designs of William Butterfield (1819–1900), whose All Saints', Margaret Street, in London, was under construction from 1849 onwards. But Butterfield was not the most successful architect of his generation; it was among the followers of his equally original Victorian contemporary, George

Edmund Street (1824–81), that a new attitude to architecture began to evolve.

For it became increasingly evident to more thoughtful observers in the second half of the 19th century that somehow a 'modern' architecture would have to be invented, just as a 'modern' painting was at that moment coming into being. And it would not be an exaggeration to claim that without recourse to fine art on the one hand and to handicraft and engineering on the other, the architectural revolution of the 20th century would never have taken place.

It is a commonplace to trace the origin of that revolution back to William Morris (1834–96), whose work is as sound a starting point as any. As a young man, Morris and his lifelong friend Edward Burne-Jones (see p. 77) were inspired to give their lives to art by Rossetti, who believed every man to be some kind of artist. Morris soon turned from painting to architecture, but this was too narrow a profession for him, for he came to feel that it was the conditions of man's existence that needed total reform. He began by building himself a home, the Red House in Bexley Heath, with the help of another young man he had met in Street's office, Philip Webb (1831–1915). As architecture the Red House (1859; *Ill. 186*) is not particularly original: Webb made use of the English vernacular tradition of cottage and vicarage building which Butterfield, for example, handled with greater originality. More revolutionary was Morris's view of the house as a totality, so that the domestic interior with all its furnishings and decorations was as important as the exterior.

Since he could not buy suitable furnishings, Morris decided to make his own, and in 1861 founded the firm of Morris and Company. His suspicion that the low standard of contemporary design was the consequence of the introduction of machine production led him to foster handicrafts – weaving, wallpaper and fabric printing, furniture design and metalwork. The Arts and Crafts Society, formed in 1888, carried on this work, softening a little Morris's antagonism to industry, partly because it was becoming obvious that only by a sensible use of mass production could well-designed objects become available to any but the rich.

It was in this ambience that the new architecture began to emerge, with the design of private houses providing

186 PHILIP WEBB (1831–1915)
The Red House, Bexley Heath, Kent (garden front), 1859

187 VICTOR HORTA (1861–1947) *Tassel House, Brussels (interior), 1892*

188 HENRY VAN DE VELDE (1863–1957) *Bloemenwerf, Uccle, Brussels (interior), 1895*

a stimulus for new thinking. In his domestic building, Philip Webb's exact contemporary, Richard Norman Shaw (1831–1912), slowly eased himself away from historicism; and his planning of the Bedford Park estate in West London in the early 1880s was the first serious attempt at designing a garden suburb. Such ideas were taken further by a younger generation: for example, Edwin Lutyens's (1869–1944) Surrey houses of the '90s and Hampstead Garden Suburb of 1908, or C. F. A Voysey's (1857–1941) private residences, which are functionally designed and stylistically almost anonymous, with the interior plan often dictating the appearance of the exterior.

Two architects whose work can be seen as tangential to this particular development in English domestic architecture – Frank Lloyd Wright and Charles Rennie Mackintosh – took these ideas to more revolutionary conclusions around the turn of the century. But on the Continent there was already an awareness of the implications of the English arts and crafts movement, particularly in Brussels, which felt it simultaneously in the early '90s with the impact of French post-impressionist painting, shown in the exhibitions of Les XX. Out of the conjunction of post-impressionism and English arts and crafts sprang an anti-historical movement, which spread rapidly and acquired many names, of which art nouveau is the best remembered and most convenient to use.

The new style began in the applied arts, and first appeared in architecture in the Tassel house in Brussels (1892, *Ill. 187*). This was the design of Victor Horta (1861–1947). The symmetrical exterior only hints at the fluid internal plan, with its grand staircase giving access to rooms at differing levels. Horta made undisguised use of iron, cast into extraordinary ornamental forms, employing it for columns and balconies and handrails. He particularly favoured a 'whiplash' line, which also appears in the wall patterns and the carpeting. Like all true art nouveau decoration, its basis is organic: it gives the impression of having developed naturally, like a plant tendril or a flame.

Another Belgian, Henry van de Velde (1863–1957), is an even better example of the marriage of post-impressionism and English arts and crafts. Abandoning painting, he turned to typography and then furniture

design before deciding, in 1895, to build his own house, Bloemenwerf, at Uccle near Brussels (*Ill. 188*). Even more than Morris's Red House, Bloemenwerf was designed as a totality, with Van de Velde himself responsible for all the furnishings and furniture. An undulating line and a frank acceptance of materials characterizes Van de Velde's early work. It was his 1896 commission to design four domestic interiors for a new shop in Paris called *L'Art Nouveau* that attached this particular name to the new movement.

But was art nouveau more than an original decorative style that broke with historical sources? It did not contradict Ruskin's contention that 'ornamentation is the principal part of architecture'. True, it implied asymmetry, and a greater sensitivity towards the materials available to the architect. It also blurred the distinction between architecture and handicrafts, anticipating the Bauhaus maxim: 'Architects, sculptors, painters, we must all return to handicraft.' Yet despite all this it did not offer a basis for a modern architecture.

The general tendency of art nouveau was to create a climate in which individual, original talents could flourish. Nowhere is this more evident than in Barcelona, where in 1883 Antoni Gaudí (1852–1926) took over the building of the Church of the Sagrada Familia. Inheriting a neo-Gothic design, Gaudí began to embellish it, structurally and ornamentally, with 'biological' forms and decorations. He continued work on the Sagrada Familia until his death, adding buildings that showed his ingenuity in the use of materials – especially brick and ceramic tile – and demonstrated his aesthetic of the divine nature of the curved line. In a secular commission, like the Casa Milà apartment block of 1905–10 (*Ill. 189*) art nouveau, in Gaudí's hands, breaks away from surface decoration to a more sculptural moulding of the building. The shapes employed are strangely organic; the Casa Milà looks like some living, writhing creature. There is, however, a sound and ingenious structural logic about the building: as always in Gaudí, rationality and fantasy go side by side.

Of all the architects associated with art nouveau it was the Scot, Charles Rennie Mackintosh (1868–1928), who showed most clearly the new road that architecture could take. His first extension to the Glasgow School of Art, built 1897–1909 (*Ill. 190*), was a highly influential

189 ANTONI GAUDI (1852–1926) *Casa Milà, Barcelona, 1905–10*

190 CHARLES RENNIE MACKIN-TOSH (1868–1928) *Glasgow School of Art, 1897–1909 (East façade, 1897–99)*

191 JOSEF HOFFMANN (1870–
1956) *Palais Stoclet, Brussels, 1905*

design which still retains a distinctly modern flavour.
There is very little evidence of historical sources: each
element of the façade is clearly distinguished, and treated
in a sculptural way. It is full of forward-looking features:
an interplay of voids and solids, an asymmetrical balance,
an emphasis on verticals and horizontals, particularly in
the treatment of windows.

Mackintosh was as interested in the decorative arts and
furniture as he was in architecture, designing the contents
of his buildings as well as their structure. In a little more
than a decade, from 1897 to 1907, his style evolved from
a curvilinear, sometimes Celtic-inspired, ornamental
manner to an austere, rectilinear one. In his interiors
Mackintosh handled space in an entirely new way,
displaying a sense of interrelated cubic volumes, pene-
trated by light and stripped of ornament, that prefigures
the simplicity of modern design.

There is a connection here with the domestic archi-
tecture of C. F. A. Voysey, already mentioned, and both
architects won a following in Germany and Austria in
the early years of this century. Hermann Muthesius's
book *Das englische Haus*, published in Berlin 1904–05,
and his foundation of the Morris-inspired *Deutscher
Werkbund* in 1907, started up the modern movement in
Germany. In Vienna, Otto Wagner (1841–1918) and
his disciples, Josef Olbrich (1867–1908), Adolf Loos
(1870–1933) and Josef Hoffmann (1870–1956), were
thinking along similar lines to the British architects.
Wagner believed that if the architect first took into con-

sideration the function of his building, the form would follow naturally. This led him to a simple architectural style with a horizontal emphasis, absence of ornament, and an undisguised use of material.

Wagner's young followers, together with the painter Gustav Klimt, established an *avant-garde* exhibiting society in 1897, the *Wiener Sezession* (Vienna Secession), as a medium for their ideas. In certain respects this is the Viennese equivalent of Belgian and French art nouveau, but in Vienna it was the very role of ornament in architecture that was soon in question. Hoffmann's work has a very personal elegance that can be best seen in the Palais Stoclet in Brussels (1905; *Ill. 191*). The design is a simple one that owes little to historical models, but the house, with its Klimt interiors, has a near-decadent air of luxury and over-refinement in the detailing that belies the basic plan. Hoffmann's contemporary, Adolf Loos, reacted against this situation by demanding that decorative ornament should be removed from architecture altogether. There was no place for it: it could only blunt the truth and honesty of a building. Loos's puritanism found expression in his essay, *Ornament and Crime*, of 1908, and in the excessively bare, flat-roofed Steiner House of 1910, which seems to be constructed out of one solid block of reinforced concrete.

The third member of the Viennese triumvirate, Josef Olbrich, died prematurely, before he had time to work out fully his new ideas. But his buildings for the Grand Duke of Hesse on the Mathildenhöhe at Darmstadt announce very clearly the transition from art nouveau to an expressionist architecture. The Hochzeitsturm (Wedding Tower) of 1907 (*Ill. 192*), for example, makes spectacular use of curvilinear forms but in a very regular manner: similarly the asymmetrical placing of the windows is balanced by their alignment into a horizontal strip running round the simple basic form of the tower.

The Hochzeitsturm is an essentially Austro-German building in some almost indefinable way. The nationalistic element is an important part of expressionist architecture, which reacted against the internationalism of art nouveau. Expressionism also encouraged the personal statement in architecture: it was a Romantic phase that remained dominant until the early 1920s, when the classical movement that became the international style completely eclipsed it.

192 JOSEF OLBRICH (1867–1908) *Hochzeitsturm, Darmstadt, 1907*

In this transitional phase the key figures were Peter Behrens and Frank Lloyd Wright. Behrens (1868–1940), like Morris and Van de Velde, began as a painter and entered architecture by designing his own house in 1901 at Darmstadt, where he, like Olbrich, was a member of the Grand Duke of Hesse's artistic colony. Behrens' house is functional in design, powerful and massive in appearance – the characteristic qualities of all his architecture. But Behrens was more than just an architect: in 1907 he moved to Berlin to work for AEG, the giant German electrical company. Not only did he build workers' housing estates and factories, notably the Turbine Hall of 1908–09 (*Ill. 193*), but he also designed the firm's products and all its display and packaging. Behrens was the first representative of a new type – the industrial designer, who imposes aesthetic standards on a whole range of machine-produced objects.

As an architect, Behrens was not an innovator, and the significance of his factory buildings has probably been exaggerated. But he was able to inspire others, and the three men who between them created the international style, Walter Gropius, Mies van der Rohe and Le Corbusier, all worked in his Berlin office at some time between 1907 and 1911. This in itself was an achieve-ment which gives Behrens his father-figure role.

The other father-figure of modern architecture is Frank Lloyd Wright (1869–1959). His work was suddenly and unexpectedly brought to the attention of European architects by the Wasmuth publications which appeared in Berlin in 1910 and 1911. Up to this date, the develop-ment of American architecture was something quite remote from Europe. There were almost no contacts: only Adolf Loos, as a young man, had visited the United States, and was able to appreciate the originality of Louis Sullivan's (1856–1924) buildings in Chicago.

Wright regarded himself, correctly, as the heir to Sullivan, in whose Chicago office he had worked from 1888 to 1893. This was a period of large, metal-framed, skyscraper construction, for which Sullivan invented an organic style of ornamental decoration. Wright, how-ever, concentrated on the building of private houses for wealthy clients, and it is in this domestic architecture that connections with English theory and practice can be discerned. Like Ruskin, Wright believed that nature must be brought into a creative relationship with build-

ings; this can be achieved in a variety of ways – for example, by imitation of natural forms, by the use of natural materials, or by breaking down any dichotomy between nature and the building. These ideas were shared by Voysey and the young Lutyens, but in the more expansive atmosphere of the American Middle West, where his clients were more open-minded than the English, Wright could display his greater originality. This he did in the succession of so-called 'prairie houses' that began in 1900 and culminated in the Robie House of 1909.

The Robie House in Chicago (*Ill. 194*) was one of the most recent of Wright's buildings to be illustrated in the Wasmuth books: its exotic, almost Japanese, appearance could scarcely have been less European. The wide-spreading hipped roofs and continuous strips of windows give it a low horizontal emphasis. There is no ornamentation of any kind, nothing to detract from the impact of the building's sculptural forms. Its parts slot together, cutting right through the space that the house occupies. The plan, with its multiple levels and easy flow between the rooms confirms this aspect of spatial freedom. Wright's innovations make an interesting parallel with those of the cubist painters in this same year.

Technically too, Wright was an innovator, responsive to demands made by the mechanics of the building – lighting, heating, sanitation, etc. – and ready to use new materials such as reinforced concrete and new techniques such as cantilevering. His Larkin office building of 1904, in Buffalo, New York, was of almost equal interest to the young European architects: here too the problems were dealt with in a completely original way.

Wright's long career faltered after 1910, and during the emergence of the international style in the 1920s he remained off the scene as far as Europe was concerned. It was easy to feel that he, like his exact contemporary Mackintosh, had made his contribution and was now left behind. But Wright was a visionary gifted with tenacity, prepared to defend his own conception of a universal 'organic' architecture with words and deeds. And in the mid-1930s Wright's late period began with a range of extraordinarily inventive buildings which includes the Kaufmann House, 'Falling Water' at Bear Run, Pennsylvania (1936); the Johnson Wax building at Racine, Wisconsin (1936–39); Wright's

193 PETER BEHRENS (1868–1940) *Turbine Hall, A.E.G. Factory, Berlin, 1908–09*

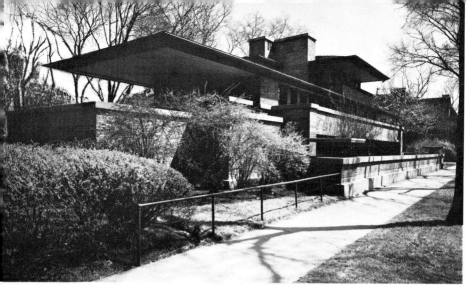

winter residence in the Arizona desert, Taliesin West (1938); Florida Southern College (1938 onwards); and the Guggenheim Museum (designed 1943–46, and built 1956–59; *Ill. 195*).

Alongside his taste for horizontally-dominated rectilinear forms, Wright had developed an interest in circles and spirals and 30° angles. The helix in particular fascinated him, and it provided the basic shape for the Guggenheim Museum. For Wright it had the particular virtue of being an organic form, and one that carried a mysterious sprung tension. The visitor feels this as he descends the spiralling interior ramp, which effectively disorientates one until the 'safety' of the ground is reached. The building may be unsuited for the display of paintings, but as a piece of pure architecture it is magnificent.

Wright's late work has yet to be absorbed into the body of modern architecture: it will be difficult to assess its importance until one sees what use other, much younger, architects can make of it. Though he has had his imitators and disciples, Wright remains an isolated figure – perhaps because his genius was too idiosyncratic. He is the temperamental opposite of Walter Gropius, whose buildings are often anonymous to the point of being characterless, but whose influence and inspiration have been immeasurable.

Walter Gropius (1883–1969) came from a family of architects and received his early training in Peter Behrens'

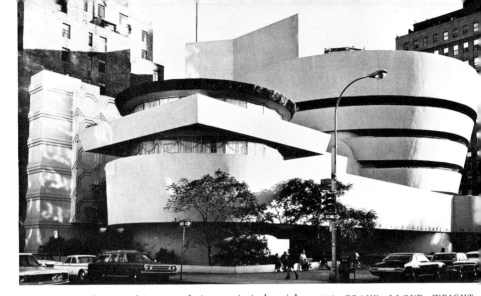

Berlin office. This gave him an early interest in industrial design, which resulted in his appointment in 1915 as director of the Schools of Fine Art and of Crafts at Weimar. Gropius took up this appointment in 1919, after his release from military service. He had been recommended for it by Henry van de Velde, his predecessor in the twin positions. Gropius immediately combined the schools, arguing that no distinction should be made between artist and craftsman, a doctrine that derives ultimately from William Morris. But Gropius did not share Morris's suspicion of industrial production: indeed he had a positive attitude towards the machine, which he regarded as essentially an extension of the craftsman's tool. He renamed the school *Bauhaus* (house of building), to emphasize his ambition to create a team that would design every component of a building. Once again, the Red House provided an example and an inspiration.

All Bauhaus students were required to take a preliminary course (*Vorkurs*), divided equally between study of the principles of form (*Formlehre*), and study of materials and techniques of working them (*Werklehre*). After this, they were allowed to concentrate on graphic design, or textiles, or furniture, or metalwork, or on architecture proper – but not on fine art, despite the presence of Kandinsky and Klee and other artists on the teaching staff. Gropius accepted specialization, but continued to stress the essential interdependence of each design field,

195 FRANK LLOYD WRIGHT (1869–1959) *The Solomon R. Guggenheim Museum, New York, 1943–46, built 1956–59*

and the best of the Bauhaus graduates – Laszlo Moholy-Nagy (1895–1946), Marcel Breuer (born 1902) and Max Bill (born 1908), for example – have been remark-ably versatile men.

The enormous influence of the Bauhaus should not conceal the fact there there was considerable change and evolution throughout the fourteen years of its existence. In the early, Weimar, days the Bauhaus was very much part and parcel of the German expressionist movement, as indeed its basic ambition – the making of a new society – proves. Gropius's own early factory designs, though structurally inventive in their use of steel and glass, belong firmly to their time, with their clear echoes of Wright and Behrens.

It is probably true that, because of the war and its revolutionary aftermath, an important phase of late expressionist German architecture has long gone under-valued. Few of the revolutionary plans of young architects could actually be executed: of those that were, the Einstein Observatory Tower at Potsdam of 1920 (*Ill. 196*) by Erich Mendelssohn (1887–1953) is the most sensa-tional. It makes an interesting comparison with Olbrich's Hochzeitsturm at Darmstadt (*Ill. 192*). Mendelssohn's Tower has an irregular, organic, sculptural quality; it seems to be a creature of the night rather than of the day, appropriately enough for an observatory. The Tower is an improbable building – a piece of visionary architecture that was actually executed.

Even more original and prophetic than Mendelssohn's designs were those by another young Berlin architect, Mies van der Rohe (1886–1969). He projected two glass skyscrapers, one triangular in shape, another with free curved forms; an office design had ribbons of windows running right round the building; two country house plans show a freedom in the handling of space that no contemporary work could rival. None of these projects was actually built: Mies was perhaps not yet ready to start building. Like Gropius he would have preferred a new society to work for: in the early 1920s he was particularly active in extreme left-wing Berlin political circles, and his Monument to Karl Liebknecht and Rosa Luxemburg (1926, destroyed by the Nazis), with its horizontal slabs of projecting and receding brickwork is probably the greatest funerary memorial erected in the 20th century.

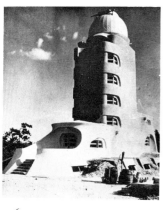

196 ERICH MENDELSSOHN (1887–1953) *Einstein Observatory Tower, Potsdam, 1920*

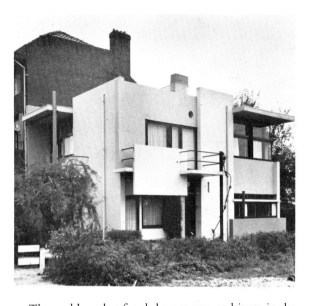

197 GERRIT RIETVELD (1888–
1964) *Schroeder House, Utrecht,*
1924

The problem that faced these young architects in the
early 1920s was to create a suitable style for modern
building. A native predilection for the classical solution
led Mies away from expressionist fantasy into a more
disciplined language. It was here that fine art exercised
such a decisive influence, for the purifying agents
employed by Mies were Dutch De Stijl and Russian
constructivism – the same twin influences that set the
Bauhaus firmly on its post-expressionist, 'modern' path.

As we have already seen, De Stijl was dependent on
Mondrian's painting, which in turn derived from cubism.
Its formulation as an aesthetic applicable equally to
design and to architecture was largely the work of Theo
van Doesburg (1883–1931). Although J. J. P. Oud
(1890–1963) was the most considerable architect of the
De Stijl group and the leading figure in modern Dutch
architecture, it is the Schroeder House in Utrecht (1924,
Ill. 197) by Gerrit Rietveld (1888–1964) that shows
De Stijl ideology at its purest. The principles of De Stijl
painting – the limitation of colour to the three primaries,
of form to the rectangle, of tone to black, grey and white –
are here transferred to architecture. The house is con-
ceived as a system of interrelated planes, which always
meet at right angles. Surfaces are smooth and totally
undecorated; the traditional Dutch building material

of brick has been rejected in favour of cast concrete slabs. The basic cube shape of the Shroeder house is in no way enclosed; rather it is opened up for easy penetration of the interior space.

The other revolutionary movement, constructivism, was a natural concomitant of De Stijl, and to a considerable extent the two merged in 1922 when the Russian activists were forced out of their homeland by an increasingly reactionary regime. At its inception, constructivism was essentially a new concept of sculpture, but its practices – articulation of space, introduction of a time element, use of new materials – were just as relevant for architecture. In any case in Russia after the 1917 revolution all the existing art forms were considered more or less obsolete, and a new, all-embracing visual language was sought. Thus the leaders of the revolutionary art movement, Gabo, Malevich, Vladimir Tatlin (1885–1953) and El Lissitzky (1890–1941) were all active in many fields, with a particular bias away from fine into applied art. The most dramatic example of this, Malevich's renunciation of painting, has already been discussed; but in 1924–26, before sinking into inactivity, Malevich produced some suprematist architectural models (*Ill. 198*) which afford a striking blueprint for later buildings. Lissitzky was the most vociferous of the constructivists, and his presence in Germany and Holland from 1922 to 1928 made him the prime channel

198 KASIMIR MALEVICH (1878–1935) *Planit: free-standing form in space (suprematist composition), 1924–26*

for these ideas. His contacts with Mies and Gropius were decisive, and his close association with Van Does' burg did much to crystallize the idea of machine aesthetic, quite independent of nature and valuable as a model for building.

Out of this welter of new ideas, a truly modern style of architecture finally emerged. To its first practitioners, by comparison with the 19th century, it did not seem to be a style at all – simply a rational method of building which would have permanent validity. Unlike art nouveau or expressionism, it could have no local flavour. Compiling a book of examples for his Bauhaus students and others in 1924, Gropius called it *International Architecture*, and it was with this adjective that the new style was named.

One of the first buildings to demonstrate the 'inter' national style' was Gropius's own design for the new buildings of the Bauhaus at Dessau (1925–26; *Ill. 199*). Political difficulties had forced the school to move from Weimar to the more sympathetic climate of Dessau, and here Gropius had the architectural opportunity of his career. The Dessau building consists of three units: students' hostel, design school and workshops, with the latter two linked by a bridge passage, which Gropius utilized to house the administration. The workshop block was constructed of reinforced concrete floor slabs sup' ported on pillars set back from the façade. This allowed

199 WALTER GROPIUS (1883–1969) *Bauhaus, Dessau, 1925–26*

Gropius to clad the building with uninterrupted walls of glass, perhaps his most significant innovation.

Gropius resigned from the Bauhaus in 1928 to concentrate on architecture; he was particularly anxious to supervise building on the Siemensstadt housing estate in Berlin. Low-cost housing was from an early date a major concern of the international architects, conscious as they were of their social responsibilities. There had already been an outdoor exhibition of housing at the Weissenhofsiedlung in Stuttgart in 1927, organized by Mies van der Rohe, who was to follow Gropius as director of the Bauhaus from 1930 until its forced closure by the Nazis in 1933.

At first glance Mies's apartment block of 1927 (*Ill. 200*) on the Weissenhof estate looks undistinguished today, like countless other modern flats. Yet closer examination reveals the two basic reasons for Mies's pre-eminence – his fine sense of proportion, and his careful attention to every detail, however apparently insignificant. These qualities are evident also in the more ambitious buildings which followed. The German Pavilion at the Barcelona international exhibition of 1929 was an extremely simple temporary structure, roofed with flat slabs of reinforced concrete supported on cross-shaped steel columns, its interior space divided by walls of glass and travertine set at right angles to each other. The elegance of the interior is exemplified by the curved steel chair – the 'Barcelona chair' – which Mies designed to go with it.

The culmination of Mies's European career came with the Tugendhat House, at Brno in Czechoslovakia (1930; *Ill. 201*). On a sloping site he designed a building with access to the upper storey at street level, allowing for a

long lower-storey living room on the garden side. As his clients were affluent, Mies had every detail custom-designed – in contradiction to any machine aesthetic, with its acceptance of standardization, but justified in the circumstances. For the Tugendhat House is quite simply one of the most beautiful houses ever built, and a demonstration that the new architectural style did not involve any abandonment of refinement.

It is interesting to compare the Tugendhat House with the exactly contemporary Villa Savoye at Poissy (1927–31; *Ill. 202*), which represents a similar stage in the career of Le Corbusier (born Charles-Edouard Jean-neret, 1887–1965). Here too concrete is used, the roof is flat and the windows run in strips to the corners of the building. But Le Corbusier's house stands on columns – *pilotis* – which lift the living area up and leave the ground free for circulation. The shape is as dramatically simple as Mies's: here are the clean, uncluttered lines, the elegant proportions of the international style.

Le Corbusier's personal history up to the time he designed the Villa Savoye summarizes the evolution of modern architecture. Born in Switzerland, he began his training in an art nouveau environment. Then followed the *Wanderjahre*, when he made contact with Hoffmann in Vienna, Tony Garnier (1869–1948) in Lyons, Auguste Perret (1874–1954) in Paris, Behrens in Berlin. The French architects were the most inventive of their generation – Perret for showing the unique versatility of reinforced concrete as a building material, making totally new kinds of structure possible; and Garnier for his visionary project of a *Cité Industrielle* (1901–04), the first master plan of its kind. Through Behrens, Le

202 LE CORBUSIER (1887–1965)
Villa Savoye, Poissy, 1927–31

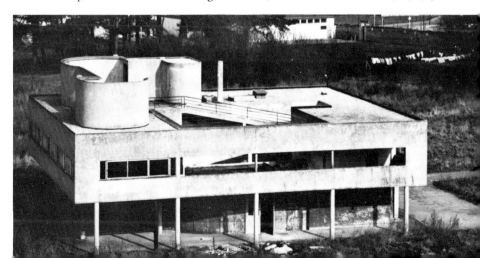

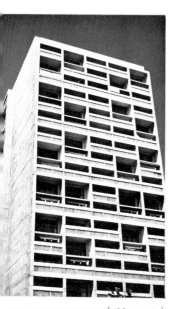

203 LE CORBUSIER (1887–1965)
Unité d'Habitation, Marseilles, 1947–52

Corbusier became interested in the concept of industrial design, and in particular the application of mass-production techniques to building. This was to lead him in due course to the celebrated definition of houses as 'machines for living in'.

But if Le Corbusier was ready to draw on engineering in his re-invention of architecture, he was equally quick to learn from fine art. When he settled in Paris in 1917, he began to paint, and to theorize about painting. As we have seen, it was in reaction against the over-decorative, too-individualistic state of cubism that purism was born. In his magazine, *L'Esprit Nouveau*, Le Corbusier also issued his *Warning to Architects*, later to become known in book form as *Vers une architecture* (1923). He favoured the use by architects of the basic geometrical shapes of the cubists, and the translation of the cubist experience of light, space and time into architectural terms. Plain surfaces were essential; decoration or stylistic references were proscribed. Buildings must be planned as machines were designed, and standard industrial products were to be used in their construction.

Le Corbusier was also very interested in the problems of urban existence, made acute by the rapid growth of cities. He envisaged the rationalization of traffic movement, and the concentration of all residential accommodation into multi-storey blocks set in open parkland. It was many years before these ideas could be realized in practice – not until after the war, when the *Unité d'habitation* at Marseilles was built (1947–52; *Ill. 203*). This was followed by similar blocks at Nantes (1952–57) and Berlin (1960); in each case they contained several hundred two-storey dwellings, and were built according to Le Corbusier's system of construction, Le Modulor, all of whose measurements are based on golden section proportions.

Le Corbusier's actual building in the '20s had, like Mies's, been confined to a few expensive private residences, often studio houses, and some exhibition pavilions and demonstration designs. The succeeding decade was to prove no more propitious: apart from the Swiss student hostel at the Cité Universitaire in Paris, Le Corbusier built almost nothing. The political situation in western Europe was such that it was almost miraculous that the new international style in architecture survived at all.

What in fact happened was a diaspora that ultimately led to the style's universal acceptance. Le Corbusier designed the Ministry of Education in Brazil (1936–45) with the assistance of Brazilian architects, including Lúcio Costa and Oscar Niemeyer. He also worked in North Africa, in Tokyo, and in India on the new capital for the state of Punjab, Chandigarh (from 1950 onwards). In 1934 Gropius, like Mendelsohn, moved to England, where he worked in partnership with Maxwell Fry (born 1899) on private house designs and the village college at Impington in Cambridgeshire (1936). In 1937 he was invited to teach at Harvard, and his association with Boston lasted until his death. Mies, in 1937, moved directly to the United States from Berlin, settling in Chicago and teaching at first at the Illinois Institute of Technology, for which he began to design a new campus in 1940.

It was in these centres far from France and Germany, the historic heartland of modern architecture, that development could continue in the 1930s and 1940s. Though conditions were at first far from easy in the New World for Mies and Gropius, they soon had influential followers, like Philip Johnson (born 1906), who did much to spread the message in a society that long remained basically unsympathetic. Gropius's insistence on the necessity of teamwork led him to sink his own energies into the co-operative partnership of The Architects Collaborative (TAC), established in 1945: Mies, on the other hand, retained a strong personal quality in his work, and emerged unmistakably as an architect in the classical tradition. The bronze-clad Seagram Building in New York (1958; *Ill. 204*) is the ultimate solution to the steel-frame skyscraper problem, a simple slab rising sheer out of a formal plaza. Mies's austerity, summed up in his favourite maxim, 'Less is more', led to a certain aridity and sameness in the late buildings, as if there were only one solution to all problems. The National Gallery in Berlin (1968), a transparent cube set upon a massive square platform, remains as self-indulgent a piece of pure architecture, doctrinaire in design, indifferent to function, as does Frank Lloyd Wright's Guggenheim Museum.

Le Corbusier's late works reveal an underlying Romantic temperament, a desire for self-assertion as an artist that both Mies and Gropius would recoil from.

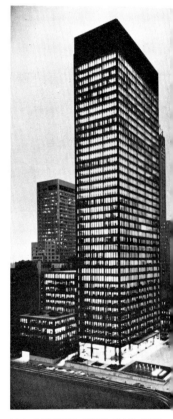

204 LUDWIG MIES VAN DER ROHE (1886–1969) *Seagram Building, New York, 1958*

213

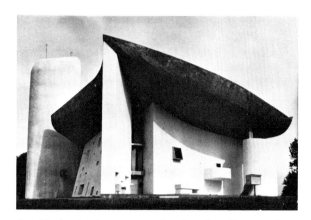

205 LE CORBUSIER (1887–1965)
Notre Dame du Haut, Ronchamp,
1950–54

Le Corbusier in no way abandoned earlier practices, but he augmented and extended them as new opportunities came his way. The shape of the pilgrimage church of Notre-Dame at Ronchamp (1950–54; *Ill. 205*) can be defended as deriving from the function of the building, but this is not the point: Le Corbusier is consciously moulding a sculptural form irrational in conception, with curved surfaces and a deliberate avoidance of right angled walls. This is a living organism, not a machine; a building that inevitably suggests the mystery of religion.

This softening of the international style in late Le Corbusier has a precedent in the work of Alvar Aalto (born 1898), probably the most inventive architect of his generation. Aalto accepted such basic tenets as absence of ornament, plain white surfaces, design following function, architecture to include furnishings – but in the particular environment of Finland these ideas are interpreted in a fresh and undogmatic way. Once again, the building's relationship to nature becomes important, and, as in Wright's case, this implies both a sensitivity in the use of natural materials, and a broader awareness of organic forms in design. Aalto's many buildings have shown his passage through various phases, exemplified by the library at Viipuri (1927–35) and the Paimio Sanatorium (1929–33) in the early 'white' period; the town hall at Säynätsalo (1950–52) in the middle 'red' period, when brick was his favourite building material; and the church at Vuoksenniska (1956–58; *Ill. 206*) in the later 'white' period.

In Aalto the rationalism of early modern architecture is absorbed into a poetic, almost mysterious, personal

style. The parts of the Vuoksenniska church, for example, have no self-evident relationship to each other, yet they belong together as an organic whole. Similarly the absolute clarity of a Mies building is here rejected for a design that allows the possibility of suggestion. In Aalto, forms may be implied without being definitively stated, and materials used for their associations as much as for their natural qualities – witness the brickwork of the red period, which breaks up the light in a way strictly analogous to the faceting of Cézanne's brushwork.

Aalto's work best exemplifies the way in which the international style took on an increasingly strong local accent. Gunnar Asplund (1885–1940) and Arne Jacobsen (1902–71) in Scandinavia; Giuseppe Terragni (1904–42) and Gio Ponti (born 1891) in Italy; Kenzo Tange (born 1913) in Japan; Carlos Villanueva (born 1900) in Venezuela; Lúcio Costa (born 1902) and Oscar Niemeyer (born 1907) in Brazil; Denys Lasdun (born 1914) in England; Richard Neutra (1892–1970), Philip Johnson (born 1906), Eero Saarinen (1910–61), Gordon Bunshaft (born 1909) of the Skidmore, Owings and Merrill partnership in the United States – all have made individual and distinctive contributions, without revolutionizing architecture as did the slightly older triumvirate of Wright, Le Corbusier and Mies.

In the late '50s and '60s architecture in fact seemed in an almost suspended state, waiting for a major change without being certain where this might come from. As before in similar circumstances, it is outside architecture that one looks – to engineering and to fine art. Combining a remarkable ingenuity in the use of reinforced concrete with a study of the rhythmic structure of natural forms, Pier Luigi Nervi (born 1891) has built exhibition halls, hangars, railway stations, sports arenas of great lightness and beauty. And with comparable originality, though he is less concerned with aesthetic values, the American Richard Buckminster Fuller (born 1895) invented the Dymaxion House in 1927 – a veritable machine for living in – and the Geodesic Dome, based on octahedrons or tetrahedrons, as a means of enclosing enormous spaces economically and quickly.

The new movements in painting, abstract expressionism, *l'art brut*, and pop art, have had their reflections in architectural developments, to a greater degree than

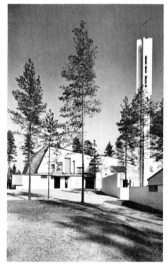

206 ALVAR AALTO (b. 1898) *Church at Vuoksenniska, Imatra, Finland, 1956–58*

practising architects are always aware. The best-known example is Brutalism, so-called to define an attitude common among younger British architects in the late 1950s, first expressed in the Hunstanton School (1954) of Alison (born 1928) and Peter Smithson (born 1923), but more evident in the buildings of James Stirling (born 1926), such as the Engineering Block at the University of Leicester (1964; *Ill. 207*), where the function of the building dictates its actual form in a more forthright, harsh way than had hitherto been thought possible. The late work of the American, Louis Kahn (born 1901), from the Yale University Art Gallery (1952–54) onwards, clearly exemplifies a new direction, and the dramatic towers of the Richards Building in the University of Pennsylvania at Philadelphia (1958–60) go beyond a successful amalgam of Wright, Mies and Le Corbusier. Paul Rudolph (born 1918) has demanded a 'new freedom' in architecture to justify a creative eclecticism in his own buildings. He appears to be, with the Chinese-born Ioh Ming Pei (born 1917), outstanding among this American generation.

As with the painting of the present, however, we are too close to events to attempt final judgments. Whether this is a moment without major figures, whether they are among us but not yet recognized as such, only the passage of time will tell.

207 JAMES STIRLING (*b.* 1926) *Engineering Block, University of Leicester, 1963–64*

Bibliography

The literature of modern art and architecture is enormous, and increases in size all the time. With few exceptions (mostly complete catalogues), recommended works are in English. A title given in the monograph list indicates that the work is by the artist in question. Periodical literature is not included, although many excellent articles on modern art appear in *Apollo, Art Bulletin, Art Forum, Art International, Art News, Art Quarterly, Arts, Burlington Magazine, Gazette des Beaux Arts* and *Studio International.*

Dates given are normally those of first publications in English, whether in Britain or the United States.

I GENERAL

Painting H. H. Arnason, *A History of Modern Art,* 1969; A. Brookner, *The Genius of the Future,* 1971 (19c. French Art Criticism); C. Greenberg, *Art and Culture,* 1961; W. Haftmann, *Painting in the Twentieth Century,* 1965 (2nd ed.); G. H. Hamilton, *Painting and Sculpture in Europe, 1880 to 1940,* 1967; P. Heron, *The Changing Forms of Art,* 1955; W. Hofmann, *The Earthly Paradise: Art in the Nineteenth Century,* 1961 and *Turning Points in Twentieth Century Art: 1890-1917,* 1969; H. Read, *Art Now,* 1933 etc., *The Philosophy of Modern Art,* 1952 and *A Concise History of Modern Painting,* 1959 etc.; H. Rosenberg, *The Tradition of the New,* 1959; A. Scharf, *Art and Photography,* 1968.

Sculpture A. Bowness, *Modern Sculpture,* 1965; J. Burnham, *Beyond Modern Sculpture,* 1968; C. Giedion Welcker, *Contemporary Sculpture,* 1960 (3rd ed.); A. M. Hammacher, *The Evolution of Modern Sculpture,* 1969; U. Kultermann, *The New Sculpture,* 1968; F. Licht, *Sculpture 19th and 20th Centuries,* 1967; H. Read, *A Concise History of Modern Sculpture,* 1964; J. Selz, *Modern Sculpture: Origins and Evolution,* 1963.

Architecture and Design P. R. Banham, *Theory and Design in the First Machine Age,* 1960 and *Guide to Modern Architecture,* 1962; P. Blake, *The Master Builders,* 1960; P. Collins, *Concrete,* 1959; U. Conrads (ed.), *Programmes and Manifestos on 20th-century Architecture,* 1970; S. Giedion, *Space, Time and Architecture,* 1967 (5th ed.); H. R. Hitchcock, *Architecture: Nineteenth and Twentieth Centuries,* 1958; W. Pehnt (ed.), *Encyclopaedia of Modern Architecture,* 1963; N. Pevsner, *Pioneers of Modern Design,* 1936, 1944 etc. and *The Sources of Modern Architecture and Design,* 1968; J. M. Richards, *An Introduction to Modern Architecture,* 1961 etc.; V. Scully, *Modern Architecture,* 1961; D. Sharp (ed.), *Sources of Modern Architecture. A Bibliography,* 1967; A. Whittick, *European Architecture in the Twentieth Century,* I 1950; II 1953.

II PAINTING AND SCULPTURE

Realism A. Boime, *The Academy and French Painting in the Nineteenth Century,* 1970; R. Herbert, *Barbizon Revisited,* 1962; L. Nochlin (ed.), *Realism and Tradition in Art 1848-1900,* 1966; L. Nochlin, *Realism,* 1971.

Impressionism J. Leymarie, *Impressionism,* 1955 and *The Graphic Works of the Impressionists,* 1971; P. Pool, *Impressionism,* 1967; J. Rewald, *The History of Impressionism,* 1961 (2nd ed.).

Victorian Painting Q. Bell, *Victorian Artists,* 1967; J. Dixon Hunt, *The Pre-Raphaelite Imagination 1848-1900,* 1968; G. H. Fleming, *Rossetti and the Pre-Raphaelite Brotherhood,* 1967; T. Hilton, *The Pre-Raphaelites,* 1970; J. Maas, *Victorian Painters,* 1969; G. Reynolds, *Victorian Painting,* 1966; K. Roberts, *The Pre-Raphaelites,* 1972; R. Watkinson, *Pre-Raphaelite Art and Design,* 1969.

Post-Impressionism, Symbolism, Fauvism C. Chassé, *The Nabis and their World,* 1969; J-P. Crespelle, *Les Fauves,* 1968; P. Jullian, *Dreamers of Decadence,* 1971; S. Lövgren, *The Genesis of Modernism,* 1959; J. E. Muller, *Fauvism,* 1967; J. Rewald, *Post Impressionism from Van Gogh to Gauguin,* 1962 (2nd ed.); J. Rewald, D. Ashton, H. Joachim, *Redon, Moreau, Bresdin* 1961; H. Rookmaker, *Synthetist Art Theories,* 1959; M. Roskill, *Van Gogh, Gauguin and the Impressionist Circle,* 1970.

Bibliography

20c English Art A. Bowness, *Recent British Painting*, 1968; A. M. Hammacher, *Modern English Sculpture*, 1966; H. Read, *Contemporary British Art*, 1951 and 1964; J. Rothenstein, *Modern English Painters*, I 1952; II 1956 and *British Art since 1900*, 1962.

20c German Art B. S. Myers, *The German Expressionists*, 1957, republished as *Expressionism* 1963; H. K. Roethel, *The Blue Rider*, 1971; E. Roters, *Painters of the Bauhaus*, 1969; P. Selz, *German Expressionist Painting*, 1957.

Cubism, Futurism, Constructivism, Abstract Art

A. H. Barr, *Cubism and Abstract Art*, 1936; M. Carra, *Metaphysical Art*, 1971; D. Cooper, *The Cubist Epoch*, 1971; T. V. Doesburg, *Principles of Neo-Plastic Art*, 1969; E. Fry, *Cubism*, 1966; J. Golding, *Cubism: A History and an Analysis 1907-14*, 1968 (2nd ed.); C. Gray, *The Great Experiment, Russian Art 1863-1922*, 1962, republished as *The Russian Experiment in Art*, 1971; A. Hill (ed.), *DATA*, 1968 (constructive art); M. Martin, *Futurist Art and Theory*, 1970; A. Ozenfant and Le Corbusier, *After Cubism*, 1971; F. Popper, *Origins and Development of Kinetic Art*, 1968; G. Rickey, *Constructivism: Origins and Evolution*, 1967; R. Rosenblum, *Cubism and Twentieth Century Art*, 1961; J. C. Taylor, *Futurism*, 1961.

Dada, Surrealism, Pop

A. H. Barr, *Fantastic Art, Dada, Surrealism*, 1937; A. Breton, *Surrealism and Painting*, 1968; M. Jean, *The History of Surrealist Painting*, 1960; L. R. Lippard etc., *Pop Art*, 1966; R. Motherwell (ed.), *The Dada Painters and Poets*, 1951; H. Richter, *Dada, Art and Anti-Art*, 1965; W. S. Rubin, *Dada, Surrealism and their Heritage*, 1968; J. Russell and S. Gablik, *Pop Art Redefined*, 1969; P. Waldberg, *Surrealism*, 1965.

III ARCHITECTURE AND DESIGN

Victorian Architecture and Design E. Aslin, *The Aesthetic Movement*, 1969; P. Ferriday (ed.), *Victorian Architecture*, 1963; R. Furneaux Jordan, *Victorian Architecture*, 1966; H. S. Goodhart-Rendel, *English Architecture since the Regency*, 1953; G. Naylor, *The Arts and Crafts Movement*, 1971; N. Pevsner, *Studies in Art, Architecture and Design, II, Victorian and After*, 1968.

Art Nouveau S. T. Madsen, *Art Nouveau*, 1967; S. T. Madsen, *Sources of Art Nouveau*, 1956; R. Schmutzler, *Art Nouveau*, 1964; P. Selz and M. Constantine (ed.), *Art Nouveau*, 1959.

De Stijl, Bauhaus H. Bayer, W. Gropius and I. Gropius, *The Bauhaus 1919-28*, 1938 etc.; H. L. C. Jaffé, *De Stijl*, 1956; second book 1969; J. L. Martin, B. Nicholson and N. Gabo, *Circle*, 1937 (republished 1971); H. M. Wingler, *The Bauhaus*, 1969.

IV MONOGRAPHS (Painters)

Bacon J. Rothenstein and R. Alley (complete catalogue) 1964; J. Russell 1971.

Balla V. D. Dorazio 1970.

Beardsley B. Reade 1967; *Letters* 1971.

Beckmann P. Selz 1964.

Bonnard J. T. Soby etc. 1964; A. Terrasse 1964; A. Vaillant 1966; A. Fermigier 1971.

Boudin G. Jean-Aubry 1969.

Braque H. R. Hope 1944; complete catalogue 1959 onwards; J. Richardson 1961; E. Mullins 1968.

Brown F. M. Hueffer 1896; Liverpool exhibition 1964.

Burne-Jones M. Bell 1903 (2nd ed.); Lady Burne-Jones 1904.

Cézanne L. Venturi (complete catalogue) 1936; *Letters* 1941; J. Rewald 1948; M. Schapiro 1952; K. Badt 1965; J. Lindsay 1969.

Chagall F. Meyer 1964; J. Cassou 1965; *My Life* 1965.

Chirico J. T. Soby 1955 and 1967.

Courbet G. Mack 1951; R. Fernier 1969.

Dali A. R. Morse 1958 & 1965; *Secret Life* 1961; R. Descharnes 1962; S. Dali and M. Gerard 1968.

Daumier R. Rey 1966; K. Maison (complete catalogue) 1968.

Degas P.-A. Lemoisne (complete catalogue) 1946-8; *Letters* 1947; P. Cabanne 1958; J. Boggs (Portraits) 1962.

Delaunay G. Vriessen and M. Imdahl 1967.

Denis Paris exhibition 1970.

Derain D. Sutton 1959; G. Diehl 1964.

Duchamp R. Lebel 1959; Tate Gallery exhibition 1966; A. Schwartz (complete catalogue) 1969.

Dufy A. Werner 1971.

Ensor P. Hassaerts 1959.

Ernst *Beyond Painting* 1948; P. Waldberg 1958; J. Russell 1967.

Feininger H. Hess 1961.

Gauguin R. Goldwater 1957; H. Perruchot 1964; G. Wildenstein (complete catalogue) 1964; B. Danielsson 1965; Tate exhibition 1966; A. Bowness 1971.

Van Gogh M. Schapiro 1950; C. A. J. Nordenfalk 1953; D. Cooper (watercolours) 1955; *Complete*

Letters 1958; J. B. de la Faille (complete catalogue) 1969; N. Wadley (drawings) 1971.

Gris *Letters* 1956; J. T. Soby 1958; D. H. Kahnweiler 1969.

Holman Hunt *Pre-Raphaelitism* 1905; Liverpool exhibition 1969.

Jawlensky C. Weiler 1971.

John J. Rothenstein 1944; *Chiaroscuro* 1952.

Kandinsky *Concerning the Spiritual in Art* 1947; W. Grohmann 1959; F. Whitford 1967; P. Overy 1969.

Kirchner W. Grohmann 1961; D. Gordon (complete catalogue) 1968.

Klee *On Modern Art* 1948; C. Giedion Welcker 1952; W. Haftmann 1954; W. Grohmann 1954; *Diaries* 1964; *The Thinking Eye – Note-Books* 1961; W. Grohmann 1967.

Klimt F. Novotny and J. Dobai (complete catalogue) 1968.

Kokoschka H. M. Wingler 1958; B. Bultmann 1961; J. Russell 1962.

Kupka L. Vachtová 1968.

Léger A. Verdet 1970; Tate exhibition 1970; Paris exhibition 1971.

Magritte J. T. Soby 1966; D. Sylvester 1969; S. Gablik 1970.

Malevich *The Non-Objective World* 1959; *Essays* 1969; T. Andersen 1970.

Manet G. H. Hamilton 1954; N. G. Sandblad 1954; P. Courthion and P. Cailler 1960; P. Courthion 1962; Philadelphia exhibition 1966; J. Richardson 1967; P. Pool 1970.

Matisse A. H. Barr 1951; G. Diehl 1958; L. Gowing 1966; California exhibition 1968; Hayward Gallery exhibition 1969; Paris exhibition 1970.

Millais J. E. Millais 1899; Liverpool exhibition 1967.

Miró J. Dupin 1962; Y. Bonnefoy 1967.

Modigliani J. T. Soby 1955; A. Werner.

Mondrian *Plastic Art and Pure Plastic Art* 1945; M. Seuphor 1957; L. J. F. Wijsenbeek 1969; Toronto exhibition 1969; H. L. C. Jaffé 1971.

Monet W. C. Seitz 1960.

Morandi L. Vitali 1970 (3rd ed.).

Munch F. B. Deknatel 1950; O. Benesch 1960; J. P. Hodin 1972.

Nash M. Eates 1948; *Outline* 1949; A. Bertram 1955.

Nicholson (Ben) H. Read I 1948; H. Read II 1956; J. Russell 1969.

Nolde P. Selz 1963; M. Urban (watercolours) 1966; M. Urban (landscapes) 1970.

Picasso C. Zervos (complete catalogue) 1932 onwards; A. H. Barr 1946; W. Boeck and J. Sabartés 1955; R. Penrose 1958; P. Daix and G. Boudaille (up to 1906 only) 1966.

Pissarro L. R. Pissarro and L. Venturi (complete catalogue) 1939; *Letters* 1943; J. Rewald 1963.

Redon K. Berger 1965; *Graphic Works* 1969.

Renoir W. Pach 1950; J. Renoir 1962; F. Daulte (complete catalogue) 1971 onwards.

Rossetti O. Doughty 1960 (2nd ed.); R. Glynn Grylls 1964; V. Surtees (complete catalogue) 1971.

Rouault P. Courthion (complete catalogue) 1962.

Rousseau (Le Douanier) J. Bouret 1961; D. Vallier 1964.

Sargent R. Ormond 1970.

Schiele R. Leopold 1971.

Schwitters W. Schmalenbach 1971.

Seurat H. Dorra and J. Rewald (complete catalogue) 1959; C. M. de Hauke (complete catalogue) 1961; R. L. Herbert 1962; W. I. Homer 1964; J. Russell 1965; P. Courthion 1969.

Sickert *A Free House!* 1947; L. Browse 1960.

Sisley F. Daulte (complete catalogue) 1959.

Soutine M. Wheeler 1950; M. Castaing and J. Leymarie 1964.

Steer D. S. MacColl 1945; B. Laughton 1971.

Sutherland D. Cooper 1961.

Tanguy J. T. Soby 1955; K. Tanguy 1963.

Toulouse-Lautrec D. Cooper 1954; H. Perruchot 1961; P. Huisman and M. G. Dortu 1964; J. Adhémar (complete lithographs) 1965; F. Novotny 1969.

Vlaminck J. Selz 1964.

Vuillard A. C. Ritchie 1954; J. Russell 1971.

Watts M. S. Watts 1912; R. Chapman 1955.

Whistler *Gentle Art* 1890; E. R. and J. Pennell 1908 etc.; D. Sutton 1963; D. Sutton 1966; New York exhibition 1971.

Wyndham Lewis C. Handley Read 1951; W. Michel and H. Kenner (complete catalogue) 1971; *Wyndham Lewis on Art* 1971.

Bibliography

V MONOGRAPHS (Sculptors)

Archipenko *Fifty Creative Years* 1960.

Arp C. Giedion-Welcker 1957; J. T. Soby 1958; E. Trier (complete catalogue) 1968.

Barlach C. D. Carls 1969.

Boccioni G. Ballo 1964.

Brancusi C. Giedion-Welcker 1959; I. Jianou 1963; S. Geist 1968; A. T. Spear (Birds) 1969.

Calder J. J. Sweeney 1951 and 1971; H. H. Arnason 1966; *An Autobiography* 1966.

Degas J. Rewald 1944.

Duchamp Villon G. H. Hamilton and W. C. Agee 1967.

Epstein *An Autobiography* 1955; R. Buckle 1963.

Gabo H. Read and L. Martin (ed.) (complete catalogue) 1957; *Of Divers Arts* 1962.

Gaudier-Brzeska E. Pound 1916; H. S. Ede 1931 etc.

Gauguin C. Gray 1963; M. Bodelsen 1964.

Giacometti P. Selz 1965; D. Sylvester 1970; R. Hohl 1971.

González Tate exhibition 1970.

Hepworth H. Read 1952; J. P. Hodin and A. Bowness (complete catalogue I) 1961; A. Bowness (drawings) 1966; A. M. Hammacher 1968; *A Pictorial Autobiography* 1969; A. Bowness (complete catalogue II) 1971.

Laurens W. Hofmann and D. H. Kahnweiler 1970.

Lehmbruck A. Hoff 1969.

Lipchitz A. M. Hammacher 1961; H. H. Arnason (sketches) 1969.

Maillol W. George 1965.

Marini A. M. Hammacher 1970; H. Read; P. Waldberg, G. di San Lazzaro 1970.

Modigliani A. Werner 1962.

Moore Lund Humphries (complete catalogue) I 1957 D. Sylvester (ed.); II 1965; III 1965, A. Bowness (ed.); W. Grohmann 1960; H. Read 1966, *On Sculpture* 1966; D. Sylvester 1968; J. Russell 1968; R. Melville 1970.

Noguchi *A Sculptor's World* 1968.

Pevsner C. Giedion Welcker and P. Peissi 1961.

Picasso D. H. Kahnweiler 1949; R. Penrose 1967; W. Spies 1971.

Renoir P. Haeserts 1947.

Rodin *Art* 1912; A. Elsen 1963; I. Janou and C. Goldscheider 1967; R. Descharnes and J. F. Chabrun 1967.

Rosso M. S. Barr 1963.

Smith C. Gray (ed.) 1968.

Vantongerloo M. Bill (ed.) 1962.

Zadkine I. Janou 1964.

VI MONOGRAPHS (Architects and Designers)

Aalto K. Fleig 1963; *Works* I 1970; II 1971; G. Baird 1971.

Breuer P. Blake 1949; *Sun and Shadow* 1956; Cranston Jones (ed.) 1962.

Butterfield P. Thompson 1971.

Fuller R. W. Marks 1960; J. McHale 1962.

Gaudí J. J. Sweeney and J. L. Sert 1960; R. Descharnes and C. Prevost 1969.

Gropius S. Giedion 1954; J. M. Fitch 1960; M. Francisconi 1971.

Le Corbusier Complete works, 1937 onwards; F. Choay 1958; P. Blake 1960; W. Boesiger 1971.

Lissitzky S. Lissitzky Kuppers 1968.

Loos L. Muenz, G. Kuenstler etc. 1966.

Mackintosh T. Howarth 1952; R. Macleod 1968; V and A exhibition 1968.

Mendelsohn A. Whittick 1956.

Mies P. Johnson 1953; L. Hilbersheimer 1956; A. Drexler 1960; W. Blaser 1965 and 1971.

Moholy Nagy *The New Vision* 1947; S. Moholy Nagy 1950; *Painting, Photography, Film* 1969.

Morris J. W. Mackail 1900; P. Thompson 1966; P. Henderson 1967.

Nervi J. Joedicke 1957; A. L. Huxtable 1960.

Rietveld T. M. Brown 1958.

Rudolph S. Moholy Nagy 1969.

Van de Velde A. M. Hammacher 1967.

Wagner H. Geretsegger and M. Peintner 1969.

Webb W. R. Lethaby 1935.

Wright H. R. Hitchcock 1942; V. Scully 1961; M. Pawley 1970 and 1971.